Steep Holm

Weston-super-Mare

Hutton

Bleadon Chri

Uphill

Brean

Loxton

Bishop

Zickfora

gton

MENDIP HILLS

Charterhous

Axbridge Cheddar

Draycot

Rodney Stoke

Brent Knoll

M5

Burnham-on-sea

Wedmore

Steart

THE LEVELS

Woolavington Westhay

Cossington

Edington

Chilton Catcott

Polden Shapwick

Bawdrip

A39

Chedzoy Moorlinch Ashcott Street

Walton

Sutton Mallet

other Stowey

A39

POLDEN HILLS

Bridgwater

Enmore Compton Dundon

CK HILLS

Goathurst Dundon

North Petherton

tone

Broomfield Othery

High Ham

ngston Mary Somerton

THE LEVELS

Langport

Taunton

Muchelney

CW0551200

SOMERSET HILLS
IN WATERCOLOURS

on higher ground

Rosie and Howard Smith

The Garret Press

First published in the United Kingdom in November 2011.

The Garret Press, 6 Stafford Place, Weston-super-Mare, Somerset. BS23 2QZ.

www.garretpress.co.uk

British Library Cataloguing in Publication Data.

A catalogue record for this book is available from the British Library.

ISBN

978-0-9541546-7-7 (paperback)

978-0-9541546-8-4 (hardback)

Cover illustration: Approaching Crooks Peak across Wavering Down. April.

Epilogue page: Katie's Field, Brent Knoll. January.

Design: Colin Baker

Type: 12 pt. Perpetua

Printed in Great Britain by: R. Booth Limited, The Praze, Penryn, Cornwall. TR10 8AA.

ACKNOWLEDGEMENTS

We would like to thank Kathie Barnes, Catherine Preston, Paul Smith, Sam Smith, Allan and Laura Hoyano for their guidance on the text.

Thanks also to David Agassiz for the information he provided on the Large Blue butterfly which led us to Collard Hill in the Poldens. Also, his instantaneous identification of a Silver-washed Fritillary! Quantock Ranger Tim Russell was generous with his time at his Fyne Court office in Broomfield. We were really impressed by the work he has put into the restoration of Somerset's cast-iron signposts - all around the Quantock area is the evidence of his enthusiasm.

We had much help with maps and manuscripts from the staff of North Somerset Library in Weston-super-Mare's Boulevard. We feel desperately sad this venerable Weston institution is being forced to move, despite considerable opposition, from its handsome Hans Price building into the anonymity of the town hall.

Again and again, Chris Richards has been a huge source of information and guidance. It was great sitting with him in a sunny garden discussing Iron Age camps, Roman roads, Mendip geology and Caving. Thanks also to David Nisbet of 'Sterling Books' in Weston-super-Mare for coming up with invaluable source books on Somerset's hills, and Mendip warden Virginia Flew who guided us to the violet meadows below Wavering Down.

As always, pulling the paintings, the script, the footnotes into the form of a book has been achieved by our designer Colin Baker. How he makes everything fit together we shall never quite understand. Thanks as well to Neil Richards at our printers R. Booth, for his sympathetic care in scanning and preparing the many paintings. And finally our appreciation to Judi Kisiel of the Weston & Somerset Mercury for her kind support.

This book is dedicated to our grandchildren Sarah, Laura and Fred.

INTRODUCTION

THE BRENDON HILLS

Page 75

THE MENDIP HILLS

Page 94

East Mendip

Mendip - the Northern Slopes

The Mendip Plateau

EPILOGUE

BIBLIOGRAPHY

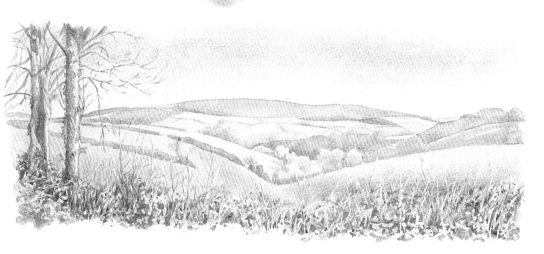

After we had completed our four books on Somerset's coastline in late 2006, it seemed time to move inland. So, as it is with these things, 'doing the hills' came to mind.

We soon realised it wasn't going to be possible to fit all of Somerset's hills into one book of a reasonable size! So after some anguish, we settled on writing and painting the four titled ranges of hills lying entirely within the borders of historical Somerset, namely: the Poldens, the Quantocks, the Brendons and the Mendips. To make our task achievable has also meant excluding individual hills, the 'lumps and bumps' so to speak, such as Worlebury, Brent Knoll and even Glastonbury Tor - although the latter does get onto these pages by sheer force of personality! But to those who might look for the Blackdowns or the Failand ridge (and all the other places we've left out); all we can say is sorry.

As before, we endeavour to combine a relaxed informative text with watercolour paintings that capture the character and season of a setting. Footnotes highlight particular subjects in more detail, with the Special Pages expanding on items that alerted our curiosity. We do describe quite a few walks but these are not strictly directional. For that, you'll need some of the incomparable Ordnance Survey Explorer maps, particularly: for the Mendips: nos. 142, 143 & 153, for the Quantocks: no. 140, for the Brendons: no. OL9, and for the Polden Hills: nos. 140 & 141. The maps found inside the book's covers are meant only to provide an approximate indication of position. They are not for navigational purposes!

THE POLDEN HILLS

We start in the very heart of Somerset, sitting in late summer sunshine up on Combe Hill at the eastern end of the Polden range, and looking down on the village of Compton Dundon with its companion hills, Dundon and Lollover, rising behind. It's an enchanting picture; Dundon Hill is tree-covered, hiding its Iron Age hill-fort, while Lollover, though wooded on its north side, rises to a clear, trig-point top - the northerly escarpment of High Ham just visible beyond. Below us, the village tucks itself around

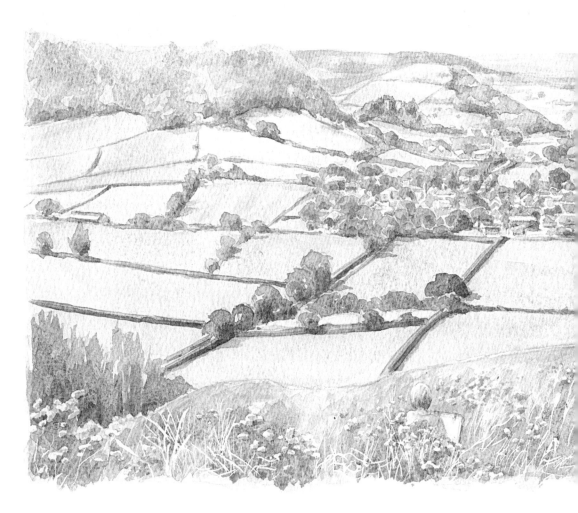

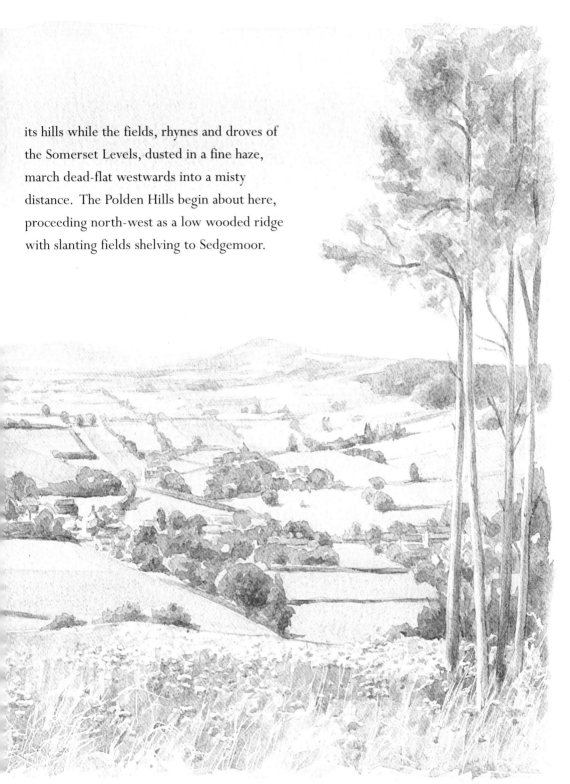

its hills while the fields, rhynes and droves of
the Somerset Levels, dusted in a fine haze,
march dead-flat westwards into a misty
distance. The Polden Hills begin about here,
proceeding north-west as a low wooded ridge
with slanting fields shelving to Sedgemoor.

Combe Hill, late summer - looking west along the southern Polden escarpment

As a range of hills, the Poldens don't appear to amount to much, rising as they do to little over 395ft (120m) in the east, south of Glastonbury, and undulating between heights of 230 and 130ft (70-40m) as they extend and descend twelve miles to the west, just north of Bridgwater. But they are clearly defined - at least from the south, where they stand, like the sea cliffs they once were, above the flood plains of the Somerset Levels. On their northern side, the gradient is gentler, rising almost imperceptibly from the peat lands of Edington and Shapwick Heaths. These days, nearly the entire length of the Polden ridge is occupied by a busy main road: the A39 - the traffic load much aggravated by the arrival of the M5 motorway in the 1970s.[1] Things quieten once the A39 branches off to Street, leaving a minor road to ride the rest of the way, up and over Walton and Collard Hills, to Compton Dundon.

The Poldens are encircled by a necklace of villages occupying the hills' lower slopes. Before its dissolution in 1539, a good many of these villages were held by Glastonbury Abbey with their various chapels looking to St. Mary's at Moorlinch as their Parish Church. Not surprisingly, the villages and their churches all have a strong family resemblance being built, for the most part, of local limestone.

Looking out from Wedmore's Mudgely Hill, the Polden range makes an almost inconsequential disturbance of the southern horizon. As so often happens in Somerset, your eye is irresistibly drawn to the hallowed eminence of Glastonbury Tor - before descending and following the straight line of the old turnpike road across the marshy levels to Westhay.[2] The road then moves south-west, bridging the South Drain waterway (where Shapwick Railway Station once stood) to begin the gentle rise into Shapwick village.[3]

[1] In Roman times, this highway linked a port near Puriton on the River Parrett to Ilchester - then the district's pre-eminent settlement. The road remained important enough as a route to Bristol and Bath to be 'turnpiked' by the Bridgwater Trust in 1759.

[2] The road was built by the Wedmore Turnpike Trust in 1827 and 'deturnpiked' in 1874. It ran from Rowberrow, near Shipham in the Mendips, to Pedwell in the Poldens.

[3] In 1854, the Somerset Central Railway built its Highbridge/Glastonbury line along the embankment of the defunct 1833 Glastonbury Canal (not to be confused with the medieval waterway) - which had incorporated a section of the South Drain.

SHAPWICK

Manor House clock.

Shapwick (the name means 'sheep-farm') is one of a string of eight villages arrayed along the northern Polden slopes. It's a pleasant and harmonious place. As you'd expect, its older houses (and some of the newer) are built of the local White and Blue Lias limestone (small, linear blocks of a soft, dusky-grey or blue stone) as is the 14th century church of St. Mary.[4] Chunks of lias are still evident in many of the surrounding fields, and the stone was once quarried locally. The church stands just off the main road through the village surrounded by spectacular Atlas and Lebanon cedars.[5] North of the church, beyond an area of open grassland and within a beautiful high brick wall, lies the gabled, medieval Manor House which is now home to a school for children with dyslexia.

[4] *White Lias is a limestone of the late Triassic period (250-204 million years ago). Blue Lias is a limestone of the early Jurassic period (204-135 million years ago) which, unlike the White Lias, has many ammonite fossils (Peter Hardy).*

[5] *The original church, possibly on a Saxon site, appears to have stood in a place called Church Field, about a half mile (1 km) east of the present St. Mary's, close to Beerway Farm. Archaeological research has revealed intense prehistoric, Roman and medieval activity in this area (M.Cole & P.Linford 1996).*

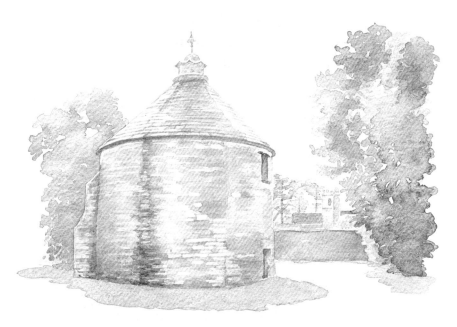

Dovecote - the Manor House

Close to the northern entrance of the village is Shapwick House which served as a convalescent home during the Second World War and is now an hotel. It's a Tudor reshaping of a moated, 15th century building and remains of the moat are still there, crossed by a small stone bridge at the entrance to the house. Interestingly, both the Manor and Shapwick Houses have elegant dovecotes - the former circular and 15th century, the latter octagonal and 18th century - though possibly on the site of an earlier model. Shapwick village has been at the heart of an ongoing investigation into Somerset's rural landscape called the 'Shapwick Project'.[6]

[6]*The Shapwick Project*

The Shapwick Project was an archaeological investigation (1989 - 99) into the history andt topography of a single Somerset parish between the 8th and 13th centuries. It was an attempt to understand why a village might have come into existence - an original thesis by Nick Corcos had suggested that Shapwick ('a typical English village') may have actually been planned. The Project, subsequently directed by Dr. Christopher Gerrard and Prof. Mick Aston, confirmed this. Shapwick was granted to the abbey of Glastonbury in the 8th century. By the 10th century, the abbey was coercively rehousing a somewhat dispersed, rural population into a compact village served by open field strip systems to its east and west. Previously, the inhabitants had depended on sheep and cattle grazing the hillside slopes and moors. It seems likely that other villages on the Polden slopes arose in a similar manner. The Project employed a host of sophisticated techniques eg. large scale geophysical surveys, heavy metal analysis, field-walking and hedgerow dating, excavation and shovel-pit testing. By the time the investigation closed, over two thousand people had been involved.

An important part of Shapwick is Loxley Wood, which bestrides the A39 (the Bath or Roman Road) at the top of the Polden ridge above the village. In 1938, Stuart Mais described walking "a long and lovely avenue of oak trees at Loxley Wood" as he explored the Roman Road along the top of the Poldens: "the best avenued range in the land". Sadly, no more. Loxley Wood is the only substantial woodland within the Shapwick parish and even up until the 1960s was still a mixture of coppiced hazel and oak, rich in wildlife. It remains classified as ancient woodland, but in 1967 it was near clear-felled and largely replanted with Norway spruce and larch ('coniferised'). Fortunately in 2000, more than 52 acres of the wood, on the Shapwick side of the Bath Road, were acquired by the Woodland Trust which is now actively replacing the conifers with native broadleaf (ash, oak, hazel).

Loxley Wood - springtime

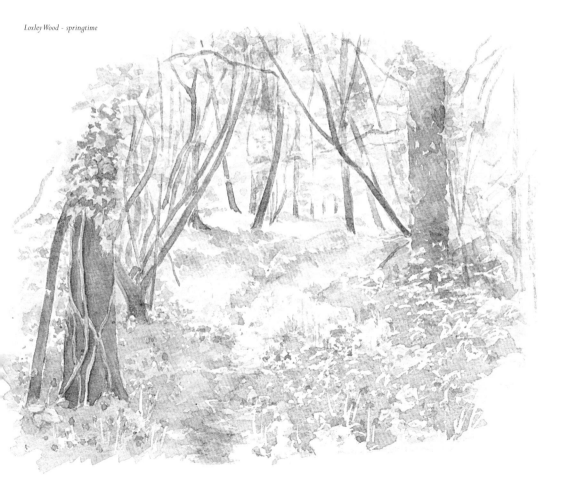

It's late April and we enter the wood from Shapwick's Wood Lane, close to the A39 junction. A high field maple stands guard opposite the gateway and the Woodland Trust have even provided an information board! It's good to see that the majority of the spruce trees have now gone and the ride, cut through the centre of the wood, has opened a wide, sun-filled corridor. Bluebells are gathered here, wood anemones and primroses - the patches of flowers are fizzing with insect life. Larch trees are coming into leaf, spindle too, but despite the sunlight, the ash are waiting for firmer evidence of spring. At the eastern boundary, the trail is awash with bluebells and their light, hyacinth scent fills the wood. There is a footpath here which would take us back to Shapwick - we can see the tower of St. Mary's Church across the fields.

At the northern border of the wood, we come upon a small pond whose banks are cloaked with flowers; bluebells, wood anemones, primroses and lesser celandines punctuated by the bright spikes of early purple orchids.

The wood is well known locally for 'Swayne's Jumps': where Jan Swayne made his famous leaps to freedom after the Battle of Sedgemoor in 1685 (See the Special Page), but that's on the other side of the A39.

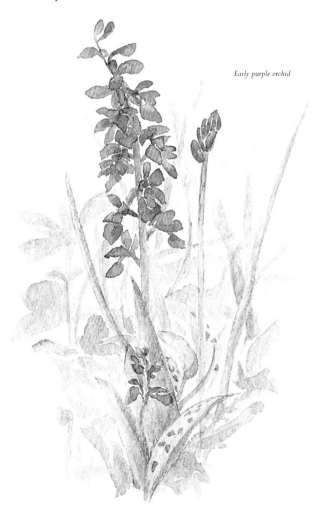

Early purple orchid

Swayne's Jumps

Loxley Wood stands between Shapwick and Moorlinch, divided in two by the busy A39. Up until the 1960s this was thick oak woodland. Back in 1685, many unwitting Somerset men were caught up in the Monmouth Rebellion; when the illegitimate son of Charles II, Protestant James, Duke of Monmouth attempted to overthrow the unpopular Roman Catholic James II. The attempt foundered on July 6th at the Battle of Sedgemoor, just north of Westonzoyland, and the rebel army broke up and men fled for their lives. Westonzoyland church was filled with the wounded, the dying and the dead. Known rebels were hunted down and hanged from the nearest gallows tree, or dragged to various assizes for a summary trial and execution. The quartered corpses were strung up around the county towns. What happened has entered deep into the folklore of the West Country.

Jan Swayne's marker stones

But some did get away. Jan Swayne of Moorlinch, who had supported the Monmouth cause, was dragged from his bed for incarceration at Bridgwater. His captors were to take him by way of the Bath Road through Loxley Wood - dense, coppiced woodland. The Royal Army men were clearly fairly relaxed and pleased with themselves - a jar or two of ale maybe and ready for a wager? - when Jan persuaded the troopers to allow him to show off his jumping talents to his children for one last time. His legs were unbound and with three great leaps he disappeared into the tangle of Loxley Wood, to reappear forever in local legend.

Jan Swayne's Jumps are measured out with marker stones (I counted four; one of which was being used as an anvil by a song thrush - it was surrounded by the smashed shells of banded snails), at the spot he supposedly made his break for freedom - there's about 13ft (4m) between them. Like Jan, they're not easy to find but there is a sign on the south side of the A39 - about 300m east of Shapwick's Wood Lane junction with the main road. But be careful for this is a very busy highway.

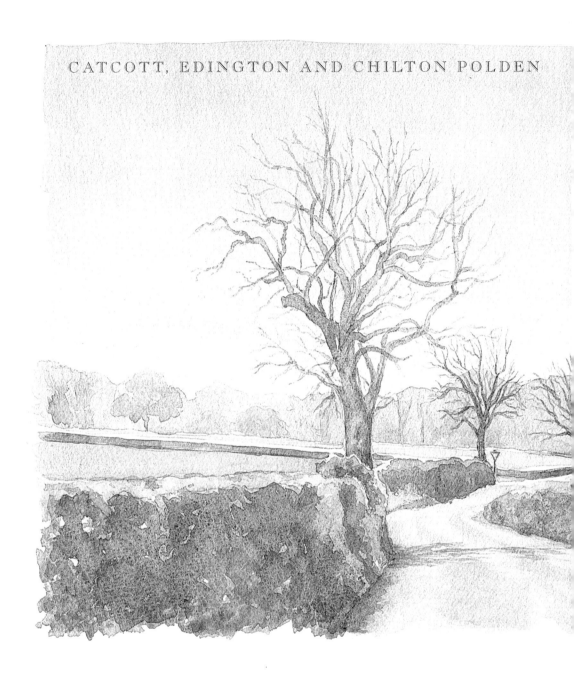

The road out of Shapwick travels west from the church and along Lippets Way the mile or so to Catcott. It has an easy incline with large, singular, ash trees marking the hedge boundaries along the way. The fields are wide, falling to the low peat lands with the grey-green Mendips in the northern distance. Catcott village has a quiet, assured atmosphere. The Standards is a footpath lined by fine, stone cottages - emerging onto

The road out of Shapwick

Langland Lane. When we were here in April, Barton Farm, a 16th century farmhouse, was draped in white, sweet-scented armandii clematis with blue iris flowering against a warm barn wall beside the lane. The rough road passes the charmingly dilapidated buildings of Langlands Farm, to roll eastwards down onto the moors towards omnipresent Glastonbury.

Close to Catcott's war memorial (an impressive headed stone column at the centre of the village), a path leads to St. Peter's Church, tucked away off Old School Road. Bel Mooney's book 'Somerset' has directed us here, for this is one of her favourite places. St Peter's is built of the White Lias and has a small, castellated tower. Someone in 1912 described it as 'very poor and utterly unworthy'. Today, it seems entirely worthy. Outside, it has an uncluttered restraint, while inside you are tugged back into the early 17th century - for this church has somehow escaped Victorian renovation.[7]

[7]*St Peter's started life in 1292 as a 'Chapel of Ease' - it saved locals the three mile hike to the parish church at Moorlinch. For devious reasons, in 1547, Squire William Coke had the chapel reclassified as a Chantry allowing its closure. Vicar Richard Hodgson was pensioned off (with £3.12sh.) and Squire Coke set about dismantling the church. Font and bells were removed along with windows and doors. In 1553, Vicar Hodgson succeeded in regaining St Peter's 'Chapel of Ease' status and Squire Coke was ordered to restore the church. At first he refused and ended up in the Fleet Prison for over a year! In the end he complied but did the work badly and 'with a very bad grace'. The cause of the quarrel was almost certainly religious - Protestant (Squire) v. Old Religion (Vicar).(source: St. Peter's Church History & Guide).*

There is an ancient octagonal font, painted wall texts, a wooden choir gallery, elm pews with pull out benches (for children or servants?), all comfortably confined within an intimate building. In the south porch, under an old blackboard titled 'Public Notices', are displayed the village stocks. Designed to accommodate a variety of ankle sizes, we wondered when they were last put to serious use, and for whom! And why!!

St. Peter's Church, Catcott

Half a mile west of Catcott, the road arrives at Edington. It's known for its Holy Well - found at the northern edge of the village, at the corner of a sharp, right-angled bend. It was restored (a mite too much, we feel) in memory of Frances Luttrell in 1937, and across its stone pavement runs a yellow staining trickle with a strong sulphurous pong.[8]

A little further west lies Chilton Polden where the main road curves and dips through the village. There is a pleasing mix of cottages and farmhouses of varying periods lining the main road, along with the Last Surviving Post Office (we were told) within quite a few miles. The tiny post office cum village store (contained in a small,

terracotta brick building tacked onto the front of a house) is wonderfully old-style - a precious reliquary! A short distance from the post office, runs the gentle declivity of Goose Lane, walled in Blue Lias stone with an unnamed stream murmuring along its east side. The brook, culverted for a short distance, re-emerges in a deep gully - in spring when we came here, its banks were covered in primroses and apple blossom.

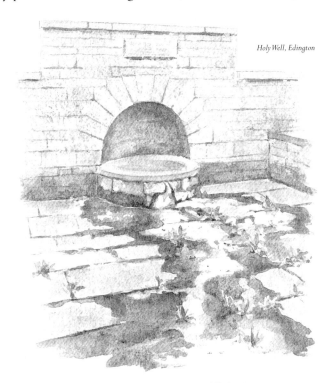

Holy Well, Edington

[8]*There are a number of holy wells associated with the northern Polden villages - probably linked to their connection with Glastonbury Abbey, all reckoned to have healing properties. The springs rise from the Lower Lias clays and are laden with sulphur. It was believed the waters could cure scorbutick (scurvy). When Jeremy Harte visited the well in April 1915 (having alighted at Edington railway station - still indicated on the village's road sign), he found the waters were collected in a stone tank, half full of decaying leaves: "The flow was slight and the water itself of a greenish milky colour, with a strong and horrible smell of sulphur."*

From Chilton Polden, we took a short detour south, uphill towards the Polden ridge and the A39. A few hundred yards before reaching the main road, we stopped to take a look at Chilton Priory - an extravagant phantasm built by antiquary William Stradling in the 1830s.[9] In April the Priory's trees were still free of leaves allowing a good view of its austere northern frontage: grey stone and castellated turrets and towers. When it was built, it must have been a remote and dramatic citadel commanding all of Somerset from its battlements above the old Roman Road. But today, the busy 21st century presses hard (and noisily) against its southern walls.

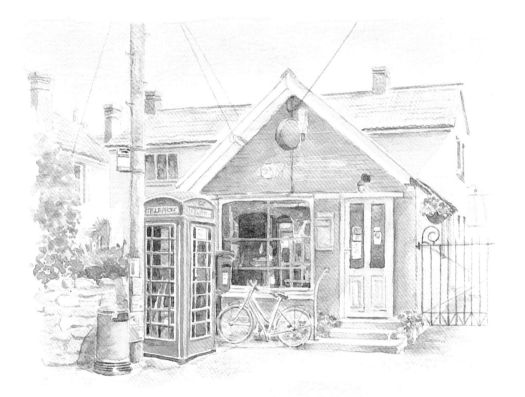

Post Office, Chilton Polden

[9] *In 1941, Arthur Mee described it as 'a hotchpotch building' made of and filled with odd treasures: pinnacles from Langport, battlements from Enmore Castle, a turret from Shepton Mallet, a door from Stogursey, a porch from Somerton. Robin Bush adds to the list with: 'a dirk from Trafalgar, an iron hook used to hang Monmouth rebels at Bridgwater, as well as a bedpost that belonged to the last abbot of Glastonbury!*

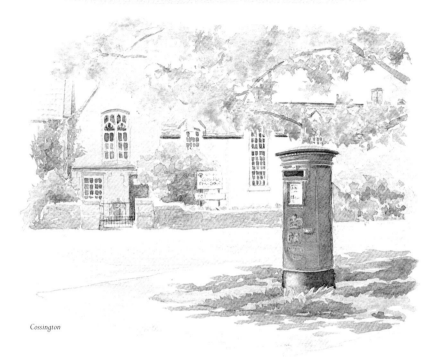

Cossington

The road west out of Chilton Polden traces a moderate rise above the northern fields and moors and, just before the road dips down into leafy Cossington, there's a clear view of the Mendips rolling westwards to Wavering Down and the tweaked top of Crooks Peak. As its name seems to imply, Cossington is a cosy place which has coped pretty well with the intrusions of the 20th century. The village straddles a small valley into which is nestled The Grove and its extensive parkland.[10] There is some modern building here, but most of it manages to remain hidden. The small, beautiful school sits in the village centre and the sound of children's voices carried across the road to where we were sitting under the horse chestnuts.

Many of village's older buildings (Launder Cottage, Millmoot Farm) stand on its eastern side within a cluster of lanes: Walnut Lane, Bell and Millmoot Lanes with Locks Way dipping across the valley floor.

[10]*During the 19th century, the owners of the The Grove (a late 17th century brick house) laid out the narrow valley below the church as parkland and secured the valley stream to form a lake. You can briefly see the culverted brook opposite the village school as it emerges from beneath the road to flow towards The Grove.*

Cossington's St. Mary's Church stands above the Woolavington road with its Manor House tight close by, separated only by a gravel path and a narrow lawn. The house has a simple elegance, rose-clad, and a handsome, gabled, Victorian extension to the east. It seems the entire house had a mid-19th century make over and what we now see hides an older, 18th century building (which itself replaced an even older house called Court Place). The church is built of lias stone; the tower neatly coursed and the main building random. Above the south porch is a large, slate sundial which we noticed, from Eric Turner's memorial bench across the churchyard, to be uncorrected for British Summer Time!

The road out of Cossington to Woolavington crosses the old railway track to reach the B3141. Work at the Royal Ordnance Factory close by has led to Woolavington growing southward and pushing its centre of gravity up the hill, away from the original settlement around the church.[11] In School Lane, a footpath leads through an orchard graveyard (apples and damsons), to where St. Mary's Church rests in the lee of sheltering lime trees. Just north of the church, Jessop's Village Store stands out in smart cream and red livery - "Hot Pork Rolls for sale!" West of St. Mary's, much of the original village lies along Lower Road and it's here you'll find 'The Old Post Office' and 'The Old Wash-house' as well as The Grange: a splendid, stone farmhouse and barn.

Farm doorway, Cossington

[11] *The Royal Ordnance Factory started life in 1939 producing explosives - its demand for water led to the cutting of the Huntspill River (enlarging the former South Drain) from the mouth of the River Parrett. By 1943, it was employing nearly 3,000 people. In 1987, the factory was taken over by British Aerospace.*

BAWDRIP, CHEDZOY, SUTTON MALLET, MOORLINCH AND HIGH HAM

Crancombe Lane climbs the slope from Woolavington to the Polden ridge to dip sharply down to the A39. Despite its Roman connections, it's best to escape this busy highway and explore the Poldens' southern aspect by taking the road down into Bawdrip. There's a reassuring surprise here; recent development has succeeded in preserving the village's character with modest, neighbourly, brick and stone cottages clustering around a village green next to the church. 13th century St. Michael's Church is raised a few feet above the road, its entrance gate watched over by two magnificent lime trees.

Crossing the King's Sedgemoor Drain and moving a mile or so south to reach Chedzoy allows a perfect view of the western end of the Polden range. From St. Mary's Church in Chedzoy, we could see Pendon Hill, green capped by Badgers Wood, rising smoothly from the freshly ploughed fields. From here, the road folds back across the waterway to follow a moorland track to Sutton Mallet.

We have a soft spot for Sutton Mallet. The small, windswept, undedicated church stands on a low bluff looking out over Sedgemoor - it's only two and a half miles south west of here that the Battle of Sedgemoor was fought in July 1685 (see Special Page: Swayne's Jumps). But back in the 17th century, all that stood on this spot was a lowly chapel - it wasn't until the 1820s that it was largely rebuilt.[12] Stone steps lead up from

Pendon Hill from Chedzoy

Sutton Mallet Church

the road to where the church stands on a grassy plateau, with an atmosphere of proportioned simplicity. Its limestone walls capture and reflect the afternoon sunlight. Inside, that simplicity is emphasised by its austere, high box pews (apparently, each one was allotted to a particular farm), a gallery, hat pegs and candle holders. This is a place that, like St. Peter's in Catcott, escaped the heavy hand of Victorian improvement.

[12] *In 1780, Edmund Rack described the medieval chapel as "very mean… a dark dismall (sic) looking place… very dirty and much fitter for a stable than a place of worship". In the 1820s, most of the old building was pulled down, but the tower was retained (and enlarged) along with some of the old chapel's windows. The walls are constructed from Blue Lias stone, which was originally rendered. (The Church Conservation Trust).*

Our road, called the Sedgemoor Hill Drove, takes a
gentle rise south from the church, past Nino's and Godfrey's
Farms, to arrive at the top of a ridge. It then descends a
steep hollow-way, with high, badger-raddled banks, to turn
east at the bottom of the hill - leaving the drove to continue
southwards across the moor. For a while, the track
accompanies a rhyne before cutting across a marsh-meadow
and up the lower slopes of Pit Hill. Moorlinch's St. Mary's
Church sits high on an escarpment to the east, just below
the summit of Knowle Hill. We enjoyed a warm and sunny
late March here, stopping for lunch amongst cowslips, on
the edge of a raised field boundary, willows at our back.

Cowslips

The footpath emerges at the lower end of Moorlinch village and there's a steepish
hill to climb up to St. Mary's Church. I remember Moorlynch Vineyard here - just up
the side road, past the handsome, Georgian Post House - sadly, they stopped making
wine in 2002.[13] Opposite the Post House, a church-path leads to St. Mary's sitting
squarely at the top of the bluff, where there's a welcoming bench at the base of its low,
west tower. From the church, the land falls away westwards revealing a glorious view of
Somerset: out across the Levels to the Quantock Hills in the west, wooded High Ham
to the south.

We took an upper footpath, a wide 'green-way', back to Sutton Mallet. This was
probably an ancient church-path linking the Sutton Mallet chapel with its mother
church at Moorlinch.[14] It's commonsensical too, for by following the Pit Hill ridge,
the track avoids the lower, boggier ground we had crossed earlier.

[13] *Anne & Peter Farmer produced floral white wines from 1981 to 2002 at the vineyard (formerly Spring Farm) from a
variety of grapes including Muller Thurgau, Madeleine Angevine, Findling and Huxelrebe. I recall Weston-super-Mare
Medical Wine Club attending an excellent evening of vinous instruction here in the 1980s!*

[14] *This track has had a number of names; in 1515 it was called Lychewey (a path by which the dead were
carried to burial) or Padenayshe Wey and was marked by a cross. (Victoria County History - Somerset).
Recent maps call it Pit Hill Lane or Samaritans Way.*

HIGH HAM

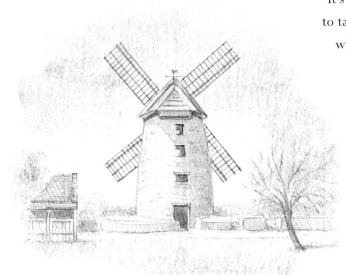
Stembridge Mill, High Ham

It's now that Rosie and I decide to take a look at High Ham which had intrigued our southern horizon for some time - not strictly Polden, but close enough! This hill rises abruptly from the southern boundary of King's Sedgemoor which is crossed by way of the Nythe Road, another causeway across the Levels. A steep and twisting road brings you up to High Ham village (a charming mix of stone houses and terracotta roofs) and arrives by bisecting the village green. Despite that, large pollarded lime and horse chestnut trees rescue the green's intimacy as do some watchful houses and St. Andrew's Church. The beautiful stone church is set back from the green and there's a mysterious Gothic gateway through a high stone wall to its rectory next door. Within the church is a touching memorial to High Ham's war dead (so many) with a compelling, sculptured head of a Tommy soldier by D. Huxley-Jones. Not far from the green is a new primary school - a heartening example of a modern building working within a traditional setting. Alone in fields east of the village, at the end of Windmill Road, stands Stembridge Tower Mill - a thatched flagon of Blue Lias stone; its sails motionless.[15] Beside it rests a small mill cottage, with an orchard of walnut and mistletoe-draped apple trees.

[14]*Stembridge Mill, supposedly the last thatched mill in England, was built in 1822. In 1894, a steam engine was installed to provide alternative power. When the mill's rotating cap jammed in 1897, steam took over completely. Milling ceased in 1910. In 1969, the mill, cottage and garden were left to the National Trust by Prof. H. H. Bellot - it's open on occasional days during the summer.*

Beyond the windmill, the road starts to descend what is called Sedgemoor Hill. Looking for the footpath back to High Ham we came upon the East Field Nature Reserve - about 18 acres of 'unimproved' grassland bounded by large ash trees and, along the hedgelines, blackthorn in brilliant white flower. From here, the prospect looks out towards Somerton over a beautiful hatched tapestry of fields and woodland. The footpath (which we discovered at the bottom of the hill) led us back up to High Ham, through fields of old terracing and saturated, soggy places where springs burst from the hillside.

View from East Field to Somerton

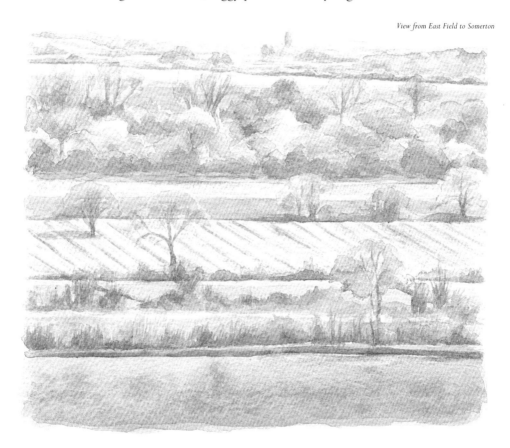

Back in the village, the road and footpaths behind St. Andrew's Church lead westward to Turn Hill: a confined escarpment of National Trust land with a glorious outlook across the Levels to the Poldens and the Quantocks. Berta Lawrence recounts the story of Joseph of Arimathea and the boy Jesus passing this way on their journey to Glastonbury and that in the 1930s, a shepherd could point out the path they took. Well, sheep still graze the steep slopes of Turn Hill and, maybe, a shepherd still tells the tale.

WALTON HILL, IVYTHORN HILL
AND COLLARD HILL

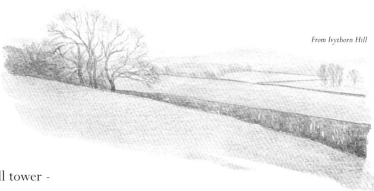

From Ivythorn Hill

Returning to the Polden ridge above Moorlinch, we left the A39 at the The Pipers Inn[15] and began a slow climb (passing a high windmill tower - but no sails this time) to the National Trust's Walton Hill. Here, a glorious view to the south suddenly revealed itself, over misty fields and farms, hills rising abruptly from the plain. In the middle distance, we could just make out Dundon's small church, poised on a bridge of high ground between its two encompassing knolls. The Trust has been working hard on Walton Hill; clearing conifers and scrub to restore the hillside's grassland habitat along with the many plants and animals it will support.

Ivy Thorn Hill is another section of the south Polden escarpment, just east of Walton Hill, under the care of the National Trust. You can take the steep road down towards Middle Ivy Thorn Farm and then turn off into a hillside wood called Ivythorn Hill. We were here during a warm early spring, sunny and soft, the fields and woods bursting with life, the woodland floor splashed with wood anemones, primroses and lesser celandine. We walked a path that took us along the southern perimeter of the wood, looking out over a soft haze of green pasture with the milky outline of Lollover Hill rising from the meadows. Mature oaks guarding the field edge, badger setts punched into the red earth of the hillside. Further into the wood, the path became chaotic with uprooted trees and swirling vines of old-man's-beard - it was quite a battle to regain the higher ground.

[15]*In June 1841, William Wordsworth was in Bath to celebrate the marriage of his daughter Dora. The day after the ceremony, which Wordsworth had been too ill to attend, the wedding party met for breakfast at Pipers Inn. Wordsworth then continued on to the Quantocks and Alfoxden, visiting for the last time the scenes of so much of his poetic inspiration. The inn probably got its name from a Colonel Piper - one of its early owners.*

We emerged from the wood close to the busy crossroads at Marshall's Elm and escaped down a lane called Pages Hill.[16] It retraced the way we had come - but this time on the far side of the fields away from the woods. At a sharp bend in the fern lined road, the track passed the grand entrance to Ivythorn Manor.[17] Through the gateway we could just catch a glimpse of the house; its wide, high gable of creamy-grey stone catching the afternoon sun. After that came a variety of Ivy Thorn farms (Manor, Middle, Lower…) inhabiting the meadows below the wooded hill. In a ploughed field, with a faithful, wooden shed by its side, stood a rusting skeleton of a water-pumping windmill.

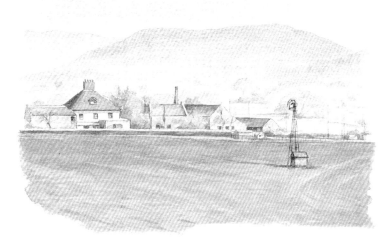

Ivythorn Farm

By mid-afternoon, the sun had still failed to lift the low moorland mist; trees and field boundaries and hazy hills slipped quietly away. We then cut back, along a footpath lined with blue and white violets that brought us up through the woods to an area of downland, west of the windmill tower, and then on to the ant-tussocked ground of Walton Hill.

[16] *Marshall's Elm; described by Robin Bush as being a place of execution and probably named after the family that owned Ivythorn Manor during the 17th century. Also the site of a confrontation between Parliamentarians and a much smaller force of Royalists on August 4th 1642 - the Roundheads were routed, leaving 7 dead and 18 wounded: the country's first deaths in the Civil War.*

[17] *Started life as a monastic dwelling and rebuilt by Abbot Selwood of Glastonbury Abbey in 1488. Passed to the Marshall and Sydenham families after the Dissolution. By 1834, it was in a ruinous state but restored in 1904, west wing added in 1938. Listed: Grade ll (English Heritage).*

There's a car park close to The Chalet hostel on Ivy Thorn Hill, a few hundred yards west of Marshall's Elm. In late June, we walked through a ribbon of woodland on the north side of the A39 with breaks in the trees that looked out to Glastonbury Tor and an area of long grass richly decorated with yellow spikes of agrimony and pink lollipops of pyramidal orchids. We crossed the road junction to the south side where a gateway opened onto Collard Hill, and headed up towards a grove of Scots pine. Below us, the grassy hill fell away steeply to the fields around Compton Dundon with the tree-shrouded escarpment swerving and continuing south. The grass was close cropped and pocked with ant-hills, many of which were topped by crowns of flowering thyme. We were here with David Agassiz (an experienced lepidopterist), keen to get a sight of the rare Large Blue butterfly, which vanished in the 1970s but is staging a comeback in the Polden Hills (See Special Page).

Large Blue butterfly on flowering thyme

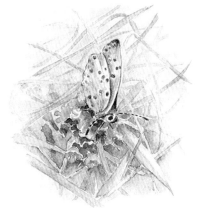

Almost immediately (and almost too good to be true!) we spotted one resting on a tuft of flowering thyme. Despite its name, the Large Blue is not large but it is gem-like and beautiful. It rested on the thyme with wings closed - at first we were only able to see its silver and blue under-wing. Later in the morning, as the sun warmed the hill, the butterflies flew quite freely, fluttering from one mound of thyme to another - spangles of bright, iridescent blue.

The Story of the Large Blue Butterfly

Searching for the Large Blue on Collard Hill

The Large Blue (Maculinea arion) has an extraordinary and complex life cycle which was disentangled just as the last colonies disappeared from the British countryside in the 1970s. Following on the work of T A Chapman, E B Purefoy and F W Frohawk, Dr Jeremy Thomas elucidated that successful breeding was dependent upon a combination of factors: a particular species of red ant (Myrmica sabuleti), a warm hillside and flowering thyme, close cropped turf. The butterfly lays single eggs on the thyme flower bud: its only food plant. After its final moult, the caterpillar falls to the ground (this is where the turf height is so important - long grass shades and cools the ground) where it, hopefully, encounters the right red ant. The ant is driven to a frenzy by secretions from the caterpillar's honey gland. The caterpillar then balloons and distorts its body so the ant is duped into believing the caterpillar is one of its own grubs misplaced from the nest. The ant then picks up the caterpillar, returns to its nest and places the faux-grub amongst the ant brood. Here, the caterpillar abandons its picky, vegetarian life style and begins to feed on ant grubs! This continues, underground, for nine months; the caterpillar becoming 'a revolting, fat, white maggot' dwarfing its accompanying brood. In the tenth month, the caterpillar pupates, becoming a chrysalis in the warmth of the nest's upper chambers. Then, in June and early July, with the sun shining once more on the flowering thyme, a beautiful Large Blue butterfly emerges from its underground, parasitic existence.

The butterfly died out through a combination of circumstances: the ploughing of previously undisturbed grassland: modern agricultural practice abandoning the grazing of unproductive slopes: cessation of gorse burning: rabbit myxomatosis and the coup de grace: drought. In a number of selected sites, Jeremy Thomas was able to ensure the right conditions prevailed and in 1983 introduced 93 Large Blue (Swedish) caterpillars. It was an immediate success and since then the program has been extended and enlarged such that public access can be allowed on Collard Hill!

(Source: 'The Return of the Large Blue Butterfly'. J A Thomas. 1989. British Wildlife Volume 1. No.1).

Earlier in the year, Rosie and I had walked over Collard Hill following the footpath to the Hood Monument.[18] The memorial overlooks this part of the Poldens from wooded Windmill Hill, and with the trees still free of leaves, the column could be clearly seen as we walked eastwards along the ridge. At the monument's wide stone base, an extended clearing had

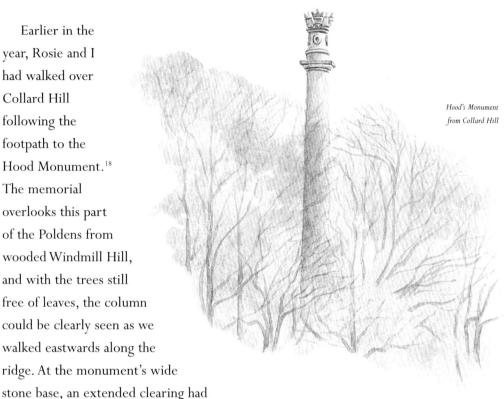

Hood's Monument from Collard Hill

been cut so there was a northerly sightline to Glastonbury Tor. Vice-Admiral Hood's high Tuscan column was capped by a carving which appeared to represent sails and boats - which made sense! We headed down a footpath, which in wet weather must become quite a ferocious water channel - in places the path was scoured and littered with large stones to arrive at a wide track called Middle Way. This led us to old Tray's Farm (truly ancient with a buttressed 14th century wing) and thatched stone cottages, and into the Compton part of Compton Dundon. Behind us, Hood's column peeked out above the treeline. The houses and cottages pressed against the street; a pleasant, slanting road of grassy pavements and soft lias walls.

[18]*A memorial column to Sir Samuel Hood 1st Baronet (1762-1814): one of the famous family of Hoods. He saw formidable naval action in the American War of Independence, the French Revolutionary Wars, the West and East Indies and the Mediterranean. He died in Madras - now Chennai, India.*

Crossing the main road (B3151) and passing a cottage with a roof more moss than thatch, we took the stone paved church-path a short distance across the fields to Dundon Hill. Further on rose its grass-topped companion Lollover, with St. Andrew's Church and vicarage perched, becomingly, between field and knoll. From the base of Dundon Hill, a steep, rutted track led up through the trees to the 330ft (100m) summit. Here, the woods gave way to the surprise of a wide, grassy expanse enclosed by the broken walls of an Iron Age hill-fort - complete with grazing ponies.[19]

Back at the bottom of the hill, the stone church-path continues (cunningly disguised as a section of raised pavement) past the village school. St. Andrew's Church, stands on an

Compton Dundon

[19]*This and the surrounding hillside (60 acres in all) is now a nature reserve, 'Dundon Beacon', with plans to restore the former downland habitat. Clearance of scrub and conifer planting has already encouraged the return of plants like rock rose and musk mallow. The hill-fort's enclosing walls now rise some 10 ft with a rampart 20 ft high at its southern end - the Beacon: possibly the remains of a watchtower superimposed on a round barrow of the late Bronze Age or early Iron Age (8-5th century BC). (Somerset Wildlife Trust).*

escarpment overlooking Dundon village and the road that separates its two hills. The church is almost overwhelmed by a tremendous yew tree which casts a dense shade over the polished lias path leading up to the porch. Inside, there's a framed certificate estimating the tree's age at 1,700 years! With that reckoning, it may well have been standing here before the arrival of Christianity. On the church's inner north wall hangs, like a kitchen cupboard, a delightful wooden pulpit (1628) with a narrow, low, stone stairway - which must have cracked a few vicars' heads over the years.[20]

At the foot of the short rise up to the church, a footpath slots itself between gardens to reach a beautiful track that leads up the north side of Lollover Hill. Unlike its sister elevation, Lollover is only moderately wooded (on its lower, northern slopes - Park Wood), the rest is hillside pasture close cropped by sheep and rabbits - and lumpy with ant-hills. The Large Blue butterfly would like it here! On our warm March days the track was sprinkled with primroses, while bumble bees and Brimstone butterflies worked the hedgerows. Below us, the church and the village cosied in the cleft between the two hills.

[20] *The engaging church leaflet, by Roger Adams and Barry Sutton, tells the tale of the Revd Thomas Wayne Harrison (vicar from 1804 to 1871) who somehow secured a surfeit of memorials: a classical monument, a shield in the chancel roof and a 'glittering east window'. The window shows Thomas Harrison witnessing the Ascension but "resolutely facing his congregation rather than,, watching the Saviour, who is apparently ascending from the site of the church between Lollover Hill and the Beacon"!*

We reached the trig-point pillar that tops the 295ft (90m) with what seemed to be most of Somerset surrounding us. From high up on Lollover Hill, it was as though we were aboard an ocean liner steaming westwards. To starboard I could just make out the Isle of Wedmore and the Mendips through a sunny haze, and Glastonbury Tor (it seems to get everywhere!) through an opportune notch in the Polden ridge. To port, High Ham rose from the plain. Dead ahead, the flat expanse of the Sedgemoor Levels intercut with rhynes and drains and droves, pricked out with ash and willows, fading into the sea-mists of Bridgwater Bay. We sat for a while enjoying a cup of Thermos flask coffee while being inspected by a scatter of rabbits and sheep. We left slowly, retracing our steps past the church, and back down the lias path across the fields to Compton. Here, we followed Combe Hollow Lane, eastwards, towards Combe Hill, a muddy stream running down its south side. Close to the entrance of the wooded combe a great sculpted oak stretched over the path with a tangle of swinging ropes dangling from its thick, horizontal branches - the steep bank below grooved by children's feet and mountain-bike tyres, all dappled by a relief of sunlight breaking through. We decided to take the westward path across the escarpment and were rewarded, as we emerged from the trees, with the open grassland of Combe Hill.

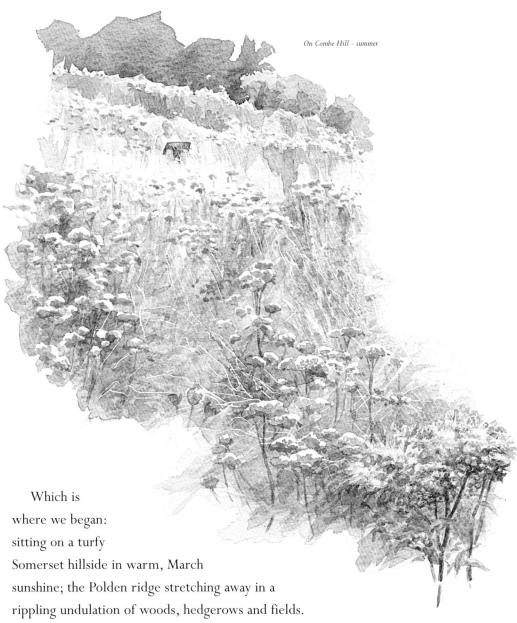

On Combe Hill - summer

Which is
where we began:
sitting on a turfy
Somerset hillside in warm, March
sunshine; the Polden ridge stretching away in a
rippling undulation of woods, hedgerows and fields.
A perfect place. So much so, we returned some months later in high summer, with light
so clear and bright the landscape was etched in sharp shadow. This time we
waded through grass up to our knees. Blushing stands of head-high hemp-
agrimony and purple knapweed covered the slopes and there were
more butterflies than I could ever remember: Peacocks and Painted
Ladies, Commas, Walls, Gatekeepers and Small Heaths. And a

Silver Washed Fritillary

single, Silver-washed Fritillary.

THE QUANTOCK HILLS

On Beacon Hill

Like many people who have lived in Somerset for most of their lives, Rosie and I have a warm familiarity with the Quantock Hills. My family often took a 'Sunday run' from Weston-super-Mare to picnic at Holford or Ramscombe - my father would light a fire and boil a black and dented, whistling kettle (which had lost its whistle) for a cup of tea, followed by a frying pan feast of Hubert Puddy's sausages. In late summer, we might pick a biscuit-tin of whortleberries. A few years further on, I would camp in Holford Combe (not allowed now) and search the limestone ledges at Kilve Beach for ammonites and Devil's toenails.

The Quantocks are a compact range of hills running for twelve miles, in a south-easterly direction, from the West Somerset coastline at Quantock's Head to a mile or so from North Petherton, close to the M5 motorway. The hills occupy an area of some fifty square miles crowned by an expansive moorland plateau, much of it more than 1000ft (300m) above the plain. It is an extraordinarily beautiful and varied landscape; so it's no surprise that, in 1957, the Quantocks became England's very first Area of Outstanding Natural Beauty.

The high moorland is carpeted in grass, bracken and heather; a kaleidoscope of green, purple and gold shifting with the seasons. Wide, grassy rides lead down into wooded combes where sparkling streams run. In the clearings, treading quietly, you may chance upon a herd of red deer or Quantock ponies. Villages of red sandstone cluster at the entrances to the combes with tracks running up to the ridge through stands of beech, rowan, holly, oak and ash. Some combes have been engulfed by alien pine woods, although these days the native broadleaf trees appear to be holding their own. Each combe has its own character and atmosphere, but always you will break out of the tree cover onto a brackened, curving hillside with intersecting grass pathways close-cropped by browsing rabbits, deer and sheep. And always there are the wide open vistas: southwards to the Brendon Hills and Exmoor, northwards to the Severn Sea, the west Somerset coastline, the islands and Wales.

The narrow road from North Petherton rises slowly over the low slopes of the eastern Quantocks, past a turnoff to Boomer Farm and twisting on through Huntstile to Goathurst. We sat and had a coffee on a bench here, nicely placed opposite the understated entrance to Halswell House and were struck by the shift from the Blue Lias stone of the Poldens to the ruddy hues of Quantock's red sandstone. Goathurst's St. Edward's Church demonstrates this exactly with its tower and walls fashioned from tightly worked, warm, grey/pink, rubble stone (Rosie called it 'Potter's Pink'!). Inside, the church was light and airy with mostly plain glass in its Perpendicular windows. Through an arch in the north side of the chancel lay an extraordinarily elaborate tomb. It belongs to the Halswell family and has a 17th century couple lying on, what looks like, a six-poster bed. Fresh and white, the figures appear as though they were sculpted yesterday.[21] More touching, tucked into a corner of the chapel, is the marble figure of a sleeping child by Raffaeli Monti - Isabella Kemeys, who died aged three in 1835. Outside in the churchyard, we came on the grave of Rose and George Wyatt covered with a profusion of small scented cyclamens.

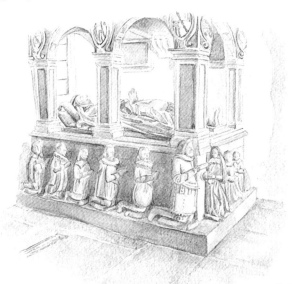

The Halswell tomb-chest

[21]*The 'tomb-chest' is dedicated to Sir Nicholas and Bridget Halswell, who lie piously side by side, ruffed and prayerful. Their dais is surrounded by nine, rather strange, kneeling figures ('weepers') - depicting their six sons and three daughters. The effigy tomb was erected by their son Henry.*

We entered the grounds of Halswell House[22] taking the public footpath that skirts the house itself. Back in the early 1950s, Quantock historian Berta Lawrence described her distress at the destruction of the house's parkland: the felling of massive oaks, beeches and chestnuts and the passing of an 'almost feudal' way of life. She recalled picking wild daffodils in the Goathurst fields. After the war, the house was in real danger following multiple changes in ownership - so many country houses were lost during this time. More recently, the building has been blessed by an enlightened restoration and once more its great, windowed facade looks out over a parkland of fields and trees falling gently away to the north.

As we continued up the footpath along the edge of a wide field, every now and again we caught sight of a small, yellow, octagonal pavilion on a bluff above us. We reached the top of the ridge and an area of woodland known as 'The Thickets'. At the woodland edge, three wide-winged buzzards were swooping and quarrelling. The pavilion could no longer be seen. From what I had read, the building, known as Robin Hood's Hut, was a ruin, but from what we had already glimpsed, this was clearly no longer the case.[23]

[22]*Built in 1689 by Sir Halswell Tynte and reckoned by Pevsner to be one of the outstanding houses of its period in Somerset. The facade has twenty large windows and a great arched doorway.*

[23]*Built as a folly (one of several in the grounds) in the mid-1700s by Charles Kemeys Tynte as part of a splendid garden park. By 1997, the pavilion was in a desperate state with no roof or windows, the beautiful, octagonal 'umbrello' had almost disappeared. Rescued and restored by the Somerset Building Preservation Trust, it has since been taken over by the Landmark Trust. Quite why it acquired the name of Robin Hood Hut is uncertain, but it probably had something to do with 18th century ideas of medieval romance.*

By cutting through The Thickets, we arrived at a gate behind the Hut and were kindly invited in. From the wood, the building seemed like a small, thatched cottage but the open, almost Moorish, central octagon the 'Umbrello', looked out over a huge panorama of the Bristol Channel and northern Somerset - we could clearly see our home town of Weston-super-Mare along with Crooks Peak and the Mendips. The couple staying there (we forgot to ask their name) had enjoyed a week of wonderful weather and perfect seclusion. They too had encountered the buzzards

Looking to the coast from the Robin Hood Hut 'Umbre.

from The Thickets for when a sheet of newspaper they were reading had been caught by a gust of wind, launching it high above the pavilion, it had been attacked and carried away. Fortunately, it wasn't the crossword page.

The road from Goathurst carried us the two miles west to Enmore where Castle House, formerly an 18th century coaching inn, stands at the road junction. Enmore village is mostly tucked down Frog Lane: a high-walled loop off the main road. There, we came on St. Michael's Church raised a few feet above the lane, with its silver-rose, sandstone tower set against a backdrop of high trees. Opposite the church gateway is Castle Farm with delightful curved gables and windows in the Dutch style (there's similar architecture in Bridgwater) - with a very reasonable Enmore tradition that Dutch craftsmen did the work! Just west of the church, a footpath led us past Enmore Castle - the remains, still impressive, of a folly-mansion built in the early 18th century.[24]

[24] *The real, medieval castle was demolished by John Perceval, Earl of Egmont in the mid-1700s and replaced with a fantastic mock-fortress complete with moat, drawbridge and a multitude of towers. Sadly the estate ran out of money and most of the building was pulled down. Today, the castellations have been replaced by slate roofs and a single round tower.*

A short distance west along the main road stands Enmore Primary School and it was here the Revd. John Poole established England's first, free Village School in 1810.[25] The original school was rebuilt in 1848 and enlarged over the years. It remains an attractive, gabled, single storey building in red sandstone, but it's a shame that high-security fencing now surrounds it. John Poole was a cousin of Tom Poole (of Nether Stowey), the great friend of the Romantic poets: Coleridge, Wordsworth and Southey. Not that the Reverend was overly impressed with Coleridge or Southey when he first met them. This entry comes from his 1794 diary, written in Latin:

> "Tom Poole brought two young men who had left Cambridge…
> shamefully hot with democratic rage… I was extremely indignant.
> At last, however, about two o'clock, they go away."

It was an antipathy that never really left him - strange in a man of such reforming zeal.

[25] *This was serious stuff. Enmore's tiny 'Rector's Village School' was the progenitor of free elementary education - within fifty years the National School Movement was to spread throughout England. At first, John Poole was its sole teacher but he went on to train others to carry on the good work. Poole even built a row of cottages whose rent was to help maintain the school. With Tom Poole, he also established a school in Nether Stowey in 1813 - after a few months it had 118 pupils! John Poole died in 1857, aged 87. He had been rector at Enmore for 61 years.*

We took the Broomfield road opposite the school which climbs steeply towards Lydeard Cross and Broomfield Common: a deep lane cutting through slanting fields and woodland, flooded with afternoon sunlight. Through gaps in the hedgeline, we caught glimpses of Steep Holm sitting mid-channel, Bridgwater Bay and the land sloping towards Goathurst and Cannington.

At nearly 700ft (211m), Broomfield is the highest village on Quantock. Even today it seems inaccessible and remote, hidden away in a tangle of lanes and trees. So it's especially surprising to discover that, at the turn of the 18th century, this place was a hot bed of electrical experimentation and ideas. The manor house of Fyne Court had belonged to the Crosse family since 1634 and Andrew Crosse inherited the estate in 1805. Fascinated by electricity, he subjected the old house to innumerable flashes and

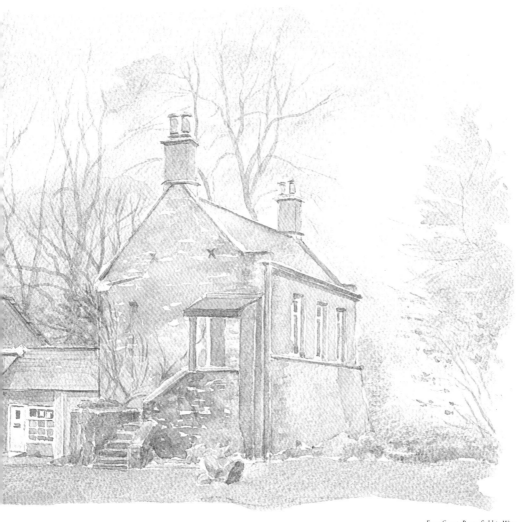

bangs which earned him the title 'Wizard Crosse'. He was a serious scientist who
believed profoundly in the experimental method and earned the regard of fellow scientists
like Humphrey Davy (See Special Page). Sadly, the main house was virtually destroyed
by fire in 1894 and all that remains is the old coach house and stables, the Library
and the Music Room - where Andrew Crosse carried out his electrical explorations.[26]

[26]Fyne Court servant Emma Morgan was probably setting off to get married, when she left the candle she had used to
heat her curling tongs burning in her room. A short while later, the kitchen maid discovered the room full of smoke and
the curtains ablaze. The fire spread rapidly and the entire community rallied round in an attempt to save the house.
By the time the Taunton fire brigade arrived, the roof had collapsed but they were able to preserve the Library and the
Music Room. Despite receiving £7000 insurance, owner Mrs Susan Hamilton moved into a cottage nearby and made
no attempt to rebuild. Fruit merchant John Adams bought the very dilapidated estate in 1952 and left it to the
National Trust when he died in 1967. ('Crosse Connections' by John Porter. 2006).

In the late 18th century, the estate was laid out as a garden with a Serpentine Lake and a boathouse, a castellated folly, hedged walks and a high walled kitchen garden. Considerable restoration work was carried out in the 1970s and 80s by the Somerset Wildlife Trust, who also instituted nature trails and hacked back invading rhododendron and laurel. At the time of writing, Fyne Court is about to undergo a major refurbishment by the National Trust.

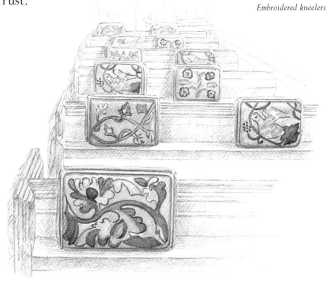

Embroidered kneelers

Broomfield's All Saints' Church stands just above and south of Fyne Court with charming modesty. It was once sheltered by stately elms and beeches, but the elms are long gone. Several large yews defend the south side. As we stepped down into the church, sun was streaming through the south windows; it felt comfortable and bright. The carved pew-ends glowed warmly and proudly arrayed along the pew-backs were beautifully embroidered kneelers - they seemed to emphasise the affection the community had for this lovely small church.[27] Intriguingly, one of Andrew Crosse's laboratory tables has arrived here - its broad copper band still evident but now bearing the visitor's book and a vase of flowers!

[27]*The pew-ends were carved by Simon Werman around 1560.*
The kneelers, inspired by the pew carvings,
were designed by Liz Silby in memory of churchwarden Harold Baker.

The Wizard of Broomfield

Andrew Crosse (1784 -1855) was blessed with limitless
enthusiasm and curiosity. His fascination with electricity was
fired by his friend George Singer, who supplied him with
'a splendid electrical machine and battery table'. Quarrying near
Broomfield had revealed Holwell Cave, which contained a
wonderful display of beautiful aragonite crystals (a kind of
calcium carbonate) in a wide variety of forms. This started
Andrew on an exploration of electro-crystallisation - for a while
he wondered if he could create diamonds!

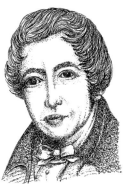

Andrew Crosse

He was also fascinated by atmospheric electricity and set up over 600m of copper wire
through the trees of Fyne Court. The wires ended up in the former Music Room where sparks
and flashes were generated between brass balls and capacitors. There were times when the
Music Room windows lit up with lightning and echoed with thumps and bangs -
to the consternation of the local peasantry!

"That's Crosse of Broomfield. You can't go near his cursed house at night
without danger of your life; them as have been there have seen devils,
all surrounded by lightning, dancing on the wires..."

His undeserved reputation as a necromancer wasn't helped when he reported,
while experimenting with silicate crystals, the formation of minute, white blebs which
went on to develop legs and move! The experiment was repeated successfully by himself and
others, but Andrew was accused of having created life - he denied this absolutely,
saying he had only made a scientific observation. However, the whole business was never
properly explained and remains an intriguing mystery.

In 1846, his first wife Mary Ann and his brother Richard both died and he had already lost two of
his children. Four years later, he was rescued from this sadness by young Cornelia Berkeley
(she had always been "intensely interested in his experiments") who became his wife, laboratory
assistant and biographer. Andrew Crosse was one of an extraordinary group of West Country
men, including Humphrey Davy, Samuel Coleridge, Tom Poole and others, who embraced the
romantic, philosophical atmosphere of their time and broke through the boundaries of science
and art. He died on July 6th 1855 at Fyne Court in the room where he'd been born.

COTHELSTONE, KINGSTON ST. MARY, TRISCOMBE AND BAGBOROUGH

From Cothelstone Hill

The road due west out of Enmore ascends the conifer slopes of Wind Down, through Buncombe Wood to skirt the flat summit of Cothelstone Hill. Early October with a cool, north wind; we left the car at the edge of the wood and walked the gentle, grassy incline towards the stand of beeches on the open crown of the hill. Looking back, there was a single, white farmhouse pressed between a curvature of hillside woodland and open fields. Beyond, a grey-green wash of the Mendip Hills along the horizon and Steep Holm island, with the blue-green nuclear halls of Hinkley Point, picked out in clear sunlight against the slate-blue of the Channel. Close by, a small herd of Exmoor ponies were grazing. Isolated thickets of red-berried hawthorn, bramble and brown bracken. It's here a group of beeches known as the 'Seven Sisters' once stood.[28] Sadly, we could only count three; the prostrate hulks of several lay on the close-cropped turf, quietly falling apart. Meanwhile, a few yards away, a planting of some eighteen, much younger, trees were waiting in the wings, ready to take over. Beneath them, a cluster of dwarfed foxgloves were still gamely flowering.

[28] *Apparently, the Seven Sisters (the beech has a feminine reputation) were once fifteen, planted on a prehistoric burial cairn in the late 18th century. The landscape planting included the construction of a stone Beacon Tower some 30ft high. Throughout the 19th century, the Cothelstone beeches and tower were a distinctive landmark on the eastern crest of the Quantock Hills.*

Standing on the broken base of the old Beacon Tower, we could look out over the mixed woodland of the hills' southern slopes to a bright angle of sea and sky and Minehead's North Hill. Between us and the coast lay the rise of the Brendon Hills, fields of ochre and green, and fresh furrows of oxblood earth. A few days earlier, we had tried to climb Cothelstone Hill from the south, up a combe called Paradise above Cothelstone village (not to be confused with the Paradise Combe above Bicknoller). We found ourselves in a grim zone of coniferisation down which a dark stream ran. Access tracks zagged across the hillside and there seemed no break through the trees above us. In the 1950s, Berta Lawrence wrote lyrically about this place; the unspoiled woodlands of ash, beech and oak that looked out over wheat fields where skylarks soared and sang. And a dip in the hillside called Paradise.

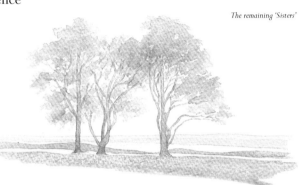

The remaining 'Sisters'

From the road, the prospect above Cothelstone remains open and beautiful, looking down on a tiny, red stone village; an ancient manor house with its church pressed closely to its side. At the bottom of the hill, the road makes a sharp right-angled turn south. Through a gap in the western hedge, we entered a soggy field full of bottle-brush spikes of horsetail. There, in charming solitude, stood the small well-house of St. Agnes's Well. It's built of rusty sandstone, shaped like a beehive, with a corbel roof of mossy, stone tiles.[29] Water flowed from under the well-house door and over a channel of Blue Lias, to percolate into the field-saturating stream. The well had recently been restored (by the Friends of Quantock) and on opening the diminutive wooden door, we were surprised by a very modern ball-valve assembly! The well still supplies water to the manor.

[29]*Described by Jeremy Harte as "perhaps the most beautiful of the holy wells of Somerset".*
It waters were a physic for sufferers with eye disease. The Eve of St. Agnes (January 21st) was traditionally one for the divination of love, and her well, a trysting-place for lovers - although locals regarded it with some suspicion as a 'pixie place'. The present well-house is possibly a 19th century restoration.
It's been mooted that the well is named after Agnes Cheney who married a local landowner, Edward Stowel.

A little further down the road, we passed the farmyard buildings belonging to Cothelstone Manor. The great, sandstone barn is raised on arches supported by short pillars with, what looked like, Norman capitals - similar to those in Stogursey church (Allen & Giddens), although most of these working buildings were put up in the 19th century.[30] Within a few paces, we arrived at a splendid, triple-arched gateway to the manor. It frames an avenue of walnut trees (these were elms in the 1950s) advancing to a medieval gatehouse with the main house beyond. They glowed warm and red in the afternoon sun. The gateway, made from a quieter, buff coloured stone, once bestrode the main road and was moved, probably as part of a 19th century refurbishment.[31]

The Gateway, Cothelstone Manor

[30] *N. Pevsner found Cothelstone Manor difficult to make out - it's a curious mix of periods, though primarily c. 1600 - not including the 19th century reconstruction of the right side of the house. Perhaps the barn's Norman pillar capitals were just a late owner's fancy? The Cothelstone estate was bought by Edward Jeffries in 1791. The manor house was restored by his grandson, Edward Jeffries Esdaile in 1856. (Robin Bush)*

[31] *Apparently, in 1685 after the Monmouth Rebellion, owner Lord (Ralph) Stawell criticised the cruelty of the Bloody Assize. Judge Jeffreys responded by hanging two rebels from Stawell's gateway arch. Previously, Ralph's father, Sir John, an arch-Royalist, had lost out badly during the Civil War, ending up in the Tower of London with his manor house being taken apart by cannon fire - on Cromwell's orders.*

We took the footpath alongside the grey, lichen-encrusted wall flanking the walnut avenue to where Cothelstone Church (dedicated to St. Thomas a Becket) stands in its sequestered ground - the top of its red tower had been visible from the road, peeping over the house. Within lay four effigies, in cool, alabaster repose, of the Stawell family: Sir John and Frances (c. 1601) and those of Sir Matthew and Eleanor de Stawell (c. 1380): green colouration still evident on her shawl, her feet on a pair of squirrels and her hands (disconcertingly detached) resting on either breast.

Behind the church, tucked at the back of the churchyard, lies the grave of Ianthe Esdaile (d.1876) who, somehow, survived for 63 years despite having poet Percy Shelley for a father - great poet, bad dad.

We grabbed a warm, sunny day in late September to take the steep, wooded descent out of Broomfield (turning right at Volis Cross) into Kingston St. Mary. The village snuggles below Kingston Beacon and Cheddon Down on the south-easterly Quantock slopes. We left the car parked in the deep lane beside the church and took the short flight of steps up into the churchyard. Immediately, we came upon one of Somerset's loveliest churches on its bluff above the village; the late morning sun lighting up its soft, red sandstone with its west tower forming a tracery of fine pinnacles against the sky. Around the churchyard, the scarlet berries of rowan trees amplified the colour of the stone and over the western boundary wall we looked out on open fields and woodland. From the south porch, a path, accompanied by an ancient yew, dipped down into the village and Church Lane brought us to a triangular road junction (known as The Green) shaded by a high crowned oak. Sitting on its encircling bench, we noticed the oak had been planted in 1897 for Queen Victoria's Diamond Jubilee. The bench itself celebrates the Millennium with ironwork featuring the renowned Kingston Black cider apple.[32]

[32] *Throughout Somerset, cider was often part of a farm worker's wages - especially at harvest time. The Kingston Black apple is related to other Somerset bittersharp varieties (eg. Lambrook Pippin) and, at one time, many Somerset cider orchards had a number of Kingston Black trees. The fruit is very variable, ranging from dark red to black with a bittersharp, rich and fruity flavour. The juice makes a delicious, full-bodied cider (often single variety) with balanced tannins and acidity - I can vouch for that! (Liz Copas: A Somerset Pomona.)*

There are a fair number of grand houses in Kingston. Across the road from The Green stands a Victorian house called The Grange where, as a boy, a future prime minister Anthony Eden came for his holidays. In 1986, over seven acres of ornamental woodland known as 'The Spinney' (it runs alongside the main road behind a high stone wall) were donated to the Woodland Trust - there's public access through The Grange. A mill leat courses the woodland's western edge supplying a mill pool at the wood's southern extremity. The mill itself stands at the main road junction called Mill Cross - Mr Carnell was still grinding flour here in the early 1950s.

St. Mary's Church, Kingston St. Mary

Back in the village, opposite the Swan Inn, we walked a short distance south, along a footpath signed for Nailsbourne, which lifted us above roofs and tree tops and so opened up a magnificent view of Kingston. Set against the tree-edged ridge of Cheddon Down, the perfect tower of St. Mary's Church captured the sun above a vale of early autumn colour.

Triscombe Stone

Lodes Lane[33] strikes north from Kingston's main road to become a steeply banked hollow-way to Broomfield. A hundred yards or so up the lane is a graceful, L-shaped manor house of red sandstone defended by a high stone wall.[34] Opposite, close to the entrance to a driveway, is a kissing-gate (where Rosie found a load of blackberries waiting to be enjoyed) beyond which St. Mary's tower beckoned. The gate opened onto an open, close-cropped field planted with beech, lime and sweet chestnut trees. A church-path led us back to St. Mary's where we sat on Humphrey and Barbara Ellis's bench in warm September sunshine... and had our lunch.

Mid-September. We left the car near Lydeard Hill above West Bagborough, a few miles west of Cothelstone.[35] Various grass-ways criss-crossed the heath, so we took the path that led us to Bagborough Plantation: woodland at the top of a track called Stout Lane bounded by gnarly, beech hedgebanks. Beside the paths, patches of gorse and heather were in flower, but further off plants were quietly waiting for winter with the bracken a hangdog brown. Just beyond the wood, the way opened onto a broad, gravelly trail where ponies grazed and which brought us to the trig point on Will's Neck - at 1,260ft (384 m), Quantocks' highest point. From here we looked eastwards, out over Aisholt Common and the wooded combes of the northern slopes. Ahead of us rolled the Quantock ridge and the trackway once known as the Alfred Road along which Alfred the Great's army marched to confront the Viking invaders. Along the road, the vistas opened up to the south and the west: the field patterns of the Brendon Hills, the coastal headlands at Watchet and Blue Anchor and the misty pattern of Minehead's North Hill. The path dipped and curved through birch and rowan woodland bounding Triscombe Quarry (invisible); the rowans bearing a weight of bright red berries and where a bench dedicated to Peter Hitchins awaited us. Thank you Peter.

[33] *'Lode' apparently refers to a copper lode (ie. ore) which was once mined in the vicinity. It was reckoned that copper contributed to the excellence of Kingston's cider. (Berta Lawrence)*

[34] *Early Elizabethan with a central, two-storey porch - Pevsner describes it as "E-plan minus its right arm". Berta Lawrence says the house was built in 1560 by Robert Knight, a churchwarden, and subsequently occupied by the Knight family for nearly three hundred years.*

[35] *The 'West' part of Bagborough is, apparently, a fairly recent imposition -introduced to distinguish the village from 'East' Bagborough which barely seems to exist! Locals, sensibly, just stick to Bagborough.*

The Drove Road to Crowcombe Park Gate

A few yards further west, we arrived at the Triscombe Stone[36] whose vulnerable anonymity amongst the hedgebank beeches surprised us - a sort of Bronze Age bollard. From the stone, a colonnade of beeches continued north-west along the ridge accompanying a wide, dirt road known as the Pack Way (also called the Drove Road) to Crowcombe Park Gate. Here, a multitude of tracks and paths converge to then take their separate ways, in all directions, across the open heathland. We did not continue to Crowcombe. Instead, after a short distance along the Pack Way, we cut south-west, down a wide grassy path, into Triscombe Combe; to our right, on the lower slopes of Great Hill: beech and conifer woodland and to our left: the hillside heath of Marrow Hill. Under the beeches were gathered occasional cep toadstools; brown and smooth, like scattered bread rolls. We emerged in Triscombe opposite the Blue Ball Inn (the 'blue ball' is the whortleberry); one of a group of thatched buildings gathered in an angled hollow below Will's Neck. We stopped here for a while; the pub's terraced garden looked to the Brendons and we enjoyed a glass of well-kept Otter Ale. Around us, several cottages were being re-thatched.

[36]*Barely two and a half feet high (0.75m), the Triscombe Stone is a Bronze Age monolith demarcating a stage on the ancient Pack Way (or Drove Road) and its fellow: the Alfred Road - mentioned in the main text. For millennia, this was an important route for traders and travellers. It also made up part of a Saxon army road known as a 'herepath'. There are only two other, known, prehistoric stones on the Quantock Hills: the Long Stone, 2.5ft (0.8m) high, on Longstone Hill above Holford and its especially diminutive half foot companion (0.2m) close by. (Hazel Riley)*

The route we then took twisted back above the pub to leave the West Bagborough road along a footpath just above the fields far below Will's Neck. The lane, part of the Quantock Greenway, was achingly beautiful - lined with oaks and hazel, sweet chestnut, holly, larch and Scots pine, with glimpses through the trees and over fields to the gentle rise of the Brendon Hills. Speckled wood butterflies jostled ahead of us, catching the sunlight and alighting, wings flat open, on the bracken fronds along the path edge. Without realising it, we found we had strayed from the footpath, ending up high above West Bagborough with the manor house and church below us. Fortunately, we regained legitimacy down a muddy, hedgebanked path that took us straight into the village.

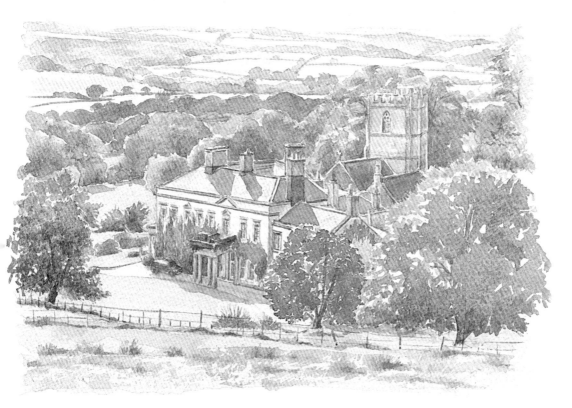

From above Bagborough House

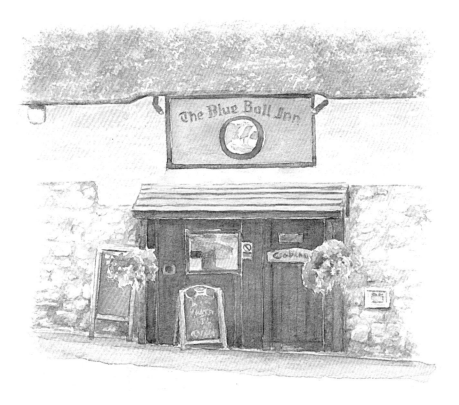

The Blue Ball Inn, Triscombe

Next to the bright, white walls of Georgian Bagborough House and shaded by high trees, St. Pancras Church looked dark and solemn in its lichened red sandstone. But this is a much-loved place; inside we came on the Bagborough Community Quilt celebrating the village in the year 2000: touching and beautifully done.[37] High up, at the back of the churchyard we found a bench (made out to Yvonne Owen who had died in 1996, aged only 32) and drank the last of our coffee, while a swirl of swallows raced around the church tower. Had we known it, we would have kept the coffee for later - we were unprepared for the never-ending climb out of the village, on and on to where we had left the car, high up on Lydeard Hill.

[37]*The quilt includes panels depicting village houses, the Rising Sun inn*
(burned down and then restored in 2002), cricket, the hunt and its hounds, and wildlife;
including an albi;no deer the village adopted and which lived from
1974 to 1993 when it was killed by poachers.

CROWCOMBE AND BICKNOLLER

Boxing Day Meet at Crowcombe

It's Boxing Day morning and it's bright and clear. Despite freezing weather, a moderate thaw has allowed Rosie and I to risk the Stowey Road out of Over Stowey, up through coppiced oak woodland to the Quantock ridge at Dead Woman's Ditch.[38] Then past the beeches at Crowcombe Park Gate and down the combe road (quite a bit of ice here) to Crowcombe. We've come to see the Boxing Day meet of the Quantock Staghounds which is assembling in a field, next to the Carew Arms, in the centre of the village. We're early, but the pub has already opened itself onto the street and started serving bacon rolls. The smell is irresistible and so we passively submit! Horses and riders start to arrive, gathering beneath the great oaks bordering the field. The red brick of Crowcombe Court shows up beyond the trees, emphasising the 'hunting pink' of the riders' scarlet jackets. Other riders are in coal-black riding jackets; one lady, the Hunt Master I'm told, has a flash of scarlet on her collar.

[38] *A prehistoric, linear bank and ditch, about half a mile long, bestriding Robin Upright's Hill. It's a substantial earthwork and, according to Hazel Riley, was probably part of a 'ritual landscape' along with the many cairns and barrows found along the Quantock ridge. The name 'Dead Woman's Ditch' was once presumed to refer to the place where John Walford (of Walford's Gibbet) hid his murdered wife Jane in 1789. However, 'Dead Woman's Ditch' actually appears on a 1782 map of the Quantocks. So, who was the dead woman?*

The horses too are immaculate: clipped and groomed, shining and sleek - their coats gleaming like conkers but their legs left with their winter covering. The dozen or so hounds are restless and eager. But there is to be no 'run' today. We are told the icy ground has made the going too hard and risky. So the huntsmen will just enjoy their hot toddies and sausage rolls and anticipate lunch at the Carew in a few hours time.

We've met up with our friends Andy and Sue Walker and together we decide to walk the footpath around the western border of Crowcombe Park up to Crowcombe Park Gate. Above us, the sky is clear blue and the air cold and sharp. The sun catches the bronzed crest of the ridge while against it, marking the field lines, stand skeletal outlines of beech, oak and Scot's pine, and the woodland of Crowcombe Park. It's a gentle, sustained climb to the park gate where we find the trackways are frozen and icy - the hunt had made the right decision. A drift of woodsmoke filters through the trees from the park lodge immediately below us and loiters along the beech hedgebanks at the head of Crowcombe Combe. There are a few people heading north-west along the ridgeway but the surface is sliddery and treacherous. We pick our way warily across the road and rejoin the footpath which is heading south-east to Triscombe Stone. But we take another way, cutting down across the sloping field into Little Quantock Combe. Across the valley, mist is beginning to blur the outline of the Brendon Hills and bleach the blue of the sky. We gain the Triscombe road and on our way back to Crowcombe, with the trees free of leaves, we can make out Crowcombe Court in its grounds at the mouth of its combe.

Crowcombe Court

Crowcombe is a beautiful village comfortably settled at the base of its steep combe, midway along the Quantocks' south-western slopes. I often used to pass this way en route from north Devon; always catching an enticing glimpse of Crowcombe Court, framed by its gate-pillars, in bright red brick at the end of its long drive.[39] The village church (unusually dedicated to the Holy Ghost) is raised up to the right of the Court entrance and bounded by a high stone wall. When we were there in mid-October, the tower was bathed in sunlight - pinker and more luminous than the lichen covered body of the church. Inside, the same light was pouring into the south aisle through the plain glass of high, Perpendicular windows. It picked out the rich brown of the sculpted pew-ends in sharp relief; the Green Man disgorging grape vines and merfolk; two Crowcombe men enacting the local legend of slaying a dragon and the date '1534' confidently carved in Roman numerals into the oak. In the churchyard stood the top of the steeple which became detached when it was struck by lightning in 1725 - it looked like a stranded pawn from a gigantic game of chess.[40]

On the other side of the road from the church, built from soft, rose coloured stone, stands Crowcombe's famed Church House, the Brendon Hills showing beyond.[41] This is a splendidly restored building: a craft exhibition was on display in the upper gallery while we were there - although it was hard to take our eyes off the dramatic oak arches supporting the roof.

[39]Replaced a 13th century house close to the church. Built around 1734 in splendid classical proportions and one of the first in Somerset to use brick. Designed by Thomas Parker, later dismissed by owner Thomas Carew and replaced by Nathaniel Oreson. Parker was accused of stealing a hoard of silver coins found in the old house; it was eventually deemed to be treasure-trove and Parker had to redeem Carew to the tune of £1300 - a fortune!

[40]The missing steeple stood 80ft above the tower. Its collapse and the falling bell took the screen, altar and pulpit with it - these were replaced in 1729. But not the steeple; the weakened tower could no longer support its weight. The steeple top spent over 200 years in the north-east corner of the tower but found its way down to the churchyard in 1954.

[41]The Church House was built in the early 16th century with its two floors having separate functions: upstairs a meeting room for the 'Church Ales' and Village Revels, while below served as a brewery and a bakery, all of which raised money for the church. Later, the first storey became the village school, while the ground floor served as 'a refuge for destitutes', ie. a poorhouse. By the end of the 19th century, the building was on the verge of collapse: separate owners of the two floors had been in dispute over the roof - the upstairs' suggestion the roof repairs be shared being met with the response that the lower floor might as well be demolished! In 1907, the building was rescued by Rev. Henry Young, followed by succeeding restoration projects right up to 2007.

About four miles west of Crowcombe, Bicknoller is a handsome, well ordered village, a short distance below its own combe. Indeed, it has been suggested that its tidiness may well have been planned like many Polden villages: 'a planted settlement' whose lordship was held by Wells Cathedral. We left the car in the car-park next to the Village Shop (community run) with Weacombe and Bicknoller Hills curving high above us. Immediately north of the shop, Hill Lane led us to the mouth of Bicknoller Combe overhung with coppiced oak and a stream running. The combe entrance was marked by an abandoned quarry - now a grassy place with its sides retaken by gorse, oak and ash. The narrow cleavage of the combe was traced by a rabbit-cropped path and a stream which meandered from one side to the other. Hawthorn trees were covered in a tracery of green-grey lichen - luminous, scarlet berries standing out in bright contrast.

A few notes at Bicknoller Post

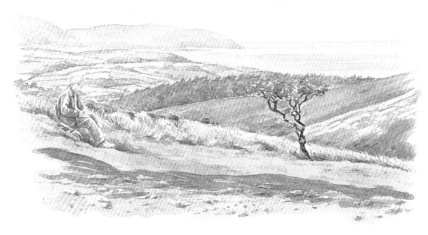

The September combe unfolded, opening onto sweeps of rusted bracken, heather still purple-pink and yellow spangles of gorse. Sheep showed their faces above the bracken as we made the gentle climb up to the Bicknoller Post.[42] We sat on a low grass bank for a sandwich and a cup of coffee and relaxed to the rhythmic chuffing of the West Somerset Railway locomotive working unseen along the valley below us.

[42]*There is a wooden post here now (dated 2008) but I'm told this was not always so. This is a place of many intersecting pathways and tracks including the Great Road (Holford via Beacon Hill to West Quantoxhead), the Pack Way (by way of Triscombe Stone to St. Audries) while others trace their way down the south-west combes: Paradise, Bicknoller, Weacombe, or northwards through Smith's Combe to East Quantoxhead or over Pardlestone Hill to Kilve.*

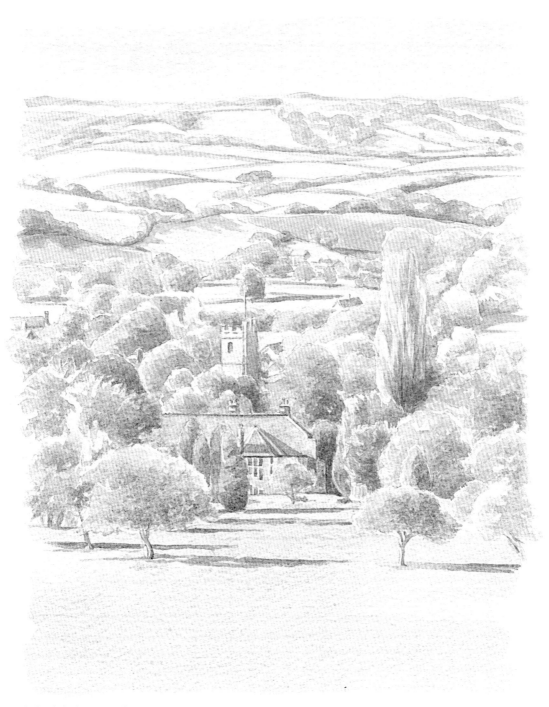

St. George's church at Bicknoller, from the Greenway

We now took the track skirting Beacon Hill, slanting our way down into Weacombe Combe. As we descended, the path stood above the Weacombe Stream while to our right; the sight of a conifer plantation crowding the lower slopes was softened by encircling broadleaf trees. Tiny, intense yellow flowers of low-lying tormentil decorated the sides of the path. We came to an area of woodland, near the combe-mouth, of goat willow, red berried hawthorn and rowan, some draped in honeysuckle. Streamlets ran across the path, larch and sweet chestnut accompanied by the stark cadavers of dead elms. Here, we joined the Quantock Greenway, following the south-east path under the trees, just above the fields. A horse chestnut was touched with early autumn colour and beyond were the red, ploughed fields, pasture and woodland of the Brendons' eastern escarpment. A train chugged by billowing a trail of white steam across the landscape. The path meandered along the field line with each break in the trees framing a slow, unravelling vista of the Brendon Hills - until we arrived back above the Bicknoller quarry with a short walk back into the village.

From the village shop, we ambled down Church Lane; a picture book congregation of stone walls and thatch overlooking the wide sward of St.George's churchyard. Through the small gate from Church Lane, we immediately came upon a parade of gravestones - seven in all: memorials to the rumbustious Bickham family.[43]

[43]The Bickhams weren't beyond using the church weathercock for target practice
and setting it whizzing when their hunting expectations were thwarted.
Apparently the holes are still there - although we couldn't see them.
they appear to have had short, busy lives! David Foot writes that the famed
Bicknoller-born, Somerset and England cricketer, Harold Gimblett, took a shot
or two with a .22 rifle spinning it one way then the other;
before getting the bird smack in the middle! Maybe everyone was at it!

A train chugs across the landscape

Not far off, in the south-west corner of the spacious grassy yard, in familiar, warm, red sandstone, modest and unadorned, stood St. George's Church. A lovely, straightforward sort of building. A little way from the church's south porch was a blasted and venerable yew tree - still vigorous, it seemed, despite its disembowelled state.[44] Within were a fine collection of 16th century pew-ends carved by a renowned Bicknoller man: Simon Werman - whose craftsmanship spread well beyond his own village. There was also a more recent pew carving (1932) showing the church with a yew tree growing from the top of its tower - presumably a sticky seed taken by a bird from the senior tree in the churchyard. Sadly, no longer there.[45]

A week or so later found us back at the mouth of Bicknoller Combe - this time we planned to follow the Greenway south-east to Paradise Combe. A short climb returned us to the tree/field margin, this time looking down on Bicknoller village with St. George's Church tower catching the morning sun. Trees, just easing into autumn colour, stood against hills patterned by the geometry of their fields and pasture. Some fields were brushed by the green of fresh sowings and their hedgerows laden with the orange and red berries of spindle and holly and the sombre purple-black of sloes. From the path, we could just make out the shape of the Trendle Ring on the hillside above us - a prehistoric stock enclosure; easier to see from a distance than close to, it would seem.[46] The path continued along the hillside edge until we reached a tumble-down wood shed (with a corrugated-iron roof supported by columns of rubble stone) at Paradise Combe. There was the sound of a stream running.

[44]Reckoned to be at least 1000 years old - so it's a good few centuries older than the church. The huge yew at Compton Dundon in the Polden Hills is considered to span 1,700 years!

[45]According to Berta Lawrence, artist Richard Jefferies included the church tower yew in sketches drawn around 1850. It was 5ft tall in 1893. It was still there for Berta in 1952 she describes it peering "over the top of the stair turret."

[46]Possibly still functioning as a stock enclosure as late as the 19th century. Just over an acre in area with a bank and ditch on its north and east sides - its origins may stretch back to the Iron Age. There are two level areas where buildings might have been sited (Hazel Riley).

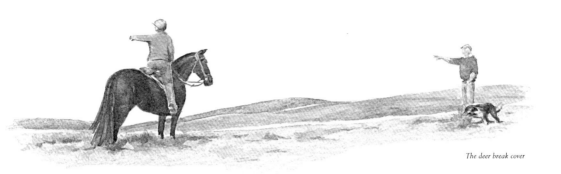

The deer break cover

We moved up the combe, along a grassy path high above the stream, entering a small woodland of beech and ash. A dry-stone wall of grey-green-pink lichened sandstone caught the morning sun, flanking a young conifer plantation on our west side. Further up the combe, we came upon a grove of ancient beech trees; the first few dead and broken - white hulks above the bracken. Some were still hanging on, old initials, stretched by tree-growth, grooved into their grey bark:

W B 1890...W H JONES 189... and a diminutive M L 1973.

Above the combe, our path opened out onto the ridge and a clear blue sky. Hill farmers were rounding up their sheep with dogs and quad bikes - not quite what we expected. Across the heathland, other cars were gathered for the hunt at Bicknoller Post and, for a moment, there was a confusion of sheep and deer as two hinds broke south, deep into the cover of Long Combe. For a while, we watched horses, people, dogs, sheep, and deer play out their positions over a vast gaming board. Then we turned back, following the deer tracks, down the eastern flank of Bicknoller Combe, to jump the stream and head for home.

Spindle berries

AISHOLT, OVER STOWEY
AND NETHER STOWEY

We took the Spaxton road out of Bridgwater, past the Hawkridge Reservoir below Lawyer's Hill, entering the deep, wooded valley of Coleridge's 'green romantic chasm'. Then down and then up to Aisholt. Even these days, this is one of Quantock's most sequestered places. The steep, high-hedged, curving lane excluding the surrounding country until we arrived, with relief, at the small car-park plateau behind the church. Descending a few mossy steps brought us into the back of the churchyard above All Saints Church. From where we stood in the shade, it had the quality of surprise; the slash of sunlight through the trees falling on the silver slate roof and russet grey of the church with its small tower.[47] Inside, the church was beautifully neat, the red sandstone chancel arch gathering the warmth of the pew wood and bestowing a sharp definition to the nave.

Thatching the ridge at Durborough Farm, Aisholt

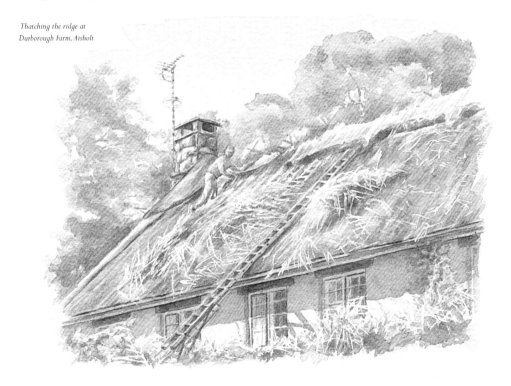

[47] *Aisholt means 'ash grove or copse'. Whether it's pronounced 'aish' or 'ash' is a source of endless debate - both appear to be right! The position of the church on a steep, remote hillside indicates a very early foundation - possibly the oratory of a pre-Saxon hermit priest. The present church was built between the 12th and 14th centuries (Rev. Arthur Moss).*

We stepped down into the road, taking the footpath west across the sloping fields towards Durborough Farm and Aisholt Common - looking back we caught the church tower peeping out from its 'green nest'. We reached the ford which crosses the Canning Brook (a fairly brisk stream that eventually feeds the Hawkridge Reservoir) and at Durborough Farm, thatcher Lee Roadhouse was at work restoring the thatch ridge of the farmhouse roof. He told us ridge-work often has to be repeated every eight to ten years whereas a thatched roof should last well over twenty. It was hard, hot work but clearly the warm, dry weather was suiting him - there had been a lot of rain during the summer. Further up the path, we encountered evidence of that; a diversionary dam had broken down and stream water was pouring down the lane. Climbing Middle Hill, we parked ourselves beneath an ancient holly tree to look out over the high grass of Aisholt Common towards the conifer ranks of Great Wood.

If you take the A39 Minehead Road out of Bridgwater, a sign will direct you south-west to Over Stowey - a road that will also take you to the conifered combs of Great Wood and up through the hamlet of Plainsfield to Aisholt. Over Stowey is a self-contained little place, tucked into the side of the hill, the road curving tightly around the church and past a terrace of perfect, red sandstone cottages stepping down a gentle decline - their small, front gardens and porches overflowing with jasmine, honeysuckle, roses and hydrangeas. In September, in the churchyard of St. Peter & St. Paul, a myriad of small white and pink cyclamens were flowering, planted a while ago by an elderly lady in the village who watched them naturalise and spread.[48]

Burne-Jones window, Over Stowey church

[48]*We were told that in springtime the church is surrounded by wild daffodils.*
Berta Lawrence describes wild daffodils in nearby orchards and fields of cowslips at Kilve during the 1950s.

The rusty, lichen encrusted church is 'over-restored' apparently - but still succeeded in being featured on the Millennium's 1st Class Christmas stamp! Inside, we found it dressed up for a wedding - wonderful sprays of scented, white lilies. Rosie was especially taken with the beautiful Arts and Crafts stained glass windows - a happy consequence of the Victorian makeover.[49]

There was a time the A39 road passed through the very heart of Nether Stowey with a constriction, just outside Coleridge's Cottage in Lime Street, where holiday traffic would stop dead. That all changed in 1968 when the village was sundered by a bypass separating the community from its parish church and its manor house. Today, this seems like an act of wanton malevolence! So now St. Mary's Church is stranded on the other side of a busy main road and the windows of Stowey Court's beautiful red brick gazebo no longer gaze down on the gentle comings and goings in St. Mary Street. The old main road is now a wide, quiet street of cottages and houses fronting directly onto the pavement - separated on its south side by a tumbling, culverted stream (Coleridge called it the 'dear gutter of Stowey'). The old shops and houses are mostly rendered but some proudly display the local red sandstone - particularly evident in a small, Gothic 'toll-house' on the north side.

Gothic Toll-house, Nether Stowey

[49]*Rosie particularly liked the four musical angels (in the west, north aisle window) playing lute, cymbals, harp and pipes in glorious reds and blues - by Pre-Raphaelite artist Burne-Jones at the William Morris & Co. workshop in 1874.*

St. Mary Street eventually reaches a fine Victorian clock tower[50] (which provides a natural centre to the village known as The Cross) from where it continues as narrow Lime Street. Coleridge's Cottage, at the top of the street, is where the poet and his family lived for around two years (1796-98); it is now owned by the National Trust. [See Special Page: 'Tom Poole - A Talent for Friendship'].

We made the gentle climb up Castle Street, past Tom Poole's house (now restored to its classical proportions - for many years its front had been knocked out to serve as a shop) to the upper outskirts of the village. As you'd expect; Castle Street led us to the earthworks of Stowey Castle raised on a hillock above the village.[51] From the high central mound, the prospect was beautiful: west to the wooded slopes of Dowsborough and Bin Combe with a neat cluster of council houses, to the east: the red tower of St. Mary's Church beyond a rising of roofs and trees, and then north to the Bristol Channel, the turbine halls of Hinkley Point and far off Mendip.

[50]*Built in 1862, the clock tower replaced an ancient market cross which had fallen into ruin. The bell from the old cross was incorporated in the new structure.*

[51]*What remains of the castle consists of a high mound where the castle stronghold would have been built (the motte) surrounded by a defensive ditch. Around the motte are two other enclosures (the baileys) at different heights: the upper bailey would have contained a chapel and a hall: the lower - stables, offices and sleeping quarters etc. The castle is late 11th century, built when the estate was owned by Robert de Chandos and his wife Isabel. By the late 15th century, for reasons unknown, the castle was abandoned and the Audley family, who owned it, moved down the road to Stowey Court. Perhaps it was just a question of comfort (Hazel Riley and Berta Lawrence).*

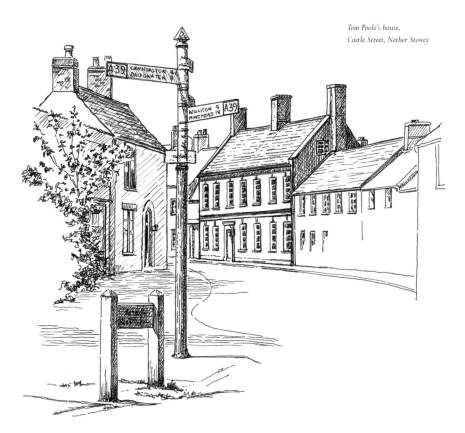

Tom Poole - a Talent for Friendship

Tom Poole of Nether Stowey probably met Samuel Coleridge for the first time in 1794, when Coleridge and his friend Robert Southey were visiting Tom's cousin Henry Poole - who lived in nearby Stogursey. Henry and Samuel had known each other as undergraduates at Cambridge. Tom was immediately enthralled.

Two years later, Coleridge was pleading with Tom to find a cottage for him and his family (wife Sara and baby son Hartley) around Nether Stowey.

Tom Poole came up with a thatched cottage in Nether Stowey's Lime Street called 'Gilbards'. It had the advantage of its rear garden connecting directly with Tom's house (and book-room) in Castle Street but was always small and 'unsuitable'. Coleridge moved in on the last day of December 1796; hoping he would soon find somewhere more commodious. He never did.

In July 1797, Coleridge succeeded in enticing brother and sister William and Dorothy Wordsworth to the Quantocks; to a beautiful house near Holford called Alfoxden (now spelt Alfoxton) - for which Tom Poole helped secure a year's lease. What followed was a period of intense, joyful creativity for the two poets which eventually led to the publication of 'Lyrical Ballads' in 1798 - and immortality. (The collection included the poems: 'The Rime of the Ancyent Marinere' and 'Lines written a few miles above Tintern Abbey'.)

Because of local antipathy, the Alfoxden lease was not renewed and the Wordsworths were on their way in June 1798. Coleridge followed soon after to join them on an expedition to Germany - but leaving his family in Lime Street. Although he made several visits to Stowey over the next nine years, Coleridge never recaptured the poetic outpouring of that wonderful year. In the Lake District, Wordsworth consolidated his poetic achievement and he would only return to the Quantocks for a final good-bye in 1841.

Tom Poole never married, continuing his life and business in Stowey. Around 1805, he moved from his Castle Street home to The Old House in St Mary Street and immediately set about making a new book-room, which inveigled Coleridge and his family to stay in 1803 and, for one last time, 1807. Tom Poole had an extraordinary talent for friendship, and the likes of Humphrey Davy, Josiah and Thomas Wedgwood, Andrew Crosse, Robert Southey, considered him to be a loyal companion. He was beloved and trusted by the people of Nether Stowey and, when he died in 1837, a great crowd pressed into St. Mary's Church for his funeral. He lies, with his father, close to the south porch of St. Mary's.

HOLFORD, KILVE
AND EAST QUANTOXHEAD

West of Nether Stowey, the A39 begins to sniff the sea. It enters the red-earth woods below Dowsborough hill-fort, passing the narrow track roads to Walford's Gibbet and Dead Woman's Ditch - there's a sandstone water fountain at one of the road junctions which I was grateful for when I cycled this way in the 1950s. I seem to remember it worked in those days. But anyway, it was a good place to stop for a breather and enjoy the view! The road then curves and descends into Holford taking a sharp left turnoff at The Plough Inn into the village.

Holford Combe

We left the car next to the 'Bowling Green'; Holford's village green - bowls here would be something of a challenge! Rosie and I have been here many times; it changes a little but retains its quietude and restraint. We made a slow circuit of the village; past the ancient Dog Pound[52] and across the bridge above the stream flowing through Holford Glen - and into Coleridge and Wordsworth's poetry. The stream no longer has the force of Coleridge's 'roaring dell' - but it's still a deep, green gully of sparkling ash leaves and hart's tongue fern. Passing through the village, we entered the wide mouth of the combe with the old water-mill tannery to our right, now an hotel (Combe House) where Rosie spent an educational week in her youth! This entrance to Holford Combe is also known as Butterfly Combe and the beautiful open glades around the ford are perfect butterfly territory - we saw Speckled Woods and Commas - and a few sheep. This is where I used to camp in the 1950s and where I lost all 'street credibility' when my mum dropped in to check I was all right.

The shallow stream flows through the grassy spaces between the trees with the slopes slowly giving way to coppiced oak and an understorey of holly and whortleberry.[53] The oaks here supplied the bark to the tannery and clearly haven't been harvested for many years - they give the woodland slopes a tanglewood atmosphere with an open canopy and pools of bright sunlight. This combe along with its sibling, Hodder's Combe (and many others in Quantock), was once threatened by 'coniferisation' but a huge public outcry stopped the Forestry Commission in its tracks. The Commission has since followed a softer, mixed woodland approach.

[52]*The story is told that one night a huntsman was killed by his own pack of hounds. They had become unsettled by a stray dog and didn't recognise him in his pyjamas. (my version) And so the pound was built to prevent such a thing happening again. Actually, the pound (owned by the manor) was a secure place where any stray animal could be placed prior to it being identified and collected. The raised sight holes are positioned so the interior can be inspected while remaining on horseback.*

[53]*Whortleberry (Vaccinium myrtillus), the local name for the bilberry and related to the American blueberry - but tastier! At one time, an important, demanding cottage industry; the 'wurts' were gathered by women and children from the Quantock slopes in high summer followed by a long walk to Bridgwater to sell for 3d (1.25p) a quart. That's two pints (1.14l) and, from experience, a lot of picking! (Berta Lawrence).*

We slowly climbed above the Holford stream, leaving it to meander through the woodland below. Gradually, the tree-cover thinned and we came upon a small gathering of Quantock ponies grazing amongst the trees. Then, quite suddenly, the canopy gave way to open heath (close to the Dowsborough hill-fort) and sun-filled, wide-open views towards Hinkley and the Severn Sea. Before long, we re-entered the woods and down into dark Ramscombe. Here, in places, the Douglas firs have been allowed to achieve some grandeur - echoing the forests of British Columbia (with which we're familiar), but not quite what you expect in Somerset. We paused to look over the picnicking place that's been set up here (and which is a favourite spot for our children and grandchildren) with tables and barbecuing stoves, while the stream is a wonderful place for children to dabble in all day.

Ben, Laura and Izzy dabbling

We took the wide track which accompanies the stream up out of Ramscombe to regain the Quantock ridge and the beech hedge-banks at Crowcombe Combe Gate. The broad brow of the hills stretched in front of us. Mid-September, a powder-blue sky and the bracken turning bronze, but still a purpling of heather and bright dashes of

yellow gorse. The wide grass tracks arched over the curvature of the heath and led us to the Halsway and Bicknoller Posts with the familiar backdrop of the Brendon Hills to the south-west. Time for a coffee and a Tunnock's at Bicknoller Post, then along the decline beside Longstone Hill to the birch and red-berried rowan grove above Alfoxton Park. Here, we rejoined the Great Road and the truly, archaic colonnade of Holford Beeches.[54] We felt they looked even more shattered than when we came this way a few years ago - which isn't surprising I suppose. Many were elegiac corpses, some with a single living branch breaking from a dying trunk. Ferns sprouted from hollows where great branches had decayed, while ledges of leathery, polypore fungi worked at the trunk below. We couldn't see the Wordsworths' Alfoxton House through the trees as we descended the rutted Great Road into Holford. Meanwhile, unsuspecting, we came upon a small herd of red deer in grassland beside the track; startled, they looked up and, in a breath, skipped away silently into the woods.

Grace, Abi and Josie with Sarah

[54]*Were these trees standing in Wordsworth's time? It's possible, although beeches are not long-lived: 250 years is a good age. Tree-man Adrian Mitchell said that a beech will die over a weekend, whereas an oak will take a hundred years!*

From Alfoxton, a short, westward walk around Pardlestone Hill brought us to
the top of Pardlestone Lane - the way the Wordsworths and Coleridge would
certainly have come to reach the shoreline at Kilve. Here, we reconnected with the
Quantock Greenway which coursed just above the fields and below the brackened
heath - passing at first through the edge of oak and beech woodland close to Broom
Ball. Then, the gentle fall of the hills' northern slopes opened up to us - an undulation
of red, soft green and amber slanting to the sea. And the hedges laden with rose-hips
and sloes. We stopped for coffee in a field high above East Quantoxhead although, even

On the Greenway, above East Quantoxhead

from this lofty position, we couldn't make out the village's Court House or its church; all were obscured by trees and woodland. Beyond lay the slate-blue of the sea and the hint of Wales along the horizon.

The Greenway continued, still just above the fields and we could see our irresistible destination; Smith's Combe and Smith's Knap demarcated by a cluster of pine trees.[55]

[55] *Smith's Knap is a small fold in the hillside set back slightly from the mouth of the combe but forming its western boundary - the higher ground immediately beyond, on which the pines are standing, is West Hill.*

We were soon there and descending into one of Quantock's most entrancing places. The air was warm and still, the path dropped down between hawthorn, elder, holly and rowan all bursting with berries! Bracken, cropped grass. Two busy, conjoining streams bridged by timber planks. Soft ash trees filled the mouth of the combe, their leaves shaping and scattering the early afternoon sunlight. We 'lingered' for some time in this lovely place, reluctant to leave, before turning back along the hillside to Pardlestone Lane and the descent into Kilve. [56]

Pardlestone Lane makes a steepish descent of the hill from a community of farms and houses, hedges giving way to glimpses of the Channel and Steep Holm, before entering high hedge-banks at its lower end. Here, the Holford Stream negotiates the western side of the lane and separates it from the mid-18th century Kilve Court and its grounds - now a residential youth centre. [57] We crossed the main road opposite the Hood Arms (a 17th century coaching inn) to walk the mile or so down Sea Lane to the beach. The stream accompanied us for much of the way and Sea Lane was combe-like until it opened out on the whitewashed tower of St. Mary's Church - a landmark for boats out on the Bristol Channel. A short distance further on, we arrived at the ruins of what is known as Kilve Priory or Chantry; the attached farmhouse serves excellent coffee, tea and homemade cakes. [58]

[56] 'Pardlestone': a wonderful word improbably derived from a Frenchman called Pardel and his mythical stone! A more likely derivation is a Saxon called Parlo and his settlement of Parleston (Berta Lawrence).

[57] Opened by Somerset County Council in 1965. Rosie attended in the mid-1960s on a film-making course - she helped with a film promoting Kilve Court! She and 'quite a few friends' slipped out under the cloak of darkness for an illicit rendezvous on Kilve Beach. All the Court's lights were on when they returned; Rosie was nabbed re-entering through the girls' bathroom window!!

[58] Around 1850, the Chantry was destroyed by fire - fuelled with smuggled brandy stored there. It's reckoned the entire village was in on the trade - even the church tower was used for storage! In the 14th century, what was possibly Kilve's original manor house, became a chantry for five monks who prayed for the soul of their founder. Up until the fire, it had served as a barn and remained reasonably intact.

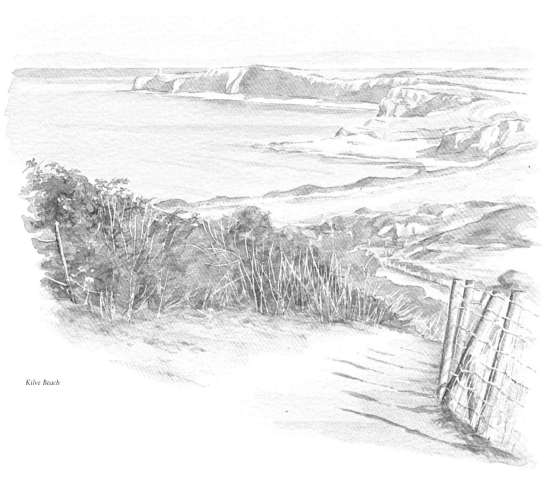

Kilve Beach

Beyond the Chantry and where I remember fields, were now a grassy car-park
and a romantic cricket ground - where Wordsworth struck a perfect cover drive?
But the red brick, oil shale retort was still there - testimony to a failed 1920s
plan to 'blast down' the Quantocks to extract oil. Passing a copse sequestering
an old lime kiln, the path slanted gently up to the low, stratified cliffs of Kilve Beach.
We found a bench above the scalloped shoreline - close to where the Holford stream
emerged to mingle amongst the smooth grey pebbles. Kilve is the Land of the Blue
Lias, where the blue-grey and creamy, soft limestones of the Jurassic are eroded
and exposed in the cliffs and swirling shoreline pavements along the West Somerset
coastline. This is where I once came searching for fossils and found a sixpence -
thus proving the existence of God! Fortunately the fossil ammonites are still there -
just not so many.

We decided to break from the coast for a while and take the short walk inland to East Quantoxhead; charming and complete by its millpond, a beautiful, timeless place. The village is built from lias stone with ammonite whorls placed above doorways or randomly in cottage and field boundary walls. From its knoll, the grey Court House turns its back to the sun, the great windows facing north; opting for the panorama of splendid gardens and the Severn Sea.[59] On the same bluff, close to the Court's south walls, stands the parish church of St. Mary. We stood in the south porch with a glorious view of the Quantock Hills, an

Gate latch, East Quantoxhead church

ammonite, locked in its chunk of stone, eloquently placed on the porch cill.

The coastal path snaked along the cliff tops to the hipped rise of Quantock's Head (where the Quantocks meet the sea) - it was good to see Rosie's drawing on the path's marker post.[60] The tide was coming in with an insistent murmuring. A warm sun, and the path was separated from the cliff-edge by a sheltering hedgerow heavy with blackberries. We'd been here before and it was still a comfortable place. So we sat with our backs to the sea, looking across the manor fields to the Court House and Longstone Hill and surely, there!, almost hidden in the hill haze - Smith's Combe?!

[59]*The Court House has been in the continuous ownership of one family, the Luttrells, for over 900 years. There were a few mishaps along the way; in the 1500s, George Luttrell made the mistake of marrying Silvestra Capps who drove him to distraction. George died and Silvestra went on to wear out two more husbands, one of whom she threw out of a window. It's Silvestra who is blamed for turning the whole house 'back to front'.*

[60]*Rosie's drawing of a Kilve ammonite (from our West Somerset Coast book) has been used by the Quantock Hills AONB Service on their white disc markers for the Coast Path.*

THE BRENDON HILLS

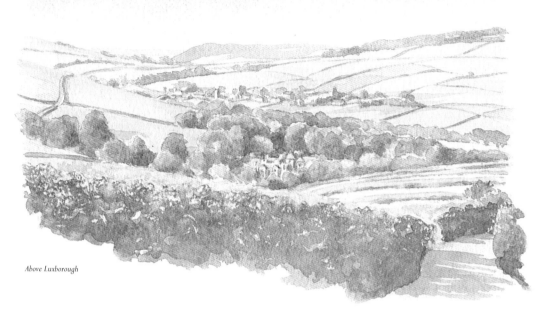

Above Luxborough

The Brendon Hills lie immediately west of the Quantocks, separated by a valley through which the Doniford Stream flows to the sea. The hills run east to west, from Stogumber to Wheddon Cross for about ten miles, rising to a height of 1388ft (423m) at Lype Hill close to their western end. They consist mainly of Devonian rock (408 to 360 million years old), with Hangman Grit sandstones to the north and then, progressively, the slates and limestones of what are called the Ilfracombe and Morte Slate beds to the south. The hills' western boundary is demarcated by the River Avill, flowing north through Dunster and the River Quarme flowing south - a tributary of the River Exe. Although distinct, these days the Brendon Hills are included within the boundaries of the Exmoor National Park.

The Brendons are different in character to the Quantocks. For centuries they have been farmed and enclosed, so they do not have the wide, open-top heathland that's such an aspect of the Quantock Hills. Also, during the 1920s much of the unproductive, borderline land was planted with conifers by the Forestry Commission, although, as in the Quantocks, this has given way to the more enlightened, broadleaf plantings of recent years. However, areas of dense 'coniferisation' still remain.

STOGUMBER, MONKSILVER AND NETTLECOMBE

The Brendon ridge carries the B3224 road, following the line of a Saxon herepath which once joined the Quantock trackways to link Bridgwater with North Devon. The road is dramatically lined with mature beech trees and hedgebanks opening out to pastureland and far flung farms.

Stogumber Station

Emerging from the north end of Crowcombe, we crossed the A358, taking the Stogumber road straight ahead. The road, lined with old oaks, dips and curls. Almost immediately we caught a glimpse of the Bristol Channel and passed the road junction where once stood the Heddon Oak - yet another Monmouth Rebellion gallows tree.[61] Close by here is Brewer's Water Farm whose spring (Harry Hill's Well) provided the water for Stogumber's once renowned beer.[62] The road then dips under the dark red sandstone arch of the bridge carrying the West Somerset Railway and on past the old Railway Hotel. We stopped here for a while and walked back under the bridge and up to Stogumber Station; which seemed suspended on the side of a cutting framed by high oaks. A small, sandstone ticket office stood by the line opposite the platform, a few milk churns and a porter's trolley completed the scene - tokens of past times.[63]

[61] *Still standing until quite recently. In 1952, Berta Lawrence described the ancient oak "from whose old limbs swung the bodies of rustic rebels captured after Sedgemoor - their ghostly chains still creak..."*

[62] *Around 1840, George Elers founded the Stogumber Brewery and its famed 'Medicinal Pale Ale'. The brewery closed in 1910 but the buildings survived until 1973 (Robin Bush).*

[63] *The line of The West Somerset Railway was first mapped out by Isambard K. Brunel in 1858 but, due to ill-health, he soon had to hand over to his assistant RP Brereton. The track from Taunton to Watchet was completed in 1862, and extended to Minehead in 1874. The lines were originally Brunel's broad gauge. Up until 1947, the railway was a moderate financial success but nationalisation marked a decline in its fortunes. It closed in 1971; only to be reborn in 1975 thanks to bunch of enthusiastic volunteers. And so it continues, running steam trains between Bishop's Lydeard and Minehead, through evocative stations with wonderful Brendon and coastal scenery.*

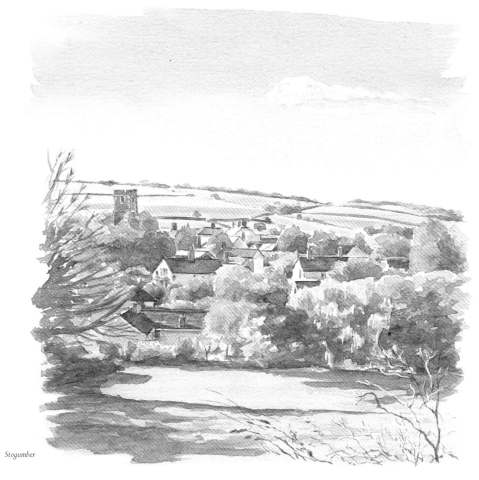

Stogumber

Stogumber is a beautiful, idiosyncratic village, folded this way and that on the eastern Brendon escarpment. A garage on steep Station Road once rescued my Mini from electrical collapse in a torrential storm, and as we passed it, I sadly noticed it now seemed closed. Stogumber High Street rises sharply from the Station Road junction, with thatched and slate roofed houses and cottages terraced together up the slope. Some of the houses have the raw, red sandstone exposed, but most are rendered and painted in soft pastels. A run of gables finishes up at the White Horse Inn standing opposite the gates and rusty stone tower of St. Mary's Church. The church is mostly 14th and 15th century but inside we were in for a surprise; the chancel is brilliantly decorated in the Arts and Crafts style of William Morris with gilded and coloured stencilling to roof and walls, and encaustic tiles to the floor. All this happened in 1875 and works wonderfully well.[64]

[64] *Work was carried out by Prebendary Edward Jones, Stogumber's vicar from 1871 to 1907. It cost £2,400 - a great deal of money. But worth it! We also enjoyed the 'begging dog' finial cresting the roof of the Sydenham Chapel.*

We returned outside, to the south of the church where the churchyard runs a full 100 yards to the high trees on Station Road. Below the tower, a sunny and irresistible bench presented itself (supplied by the W.I. in 2004) so a coffee was called for - and a toast to the W.I. We then walked past the White Horse, down and then up Kingswood Lane - great views over the village. Further up, at the hill's crest, an overgrown lane into a stubbled field opens onto a fantastic panorama: much of the southern aspect of the Quantocks, from West Quantoxhead to beyond the slash of Triscombe Quarry.

Back to the village and down the gentle fall of Brook Street with its houses packed one against the other, verandas and gables, the red stone of the old Baptist Chapel (now an arts centre) set back from the road. We also wandered down the Vellow Road with high sandstone barns and what appeared to be a former mill where the Stogumber Brook cuts through gardens on its way to Vellow. We crossed the stream, taking the footpath in the direction of Escott Farm, to gain another lovely perspective of the village - a rising assembly of roofs pinnacled by St. Mary's tower.

The road west out of Stogumber, Ashbeer Hill, is steep and narrow with passing places not always where you would like them to be. We took the right turn down into Monksilver - a distance of about four miles.[65] The village occupies a deep groove in the Brendon Hills overlooked by tree-topped Bird's Hill to the south-west. Like Stogumber, many of the houses are rendered and colour-washed, with slate roofs or the occasional thatch and red sandstone. There's been a fair amount of late 20th century building here - not overly obtrusive. Behind the Notley Arms, just off the main road (B3188), stands All Saints' Church, rosy-hued in rubbled Old Red Sandstone, although the south wall with its Perpendicular windows, buttresses and dressed stone are from a local Devonian limestone (Monksilver Church Guide). Inside, the church was decorated with a breathtaking array of flowers, spindle berries and autumn leaves for Harvest Home, all illuminated with light pouring through those high windows.

[65] *Monksilver has the distinction of being the place where Sir Francis Drake married his second wife: Elizabeth Sydenham. There's a wonderful story that Elizabeth was on her way to Stogumber Church to marry someone else (her father, Sir George, having wearied of Sir Francis gallivanting around the world)) when her procession was arrested by a cannon ball, blasted by Sir Francis from some distant ocean, crashing into her path. So she went home. Sir Francis turned up a while later to claim her hand. It seems the cannon ball may well have been a meteorite.*

Ruinous barn, Monksilver

Behind the church, the High Street rises past the high-roofed Old School House with its wooden bell-tower. Here the street becomes Birchanger Lane making a right angled turn westwards at the Old Rectory. We followed the Colton Cross footpath for a short distance along a field margin below Bird's Hill - the hay had been cut and packed in great shredded wheat rolls scattered over the stubble. Looking back towards Monksilver, a thin drift of wood smoke trailed from Orchard House in the middle distance, while beyond rose hillside meadows, crested by the red-brown of freshly ploughed fields. Birchanger Lane dipped and twisted its way along the hillside with massive oaks rising from the hedgeline. At Birchanger Farm, a stand of sweet chestnut trees had unloaded prickly, green clusters of fruit onto the roadway; so plump and full they burst open as we rolled them underfoot. A cornucopia of chestnuts! Many had been squashed flat by passing traffic; so we filled our pockets. (Later that evening we roasted them; they were scented, nutty and sweet.)

Chestnuts at Birchanger Farm

We now took the footpath across the fields to Nettlecombe, cutting down to the narrow valley floor along a green trackway that led to Nettlecombe Court. We emerged from encircling woodland to the perfection of an Elizabethan manor house and its parish church; warm red against the trees, but curiously alone. Where were the accompanying farmhouses, barns and cottages?[66] Pressed close to the house for companionship, St. Mary's Church appeared solemn and restrained like a serious, elder sister. There's been a house here since the mid-1100s - in continuous family ownership right up to the present day.[67] The church goes back to the 14th century but, like the house, was almost certainly preceded by an earlier model! Since 1967, the house has been leased to the Fields Studies Council which runs courses on the environment.

North of the house and church stands an imposing Georgian stable block - not so long ago this was occupied by a group of artists and craftsmen. We remembered calling on Geraldine (jeweller) and Alexander (artist) Hollweg one September during Somerset Art Weeks. Now, as we walked around, the

Stables at Nettlecombe

allotment plots appeared abandoned and a lone dog barked. After a while we headed back, over the folding fields to Monksilver. Pheasants clattered out of the high grass, while a fox, low slung, slinking the hedgeline before us, cast a casual gaze and anticipated easy prey.

[66]*Sometime in the 18th century, Nettlecombe village became parkland. Cottages, homes and field boundaries were cleared away in a fit of landscaping excess. (A similar thing happened in West Quantoxhead in the 1850s.) You can still see the line of the extinct field margins traced by the parkland trees which originally grew in the old hedges. Such was the power of the lord of the manor (Hazel Riley).*

[67]*The house was remodelled in 1599 (it's on the porch) by John Trevelyan (there were eight Johns over five centuries!) who incorporated an earlier building. The west front had a Georgian makeover around 1760 (Robin Bush).*

COMBEROW, LEIGH BARTON
AND RALEGH'S CROSS

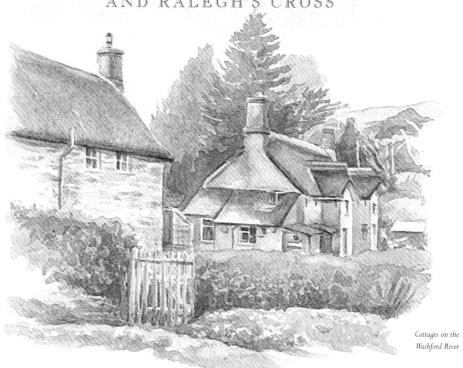

*Cottages on the
Washford River*

We decided to follow, as best we could, the Brendon part of the famous West
Somerset Mineral Line which from 1856 to 1898 carried iron ore from the area around
Ralegh's Cross on the Brendon ridge, down the steep hillside ('The Incline') to
Roadwater and from there, through Washford, to Watchet's West Pier and the sea.
[See Special Page: 'The West Somerset Mineral Line'.] We began at Roadwater where
a confluence of two streams forms the Washford River, which we could see and feel
hurrying through the village. We followed the old line's route, now a narrow road with
an accompanying stream, due south, passing a cluster of tiny hamlets (Traphole, Lower
Hayne, Stamborough, Leighland Chapel) to Pitt Mill. Much of the hillside is covered in
conifer plantations with areas of open pasture alongside the fast flowing stream. Hazel,
oak, and ash were colouring to autumn. Bright, pink-red fruits of spindle decorated the
stream-side hedges. Thatch and slate on colour-washed houses and cottages, while high
up on the escarpment, morning sunlight caught the yellowing larches against the
backdrop of conifer green. At Pitt Mill the pines come down into the valley, swallowing
the narrow road - we had been here a few years before, visiting the water mill that
powers the press of the Two Rivers Paper Company close by.

The conifer corridor continues, with occasional areas where the trees have been cut back to allow a red stone house to breathe. Reaching Combe Row (or Comberow), at the base of the hill, we were just able to make out where the sharp rise of 'The Incline' began - unfortunately this was no longer a 'permitted path' during our explorations (it has since been reopened), so we were unable to trace the line up the most remarkable part of its route. We would try and see what we could from the top! On this day, we decided to follow the trail up through Broadfield Wood to the north of Combe Row, and take the hillside road back to Roadwater. The route through the broadleaf wood felt like an old bridleway, the track easy underfoot with fallen ash and oak leaves. Glorious aspects of the opposite hillside slopes opened out; the trees softened by leaf fall and with just sufficient leaf cover to give a dusting of old gold.

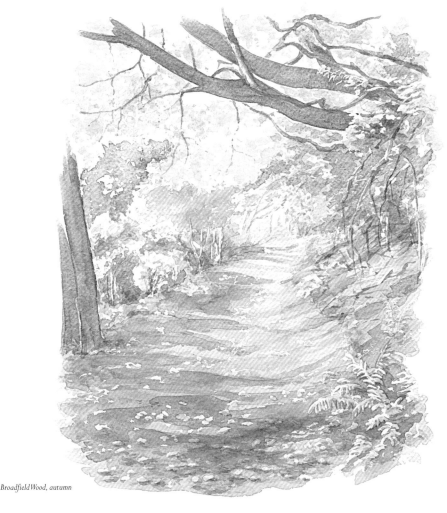

Broadfield Wood, autumn

Emerging from the wood, we were in for one of our surprises; we came upon the extraordinary hamlet-farm of Leigh Barton: a grouping of grey-red, stone buildings, set high on a sloping roadway with a potent and ancient presence. We weren't surprised to

Leigh Barton

discover later that this remote place was once a refuge for Catholic priests during the 17th century, one of whom met a grisly end.[68] We walked slowly back to Roadwater (nestling in a cocoon haze of woodsmoke), along a track-road high above the Leighland valley - a small, chapel bell-tower just peeping above the fall of the fields. And beyond the coastal meadows; the blue, indistinct line of the Severn Sea, and a rainbow, presaging rain.

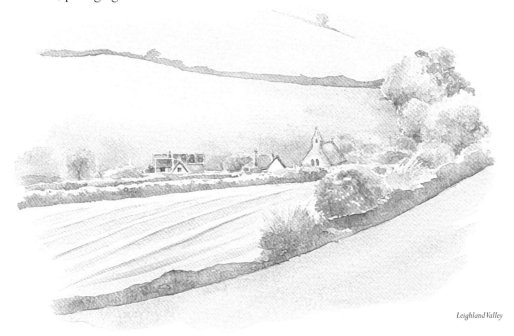

Leighland Valley

[68] *Leigh Barton Farm is an enclosed courtyard or barton farm with a predominance of 17th century buildings including a remodelled (19th century) farmhouse. Formerly known as Leigh Grange, it was one of the five granges of Cleeve Abbey. The tall granary and threshing barn extends the full eastern length of the barton with smaller barns forming the other sides of the enclosure. It was, clearly, an organised agricultural machine. In the 17th century, the farm was occupied by the wealthy Poyntz family; loyal Roman Catholics who sheltered many Catholic priests - there are remains of a chapel behind the farmhouse. The priests included Philip Powell who was captured during the Civil War and was hanged, drawn and quartered at Tyburn in 1646. (sources include: Hazel Riley & Robert Wilson-North, Robin Bush and Jeanne Webb).*

A few days later, we were at the top of the Brendon escarpment, just a mile or so west of Ralegh's Cross. Here, close to the main road, stand the remains of the roofless Mineral Railway's Winding House that once contained the massive cast-iron drums which wheeled the cabled trucks to and from the valley below. Shaded by pines, it felt gaunt and austere, its rubble stone walls and arched steel-framed windows gloomy and dark.[69] The Incline track dives into the trees and disappears. Hard to believe that for nearly 50 years this was a busy industrial scene, for the signs of settlement have nearly all gone. A restored Beulah Methodist Chapel stands at the road junction a few hundred yards east of the Incline. To the west, a terrace of miners' cottages with a sheltering grassy gulley (left by the old railway track to the Gupworthy mine) running on through the fields. We discovered this by turning south close-by, past the triangular Naked Boy's Stone, grateful to escape a cold, northerly wind despite a sunny April day. The track led to the Burrow Farm engine house. Pressed against the field edge of beeches and surrounded by sheep, it represented a lonely testimony to a vanished way of life.[70]

[69] 1930's photographs of the Winding House show a complete ruin - blown up when the winding drums were removed in 1917. The anachronistic iron framed windows were part of a rebuilding for farm use. (R.J. Sellick). While writing, the Winding House and Incline (it's a hard steep climb) have been made safe and reopened to the public by the Exmoor National Park Authority. Hooray!

[70] The Naked Boy's Stone, a substantial chunk of white quartzite, demarcates the southern boundary of the parish of Old Cleeve. According to Martin Hesp, youths were once separated from their trousers and walloped in a process of 'beating the bounds' of the parish, to impress them with the memory of its boundaries. It's probably a Bronze Age standing stone, which, along with funeral barrows, defines the Brendon Herepath along the ridge. The 1880 engine house was built to a Cornish design (many of the Brendon miners came from Cornwall) and housed a pump and winding rotary beam engine. It's the only one to have escaped demolition on the Brendons.

The West Somerset Mineral Line

Iron ore had been taken from the Brendon Hills since at least Elizabethan times (and probably even earlier by the Romans), but in 1853 the Ebbw Vale Ironworks embarked on industrial scale extraction. Most of the mines were sited around Ralegh's Cross, Brendon Hill village and Gupworthy, high up on the Brendon ridge - so a railway was built to carry the ore to the port at Watchet, from where it would cross the Severn Estuary to the iron foundries in Wales. Construction of the line between Watchet, Roadwater and Comberow was fairly straightforward (even so, three men lost their lives), but then it encountered a three-quarter mile, 1 in 4 escarpment ('The Incline') - a rise of 243m. (800ft). This was solved by trucks attached to winched cables on two, huge, 18ft, cast-iron, linked winding-drums self-driven by gravity; as the loaded trucks went down another came up. It was a formidable

The Winding House

technical achievement - completed by 1859. The Incline trucks were used primarily for the transport of ore but people could take a free ride - at their own risk. One passenger described the trip as "curious, rather than agreeable"!

A substantial working community rapidly became established in Brendon Hill village with a church, chapels, cottages and a store. Mining on the Brendons continued until 1898, when it was closed down by the arrival of cheap, open-cast, Spanish ore. For a while, with no ore to provide the gravitational lift, the winding drums were driven by a steam engine. Between 1907 and 1911 a number of attempts were made to restart mining and reopen the line - all ended in failure. During the First World War, the rails were commandeered by the Ministry of Munitions and later an Act of Parliament was passed to close the line. In 1917, the cast-iron winding drums were blown up which left the Winding House a ruin. The line's land and buildings were sold off in 1924. In recent years, much restoration work has been carried out on the Mineral Line by the Exmoor National Park Authority. It is now, once again, possible to visit the Winding House and climb the formidable Incline.

('The West Somerset Mineral Railway' 1981 & 'The Old Mineral Line' 1981 by R.J. Sellick)

Clatworthy Reservoir

On the Brendons' southern escarpment, a few miles south of Ralegh's Cross, lies Clatworthy Reservoir occupying a confluence of streams from six valleys: the source of Taunton's River Tone. The waters fill a deep trough, hidden from our view as we descended the narrow road from the ridge. With the reservoir still unseen, we stopped in Clatworthy village just below St. Mary Magdalene's Church whose sloping lawns were a profusion of wild daffodils. Audrey Tout kindly crossed the road with the church key and inside we found a simple, unadorned place still reliant on oil lamps perched on poles above the pews and an ancient, stone tub font. Outside stands John Surridge's 1858 gravestone with the following stern admonition:

> All you young people that do pass by
> As you are now so once was I.
> As I am now so you must be,
> Prepare for death, and follow me.

Despite its man-made waters covering a Domesday farm, Clatworthy Reservoir is beautiful. We crossed its high dam to the birch and beech woodland of Clatworthy Wood on its east side, following the path through the trees some way above the lake, before it descended to the waterside. Silver birches trailed their branches in the water. With the cold, early spring, everything was late - although, as always, the gorse was managing to be in flower. We were escorted along the path by two Peacock butterflies while a pair of Canada geese patrolled the water's edge. The lake sequesters itself in small inlets, with woods, hedges and trees covering the gentle rise of the surrounding hills. Short distances along the perimeter path brought enchanting changes in perspective. This is a lovely place and we were lucky to have it, on this bright spring afternoon, virtually to ourselves.

Much of the Brendon Hills' northern slopes has been taken over by monotonous conifer plantations crowding out an earlier landscape of hill pasture and broadleaf woodland. Taking the road down to Luxborough it seemed, at times, we were engulfed by pines. Vistas did open during our descent, providing snapshots over hedges and through field gates, of farms and meadows to pine-clad Croydon Hill and, in the far distance, a glimmer of the sea. Luxborough is folded into several narrow valleys and divided into three small hamlets: Pooltown and Kingsbridge which take up separate stations along the valley floor (busied by the youthful Washford River), and Churchtown, a mile or so west, perched on a south facing hillside.

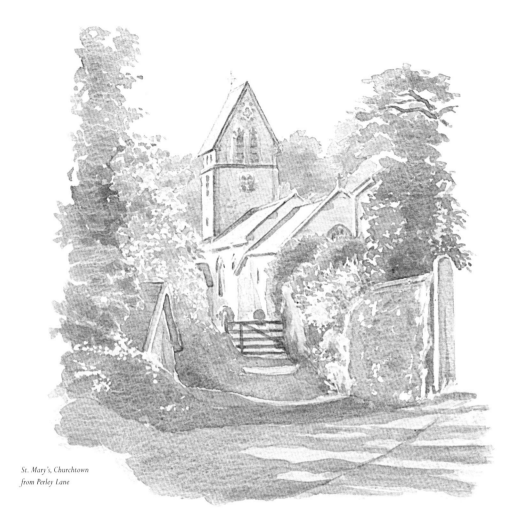

St. Mary's, Churchtown
from Perley Lane

We took a westerly path through Church Wood, following a stream tributary to the foot of a deep lane which led up to Churchtown. On the hillside above us stood the saddle-back, stone tower of whitewashed St Mary's Church. Standing outside the small church, the view of fields and rolling hills was captivating, and the clear glass windows onto the nave allowed that same landscape to follow us indoors. The building and its grounds were so bright and clean. There was even a fresh, coloured glass window that sparkled with afternoon sunlight: blues, emerald, amber and red.[71] A gateway to the east of the church leads into Perley Lane, a rutted and rocky hollow-way, by which we climbed the hillside between high hedge walls. At the top of the hill the panorama opened out; a lowering sun etching the slanting fields and woods with a glaze of soft sunshine.

[71]The window is by Frankie Pollock and was completed in 2002. It shows the Virgin Mary
('All generations shall call me blessed') in a sweeping blue robe amongst trees, fields, ferns and a solitary lamb.

A few miles further west along the Wheddon Cross road, we turned north at Heath
Poult Cross for Timberscombe - a gently falling road which first skirts the middle
contours of Kersham Hill before descending along the western side of a beautiful valley
looking to Croydon Hill - with an enticing footpath sign to 'Clicket 1 mile' which we
didn't take. We entered Timberscombe by a road bordered with larches; a sandstone
village surrounded by hills with its red church to St Petrock perched on a knoll above a
press of houses, and a busy stream (a tributary of Dunster's River Avill) rushing through
below. This waters-meet must once have been a place of mills, and one still stands (no
longer milling) next to a ford bridged by a raised stone footway, which we crossed on
our way up to the church. We were delighted to discover the village still had a post
office so we dropped in with a parcel to post the next day - only to discover it closed
between 11.45 am and 2 pm. By which time we were up on Dunkery Beacon.

The wooded A396 from Timberscombe winds its way up to Wheddon Cross above and beside the River Avill coursing down its combe to Dunster. Towards the top of Cutcombe Hill, we turned off to its namesake village. This is a lonely and ancient place - Somerset's highest parish. We were there in mid-December with a low winter sunlight silhouetting the hedgebank beeches of St John's churchyard and lighting up the remains of the Brendon ridge as it heads into Exmoor. Sadly, the church tower is in something of a bad state so we were unable to see inside; but happily, the building was in the throes of restoration and repair - a huge community project.[72]

[72]*Sheila Bird writes that at Eastertide it was custom to carry posies of primroses, catkins and violets into the church and to climb Dunkery Beacon for the Easter Day sunrise (as did the folk from Luccombe); all to attract good fortune. It seems to be working.*

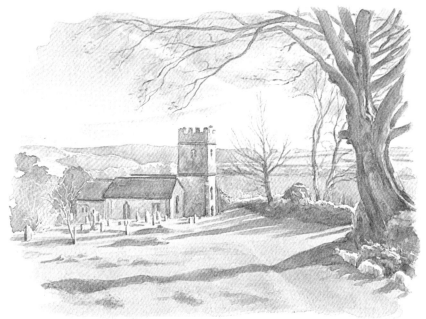

The church at Cutcombe

We sat for a while on a bench at the back of the churchyard (dedicated to the memory of Stewart and Elsie Hodgson) looking beyond the church to where sheep were scattered like salt across the slopes of Lype Hill, a brush stroke trail of cirrus cloud across the sky.

Having negotiated the deadly crossroads at Wheddon Cross, we parked the car at Dunkery Bridge and made the easy climb to the beacon top. Dunkery Beacon rises some 1703ft (519m) making it Somerset and Exmoor's highest point - but it does so very gently. A wide grassy pathway led us to the well-fashioned beacon cairn where a brisk breeze was blowing.[73] It seemed all of Somerset was about us and from here a beacon fire would have been seen for many scores of miles in all directions. We stood in

languid sunlight with mist drifting along the coast, a criss-cross of fields and woodland over the Brendons, and the wide foreground sweep of dead, brown bracken as Exmoor folded away into the west.

[73]*A sign on the beacon cairn commemorates the day in September 1935 when Dunkery Hill was handed over to the National Trust by Sir (Richard) Thomas Acland, Colonel Wiggins and Allan Hughes. In 1944, Sir Richard Acland went on to gift his entire Somerset, Holnicote Estate (some 12,500 acres) to the National Trust - as well as 6,400 acres at Killerton in Devon!*

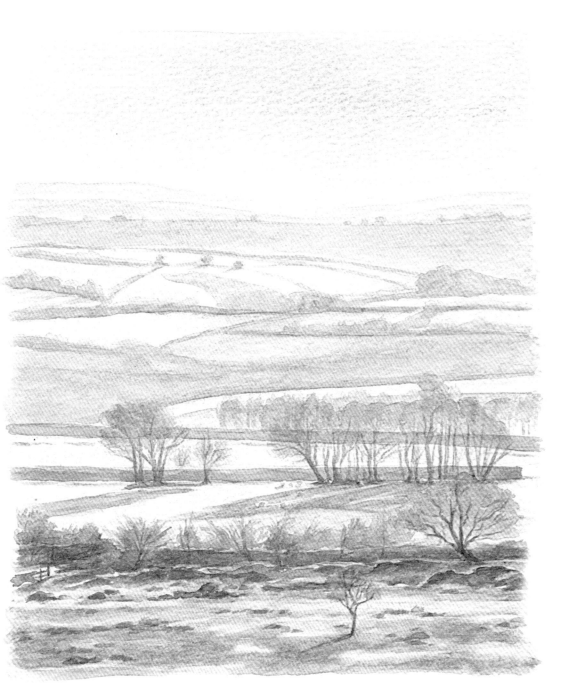

The Brendons from Dunkery Beacon

THE MENDIP HILLS

Above Compton Bishop, looking east

The Mendip Hills, Somerset's predominant range, run some thirty miles, south-east to north-west, across the centre of the county. These are tough and wind-stretched hills, criss-crossed by a maze of rolling roads and dead straight tracks, girdled by villages and small towns tucked into sheltering valleys and combes.

Since unrecorded time, man has moved across the Mendip high ground, making his home in its combes and caves, leaving his traces in funeral barrows, hill forts, mines, farmhouses and dry stone walls. Valued for its mineral wealth (a probable motivator for the Roman invasion of Britain): lead, coal and limestone have all been extracted in enormous quantities leaving the scarred 'gruffy ground' around Charterhouse and Priddy, the eastern spoil-heaps and, nowadays, the sound of the limestone-laden lorries of east and west Mendip.

The eastern foothills rise from the narrow corridor running between Frome and Bruton (hard on the Wiltshire border and Salisbury Plain), to form a wide, elevated plateau that gradually narrows westwards and lifts to the hilltop slopes of Black Down. From there, the hills taper and descend to the sea, closing with the peninsula of Brean Down and the fulfilling stop of Steep Holm island, three miles offshore. So, the hills can be conveniently divided into five areas: the eastern section rising to Beacon Hill and Maesbury Camp: the northern slopes: Wells and the southern fringe: the central plateau with Priddy at its heart: and west Mendip to the sea. Living in Weston-super-Mare for much of my life, has meant my southern horizon has always been bound by the Mendip's seaboard escarpment: wooded Hutton and Bleadon Hill, grassy Wavering Down and the high, tweaked top of Crooks Peak. So for me, there is a logic to moving from east to west towards the sea and, as we make this journey, it will be visible for much of the time.

The Geology of the Mendip Hills

The geology of the Mendips is complex, but it's useful to have a rough
idea of how they formed and it helps explain what we see today.
The oldest rocks are from what is known as the Silurian Period
(428-420 million years ago) when volcanic activity deposited lava and
ash in shallow seas. These are exposed in the Beacon Hill area to the east.
The Silurian rocks were then overlain by the Old Red Sandstone of the
Devonian Period (400-350 million years ago), a time primarily of arid deserts -
the sandstone is particularly evident on Black Down. With the return of the sea,
the limestone strata of the Carboniferous Period (350-290 mya)
were laid and these now form the main mass of the Mendip Hills.
During the later part of the Carboniferous, coal measures formed in tropical
swamps and river deltas. In west Mendip, these have been lost to
erosion but in the east, the measures survive, to be mined for hundreds of years -
right up until the 1970s.

At around 290 million years ago (the Permian Period, 290-250 mya),
the gigantic land masses of Euramerica and Gondwanaland collided (the Hercynian
Orogeny) resulting in massive rock folding and uplifting. In what became the Mendips,
this resulted in four major folds represented from west to east by: Black Down, North
Hill, Pen Hill and Beacon Hill. In their youth, these hills probably rose to over
5,000ft (1,500m) - five times today's height. Next came the mainly hot and
arid Triassic Period (251-200 mya) during which storm-water carved deep
ravines into the hillsides, flushing scree and debris onto the lower slopes -
this later fused to become the beautiful, iron-stained rock Dolomitic Conglomerate
(as seen, for example, in the walls of West Harptree and Draycott).
The shape of the Mendips during this period is thought to
have been much as it appears today.

By the end of the Triassic, the sea was advancing again, the hills became
islands and then disappeared beneath the waters and the rock formations
of the Jurassic and Cretaceous Periods (200-135-70 mya). It's reckoned that
by the end of this time, the present hills lay beneath 3,300ft (1000m) of rock!
Over aeons, much of that younger rock eroded away to reveal the present
Mendips in their previous Triassic form.[74] The last few million years have
been dominated by a sequence of Ice Ages. The glaciers did not get as far as the Mendips,
but with the extreme permafrost conditions water was unable to drain through the
limestone strata (as it does today) because of the frozen ground.
During those 'arctic' summers, torrential meltwater cut into the limestone
to form the valleys and famous gorges of the present landscape.
In today's wet temperate climate, the ancient, re-exposed
Carboniferous Limestone is being dissolved, with the subsequent
formation of Mendip's caves, subterranean rivers and streams.
There is little standing surface water and the valleys and gorges are dry.

[74]*An alternative theory suggests that the plateau formed much
later and that the Mendip islands were never covered by the sea,
and thus never covered by later rock formation.*

(Sources: Peter Hardy, Andy Farrant and David Wright).

FROME, MELLS, NETTLEBRIDGE VALLEY, BUCKLAND DINHAM, VALLIS VALE

This area of the hills is encircled by four small towns: Frome to the east, Radstock to the north, Shepton Mallet roughly west, and Bruton to the south. The western border of Frome delineates the eastern boundary of the ancient Royal Forest of Mendip where the land gently rises to the Beacon Hill ridge.[75] I used to come this way driving from Salisbury to Weston (I was working at Salisbury Infirmary) and was largely unaware of the vast quarries

Alleyway, Frome

I was passing by. Even today, they are shrouded by woodland, although the lorries and the limestone dust give them away. Despite being the meeting point of several major roads, Frome has succeeded in surviving as a successful small town. Stone houses fold down its hills to a bevy of shops and market stalls in Cheap and Gentle Streets. High stone walls sprung with red valerian, its namesake River Frome coursing through.

[75] *'Forest' originally signified land set aside for the hunt. Mendip Forest belonged to the Saxon kings and extended from Cottle's Ash (nowadays, mysteriously, Cottle's Oak) on the western edge of Frome to Black Rock at the mouth of the River Axe below Brean Down. The 'king's houses' or hunting lodges were sited in Cheddar - where Kings of Wessex School now stands.*

On a warm July day, we took the road from Frome through the houses of Cottle's Oak to Mells, entering the deep valley cut by the Mells Stream. It was hard to believe that we were only a hillside and a few hundred yards away from the enormous Whatley Quarry. The stream and roads meet at a riverside shelter - an elegant, stone pyramid designed by Edwin Lutyens.[76] Close by is the local post office and general stores. From here we walked up to Selwood Street with rose-strewn cottages, high stone walls and the handsome Talbot Inn. At right angles, we turned into medieval New Street - the only completed section of a 15th century 'town plan' - and approached the magnificent tower of St. Andrew's Church behind its great gates. In the churchyard, over the wall of the next door manor house came the luxuriant, orange blossom scent of philadelphus in full flower.

[76]*The shelter is dedicated to Mark Horner who died in 1908 aged 16. There's quite a bit of Lutyens about Mells. The haunting, equestrian statue (by Alfred Munnings) of Edward Horner who died in World War I stands on a Lutyens plinth (presaging his London cenotaph) in the parish church. He designed the village war memorial and the rebuild of Mells Park House (destroyed by fire in 1917).*

The Horners were lords of the manor from 1543. Unfortunately, the nursery rhyme 'Little Jack Horner' where Jack acquires the deeds to Mells manor (the plum) by removing them from their hiding place in a pie appears to be a 19th century invention. The family ruled the village with feudal severity up to the beginning of the 20th century. Frank Clevedon gives a wonderful description from the early 1800s of a Colonel Horner sitting in church, cosily ensconced within a carpeted pew with its own blazing fire - which he prods with a poker, while the rest of the congregation freezes...

At the rear of the churchyard (where the poet Siegfried Sassoon lies), an avenue of shaped yews led us to a hinged stile and a wide open field with a gentle rise. From the top of the field, we could see the church and the manor house sitting amiably together. Warm buff stone and a backdrop canopy of trees. Conduit Lane led us over the railway line which follows the direction of a never completed Dorset and Somerset canal - whose indented remains were just visible beyond the bridge.

Fields close to Hill House Farm

We then followed the footpath to Hill House Farm. The dry weather had left the ground hard, cracked, stony and laden with fossil oyster shells. The field margins were strewn with small white bells of hedge bindweed and yellow shocks of ladies bedstraw. In the hedgerows, a haze of cow parsley and sky-blue meadow crane's-bill seduced countless Marbled White and Meadow Brown butterflies. And beyond the brambled hedgelines, a soft glow of ripening wheat.

Leaving Hill House Farm, we walked over and down Clareham Lane with the remains of an ivy-topped, brick colliery chimney poking up incongruously from the high grass.[77] It seemed extraordinary that so much of what surrounded us was once a 19th century industrial landscape: canals, mines, spoil heaps so quickly absorbed, leaving only the slightest traces. Suddenly, high up above the meadow, two skylarks (almost an exaltation!) let loose in ecstatic song, one slowly descending into silence leaving his companion to a lone, flickering carousal. We continued on down the lane into Buckland Dinham to St. Michael's Church, passing the small, stone, village gaol close to the entrance, and sat down with a coffee on Fred Luke's bench. (Rosie couldn't resist noting a high Celtic cross standing eloquently at the entrance to a secondary churchyard).

We then moved south, down to the Mells Stream below Great Elm village. From here, we entered the deep, wooded Wadbury Valley with the stream coursing below high limestone cliffs. Splashes of sunlight broke through the tree canopy (birch, ash, sycamore) onto banks of enchanter's nightshade and glossy hart's tongue fern, but mostly it was claustral and dark. Suddenly, pressed against the stream-side and under the cliffs, emerged the tall, broken, but continuous walls of what was Fussell's iron works (Special Page: Fussell's Ironworks, Mells). They extended for over a quarter of a mile: a complex, collapsing lattice of defunct leats, sluices, stone sheds, yards and open roofed workshops. During the 18th and 19th centuries this factory had supplied 'edge tools' (blades, axes, scythes etc.) of wonderful quality to the whole world.

[77]*Known as Oxley's Colliery: an unsuccessful, late 19th century venture.*
"The sinking was abandoned in disturbed ground at a depth of 420 feet."(Shane Gould).

We re-emerged into sunshine on the Mells road and walked back into the village. Directly opposite New Street, a small doorway in a high, stone wall invited us into 'The Walled Garden at Mells' - an impressive, plant nursery; 'open for teas, plants and cut flowers'. So, sitting on a hay bale, we indulged in delicious lemon drizzle cake and a perfect pot of tea.

The Walled Garden, Mells

We came back here in mid-February to explore the Mells Stream east of Great Elm. Starting at Hapsford Bridge, we passed through a small industrial estate into Vallis Vale where the Mells Stream is promoted to Mells River. It courses past a number of small quarries; one of which, close to the point where the Stream is joined by the Egford Brook, has achieved a fair degree of geological celebrity. The quarry face demonstrates the 'de la Beche Unconformity' - we caught it illuminated by a winter sun; the upper, horizontal level of yellow Jurassic limestone standing out brightly above the grey, angled Carboniferous Limestone below.[78]

[78]*The horizontal beds of Jurassic limestone rest directly on the angled strata of the Carboniferous rock - over 190 million years separates their deposition; the Permian and Triassic periods are missing. This is known as an 'unconformity'. During the intervening periods the Mendips were above sea-level; so no deposition took place. At the start of the Jurassic, sea levels rose and wave activity planed the angled Carboniferous Limestone to a flat surface. During Jurassic times, sea levels rose further, covering the Carboniferous Mendips and the yellow Inferior Oolitic limestone was then laid down. This particular geological section was first described by William Conybeare and William Buckland, and later illustrated by Henry de la Beche in the first Geological Survey Memoir 1846. It's reckoned to be one of the best examples of Angular Unconformity in Britain. (Andy Farrant).*

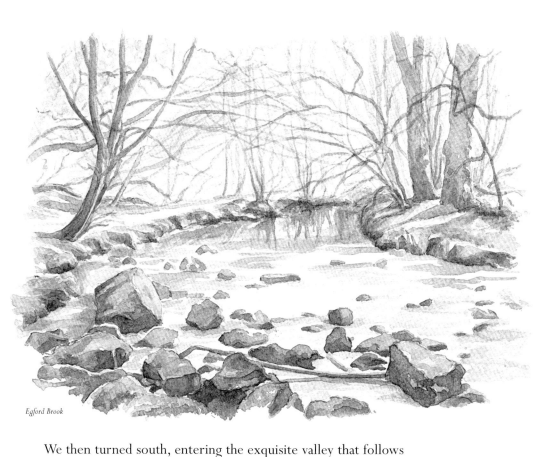

Egford Brook

We then turned south, entering the exquisite valley that follows
the course of the Egford Brook. We were alone, but this was
clearly popular territory; the sides of the stream were well
tramped. The brook stepped briskly through
ancient, coppiced woodland, while an open,
winter canopy allowed sunlight to fall on low
branches laden with fur coats of moss and
polypody ferns - fringes of the most vivid
greens. Back again at the confluence of the
Egford and Mells streams, we retraced our way
to Great Elm, but this time entered the south-
west valley: Fordbury Bottom, which carries
the railway that transports limestone out of
Whatley Quarry a mile or so away. While we
were there, a freight train hauling countless
wagons of Mendip stone, clanked by and disappeared
into a tunnel in the hillside.

Snowdrops

East Mendip is characterised by these tight, narrow valleys and fast flowing streams. The streams provided the power to drive a multitude of mills which started life grinding corn, but then turned to the production of paper and woollen cloth, iron-work and pumping water out of coal mines. During the 19th century, many of these functions were augmented or taken over by steam. Coal had been extracted in north-east Somerset from surface 'bell pits', probably since Roman times and as the superficial supplies ran out, the pits and shafts became ever deeper. An arc of defunct colleries between Mells and Vobster extending to Coleford and the Nettlebridge Valley represent the southern edge of the Somerset coalfield. The coal seams here are distorted with faults and folds making the coal very difficult to mine. Despite these difficulties, some coal mining continued until well into the 20th century: the Mells shaft until 1943 and New Rock, west of Stratton on the Fosse, as late as 1968. But despite all this industrial activity, there is little surface evidence that remains; for once the shafts were made safe or filled, the buildings were often demolished leaving only a grassy mound or indentation to mark their passing.

The Nettlebridge Valley lies some six miles west of Mells where the A367 makes a diving swerve above Stratton Moor. In mid-July, Rosie and I walked down into the deep ravine of Harridge Wood; there is evidence here of medieval coal mining although little to be seen (by us) today. The tree canopy was dense (ash, field-maple, hazel) and, despite there having been little rain for many weeks, a stream coursed along the valley bottom in good flow. It felt humid and moist. We were following the main drive to what was once Ashwick Grove (demolished 1955), the home of the remarkable John Billingsley.[79] At intervals along the stream were ironwork 'cages' and leats - possibly related to water driven pumps used to drain the mines or drive a variety of mills. At the bottom of the narrow valley, where the canopy thinned, sunlight picked out the red stone remains of a gamekeeper's cottage - now part restored to provide a habitat for bats - both the Greater and Lesser Horseshoe species.

[79]*John Billingsley (1747-1811) was born and died at Ashwick Grove. He was a man of enormous energy and entrepreneurial drive. He had his fingers in many pies, but so far as Mendip was concerned, he formulated a treatise on the enclosure of the Mendip plateau which generated the landscape we see today: the dry stone walling, straight roads and sheltered farmsteads. He confirmed the virtues of the double-furrow plough. He was involved in many Somerset canal projects - including the unrealised Dorset and Somerset. And he was an owner of the renowned Oakhill Brewery! (Robin Atthill).*

Pixie doorway

We emerged below a wooded ridge (Limekiln Wood) into a field of high grass busy with Meadow Brown butterflies. Beyond, we came to St. Dunstan's Well where an energetic stream poured out of the hillside only to disappear under a small arch beneath the pathway.[80]

The path now opened onto a wide wheat-field, by Stoke Bottom Farm and along Marsh Lane to Ham Bridge. Just beyond the bridge, a footpath stepped onto the towpath of the Dorset and Somerset Canal - designed to service the Nettlebridge coal fields but was never to be. Beech trees were flourishing here. Above us and around us lay meadowland owned by the Somerset Wildlife Trust, packed full of wild flowers - knapweed, spotted orchids, buttercups, bird's foot trefoil, white clover. One sunny field dived down to the wooded Mells Stream, its sun-full slope tussocked with ant hills - reminiscent of Collard Hill in the Poldens. Regaining the road, we reached the old canal bridge just north of Edford Wood, and descended the steps beside it following the footpath through the fields. One field traced the edge of Edford Wood, and in the hollowed base of a tall oak tree on the wood's margin some soul had fashioned a winsome, 'pixie' doorway complete with a brass doorknob and two sprites! It seemed to fit a magical sort of day perfectly!

[80] *Vigorous though it be, sadly, St. Dunstan's Well 'appears to have no surviving traditions or repute'. According to J.M. Harte: "It is regarded as uncanny." It's a 'rising': an underground river emerging from the Carboniferous Limestone rock. Close by is the lost village of Fernhill which once boasted log and paper mills, and Stoke House whose water gardens were fed by St. Dunstan's Well, all evocatively described in Robin Atthill's 'Old Mendip'.*

Fussell's Iron Works, Mells 1744 - 1895

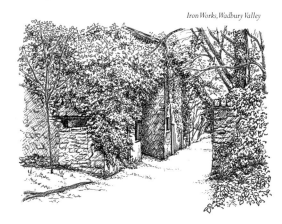

Iron Works, Wadbury Valley

The iron works in Mells' Wadbury Valley were established by James Fussell in 1744, possibly taking over a failed factory. The works produced 'edge tools' (axes, lawn scythes, shears, slashing hooks, hay-knives etc.) of very high quality. It's uncertain where the iron ore came from, but the Mells Stream provided the power for the grinding mills and hammers with Somerset coal fuelling the furnaces and hearths. Steam power was introduced in the 1860s. At its height, the Wadbury Valley was a clatter of smoke, steam and stench - an 18th century pamphlet describing it as "looking into the mouth of hell"!

The Fussell factories expanded out of the Wadbury Valley into Great Elm, Railford, Chantry and Nunney supplying tools throughout the known world. A visit in 1828 is described by Rev. John Skinner in his 'Journal of a Somerset Rector':

Tuesday July 15th, 1828. "I rose before seven, and walked with Richard Hoare to the Iron Works at Nunney to purchase a scythe for mowing the garden, as the best in the county, perhaps in the kingdom, are made by the Fussells… and have realised an immense property among the fraternity by their superior skill in hardening edged tools. We saw two men grinding scythes with their noses literally at the grindstone; if any of our West Indian slaves had been seen by our modern philanthropists in such a situation, the tocsin of anti-servial malediction would have resounded from John O'Groat's house to Land's End."

As well as employing highly skilled craftsmen, the reason for the tools' success may have been the addition of black manganese oxide in the smelting process giving Fussell's iron 'a peculiar virtue' - it anticipated modern manganese steel. Whatever, Fussell's Edge Tools were recognised as something special and, even today, old specimens are still treasured.

By the 1870s, a slump in agriculture weakened the market for high quality edge tools. Mass production began generating cheaper implements, quality giving way to price. Fussell's couldn't adapt and slipped into decline. Later generations of the Fussell family became detached from the business which eventually closed in 1895.

(Sources: Robin Atthill, Ken Griffiths & Roy Gallup).

Doves at Moore's Farm

Some months later, we took the road to Holcombe, just north of Nettlecombe, across a beautiful tree filled valley and through Harridge Wood, climbing Holcombe's long, house-lined hill to the top and on to Moore's Farm, where we left the car in a wide open area below the farmhouse. Some miles distant, above the westerly, wooded horizon, rose the tall tower of Downside Abbey. We were looking for Holcombe's Old Church of St. Andrew. It wasn't difficult to see but it was some way off, singular, nestling in a hollow, amongst a cluster of autumn touched trees at the bottom of a curving approach.[81] The small church was enclosed by a lichen encrusted wall of grey limestone, two pollarded lime trees guarding the church path. The south porch, made up from a repositioned Norman doorway, incorporated an inscribed, upside-down capital (Gaelic) which no-one has worked out yet. A notice asked us to go to Holcombe Post Office for the key - which we did, and let ourselves into a delicious, unrestored past of limewash, a west gallery, candles and box pews. To the north of the tower lies the grave of John and Hannah Scott, parents of the Antarctic explorer Captain Robert Scott, himself remembered with the words: 'who in returning from the South Pole with his Companions was translated by a Glorious Death'.[82]

Returning the key to the Post Office, we descended bosky Common Lane the two miles into Coleford. This seemed to me like a true mining village, strongly reminiscent of some of the places in the Welsh valleys where I had once worked. Houses, cottages and chapels stacked on top of one another with tight, twisted streets.

[81] *It's something of a mystery why the old church is so far from the present village - it has been called the 'Plague Church'. Local legend has it the Black Death decimated the original community - which then decamped the mile or so to its present position. It's more likely the reason was economic - proximity to the main road and the availability of work. (Robin Atthill).*

[82] *John Scott was the last manager of Holcombe Brewery and lived in the village's Georgian manor house.*

We left the car beside the church and walked down Church Street, past the imposing three storey Wesleyan Chapel, its Gothic Sunday School and beautifully tended cottages pressed against the road - one with a tiny Austin A35 car squeezed into the front garden. The Mells Stream flows through the bottom of the village - the site of the original ford and an important crossing point for all the Nettlebridge mineries.[83] Behind some houses, just off Springer's Hill, we found the ivy and tree-festooned brick arched aqueduct (locally the 'hucky-duck') - built in 1801, another remnant of the doomed Dorset and Somerset Canal. Despite the general mood of neglect, the two high brick arches looked as though they could last a further two hundred years.

[83] *There's a most evocative scene in Chris Chapman's video 'Secrets of The Mendip Hills' (1998) when he talks to a group of former Coleford miners. Fred, a gently spoken man in his late 80s, describes working in the mine when only a boy. He still had the waist lariat he wore to haul the coal. Deep in Norton Hill Colliery, a rock fall injured his back and nearly severed his right hand at the wrist. "I went back down again after it was well."*

The majority of the Somerset collieries were centred around and north of Radstock - just outside the Mendip area. Deep in its valley, surrounded by spoil heaps (now tastefully landscaped), Radstock holds on to the character of a mining town. I spent two weeks here in the mid-1960s with a local GP (a medical

Austin A35 - Coleford

student attachment) and I recall there were many miners suffering from the effects of coal dust - the condition known as pneumoconiosis - and I remember being impressed by the town's strong sense of community. The mines were being closed down one by one - the Somerset coal seams had always been difficult to work and had now become uneconomic. When the Portishead Electrical Power Station (itself dismantled in 1992) switched from coal to oil in 1972, the last Somerset mine at Lower Writhlington (south of Radstock) had nowhere to go and closed a year later. In recent years, the old Market Hall in Radstock has been converted into a brilliant mining museum with the most vivid exhibitions describing a vanished way of life.

Between Frome and Shepton Mallet, north of the A361, are a number of huge quarries (Whatley, Westdown, Asham, Merehead) all extracting Carboniferous Limestone in mind boggling quantities. The extent to which these operations have been permitted has given rise to the justifiable suspicion that east Mendip is something of a sacrificial lamb. Quarries are also munching into west Mendip, but on nothing like the same scale. The quarries are mostly concealed behind carefully planted banks of woodland and little can be seen from the road. Between Whatley and Merehead Quarries is a precious area of ancient woodland: Asham Wood; already much diminished, it remains in deadly danger.

NUNNEY, BATCOMBE, CHESTERBLADE, EVERCREECH

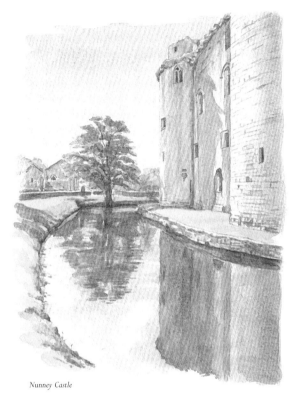

Nunney Castle

On the south-east fringe of Mendip, about three miles due south of Mells we found Nunney - on a sunny September day! The village was almost too pretty for its own good; soft yellow stone, a gentle bend and curve of the main road, cottage gardens with roses of every colour bursting out everywhere and an energetic stream, the Nunney Brook, pushing beneath a bridge. In the air around us, swallows and martins swooped and skittered. And behind all this, the backdrop of a fairy-tale castle complete with moat. But somehow, it didn't seem quite right: almost a caricature of a castle.

Apparently, it was modelled on the chateaux of the Loire; more a manor house than a fortress and Robin Bush describes it as being 'ludicrously indefensible'.[84] The Fussells had one of their ironworks here producing their famous 'edge' tools - a visit in 1828 is described by Rev. John Skinner in his 'Journal of a Somerset Rector' (Special Page: Fussell's Iron Works). Indeed, there appears to have been a local tradition of working with iron, recognised well beyond the county borders, because in nearby Trudoxhill, in 1583, something dreadful happened. Bush recounts that: "The armour-making smiths were all murdered in a single night by their rivals from the Forest of Dean."

[84]*The castle dates from around 1373, built by John de la Mare, inexplicably, on an indefensible site! Ownership passed to the Prater family in 1577 and, subsequently, Col. Richard Prater, a prominent Royalist, found himself on the losing side defending the indefensible. In 1645, the castle was attacked by Parliamentary forces with three cannons. A great hole was blasted in the north wall, Prater surrendered and the castle was 'slighted': i.e. destruction of roof, floors and inside walls. Other than some further collapse of the north wall, it's much as the Roundheads left it.*

*Closed for business
in Batcombe*

South-west of Frome, the Mendip escarpment bends and folds, with tree-lined valleys and fast flowing streams. During late Triassic and early Jurassic times (200 million years ago), this area was stretched by tectonic forces resulting in deep rock fissures that later became filled with sediment. In a quarry in the village of Holwell, just west of Nunney, this sediment has revealed the remains of one the earliest mammals.[85] Ten miles south-west of Frome, we took a minor road off the A359 to Batcombe; a village perched on the side of its steep-sided valley through which the small River Alham flows. The road cut along the hillside, passing a terrace of creamy stone houses, interrupted by a bold, faded blue Edwardian shop front with a tiled riser declaring: 'A. GIBBONS'. A butcher, a baker, a grocer? - there was no-one to ask, and there was nothing for sale. Then came a becoming collection of stone buildings, fitted into the elbow of the street, which rose through woodland to emerge below the supremely positioned Church of St. Mary and its beautiful, Perpendicular tower. The church stands on a low bluff above the road, looking out over an open, wooded valley, cross-folded with fields and orchards.

[85] *The teeth of the vole-like Haramiya. - first described by Charles Moore following a visit by the British Association in 1864. Moore sieved through three tons of sediment to reveal 27 Haramiya teeth - along with 45,000 fish teeth! (Andy Farrant).*

A couple of miles north-west of Batcombe lies another village snug in the fold of its hills. I had read a lyrical description of Chesterblade in Arthur Mee's 'Somerset': "We left the haymakers just over the churchyard wall and came into this lovely place..." and indeed it still is a lovely place. Rosie and I came here on a warm, sunny day in late September, relieved to find the hay meadow still lay just over the churchyard wall. Leaving the car opposite the wide gateway to 'The Manor', we walked back to the small church of St. Mary, half-hidden behind a stand of yews and set above the steep lane to Stoney Stratton. The church had a simple charm, with stone remnants of Norman carving scattered about the outside walls and an anguished Mary above the doorway (Pevsner thought her 'rustic').[86] The south porch, almost as big as the church itself, allowed us into a brightly lit chancel - we had caught the late morning sun and it poured in, illuminating a collection of beautifully embroidered, blue kneelers lying between the pews on either side of the knave.

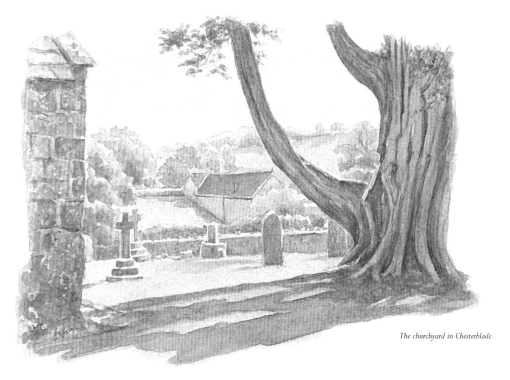

The churchyard in Chesterblade

[86] *St. Mary's is more correctly described as a 'chapel-of-ease' - more accessible to the community than its parish church down in Evercreech. The statue of St. Mary is not at all 'rustic'; it is the work of James Gane of Doulting who also carved the pulpit in 1888. She was inserted into her elegant niche some time after 1897. (John R. Guy, 'The Chapel in the Tithing' 1992) . The kneelers were the inspiration of Tessa Calver and dedicated in 1993 by Rt. Rev. Jim Thompson, Bishop of Bath and Wells.*

Then it was down the steep hill to Chesterblade Bottom - a carved out combe overlooked from the east by the hill-fort on Small Down Knoll.[87] At the Bottom, we took the footpath through Mill House Farm - the waters from three valleys meet here - past the new and old farm buildings, across fields and following the stream. The brook, along much of its course, was protected by low concrete embankments with a convenient, accompanying path. It seemed much like a mill leat - and walnut trees had been planted in the streamside hedges. Crossing a shallow ford, we came out into the hamlet of Stoney Stratton, and the classical elegance of Rock Farm House with high walls of Blue Lias stone.

Walking in the Evercreech direction, we passed The Neill Orchard - a wonderful, mature orchard of proper sized apple trees (and generously laden) left to the village by the family of David Neill in his memory. We then crossed Stratton's High Street, with the tower of Evercreech Church in our sights across the meadows. Evercreech suffers the Bruton/Shepton Mallet road running

Evercreech angel

through its heart - while we were there, a fair number of quarry lorries rolled by. Like Stoney Stratton, the old village is built largely of Blue Lias which gives the buildings an airy lightness - large ammonites bedecking their walls.[88] Some of that has been disturbed by modern infilling; although recent terrace houses are much more sympathetic. The tower of St. Peter's Church is rated as one of Somerset's finest and rises 110 ft (33.5m) above the village.

[87] *Small Down Camp, described as a Bronze Age hill-fort (1000-400 BC). Six acre oval, double banked with three to the east - up to 20 ft (6m) high containing a row of eleven 'cremation barrows' which is unusual. Excavated in 1908 by Rev. Dyne and H. St. George Gray who discovered 'funerary relics of the period'. (N. Pevsner and Jim Doble.).*

[88] *Ammonites of the Jurassic Blue Lias Formation - about 200 million years ago.*

We sat and had lunch on the steps of the village cross just over the road from St. Peter's. From this vantage point, the church tower rose before us: a graceful composition in buff stone - but with an oddly faced clock (see footnote). Inside, there were balconied arcades on either side of the nave; the atmosphere was bright and spacious; all compounded by the startling effect of its painted roof - blue, white, red and gold - and angels to boot! A short distance from the church, we meandered down the Drang (Old English for a 'narrow passageway') passing a rather abandoned Millennium Garden. The lane connected with the High Street on whose west side stood the beautiful, stepped bays of Evercreech House.[89]

We made our return from the village down Queen's Road, past a large dairy complex into Shapway Lane and thence to Stoney Stratton. Retracing the stream uphill to Chesterblade, we arrived back at St. Mary's quiet churchyard finishing our Thermos of coffee on a bench dedicated to 'Ali'.

[89]*Built around 1777 by William Rodbard - his children added the bays.*
A later owner, John Sherston, provided the church with its clock -
which came with two 12 o'clocks (XII) but no 10 o'clock (X).
Apparently, John was instructed by his wife to always be home from the Bell Inn
by 10 o'clock - so he had the hour deleted so he would never be late!
However, some accounts say the clock was in his memory -
so maybe he was anticipating similar difficulties in the hereafter!!

The Market Cross, Shepton Mallet

Fortunately for Evercreech, the A371 avoids the village in its low-lying vale as it climbs the south Mendip slopes towards Shepton Mallet, passing the Royal Bath and West Showgrounds on its way. Shepton Mallet, one of the truly ancient towns of Mendip, hasn't been served kindly by the 20th century; its town centre reduced to a cipher by early 1970's development. A wonderful Market Cross has been left standing forlornly in a modern, pedestrianised piazza; brutally severed from its parish church by the opaque mass of the 'Academy Theatre', ironically an arts and community centre.[90] More recently, the arrival of Tesco and other retail sheds at the south end of the High Street has siphoned a vast amount of trade from the old shopping area - a killer blow?

A passageway through the theatre complex led us to the hemmed in tower of St. Peter and St. Paul's Church. Inside, the wonder of this fine building is its 15th century roof - rated by Pevsner as "the most glorious of all the wagon-roofs of England". In dark oak, it is a display of extraordinary craftsmanship: a sequence of 350 beautifully carved panels. We left with cricked necks! Back in the High Street, it was sad to see so many closed shops, although businesses like 'Fred's', a gardening and general provisions store with a great tumble of goods on the pavement, seemed to be surviving.[91]

[90] *Funding for construction of the theatre (formerly called the 'Amulet Theatre') came from the local Showerings family (of 'Babycham' fame) and there is no doubt they meant well. Amazingly, the town trail still describes the theatre as a 'splendid modern building' - clearly it works effectively as a theatre and a music school, it's just a tragedy it's such an unsympathetic structure.*

[91] *In 2010, an intriguing but inconclusive BBC television series called 'Turn Back in Time' followed the fortunes of various fictitious businesses in Shepton's High Street from Victorian times to the present day.*

Cranmore Station

A few miles east of Shepton lies the small village of Doulting whose quarries supplied the golden stone of Wells Cathedral and Glastonbury Abbey.[92] A little further to the east stands the quiet village of Cranmore, with the East Somerset Railway Station on its southern edge - it must have been much noisier in the days the line had a regular service between Wells and Frome.[93] Nowadays, it runs excursions mostly between April and September. Cranmore's St. Bartholomew's Church is hidden in a small close off the main road - we walked through a small gateway and down the church path. The churchyard felt intimate and enclosed; a thatched, limewashed cottage incorporated into the south perimeter wall and a churchyard cross completing the scene. Inside, the feeling of intimacy was maintained - bright and beautifully cared for.

[92]*Still being quarried just north of Doulting. The stone is a soft, pale, easily worked, shelly limestone of the Middle Jurassic Period (170 million years ago). These days it's a creamy-brown colour - the strata now being worked are different from centuries ago.*

[93]*The East Somerset Railway originally opened in 1855 and was absorbed into the Great Western Railway in 1874. Passenger trains continued until 1963 and freight to 1985. Meanwhile, artist David Shepherd, with two steam locomotives and nowhere to go, bought the Cranmore site in 1971, opening the new East Somerset Railway in 1973. The organisation is now a registered charity run largely by volunteers.*

To the north of Shepton Mallet, the A37 climbs 478ft (175m) to the top of the Mendip ridge at Beacon Hill, to bisect the Old Frome Roman Road running east to west. Turning east at the intersection, a few hundred yards brought us to the summit of Beacon Hill (973ft/295m) at Beacon Hill Wood.[94] It was a bitterly cold mid-December and even though there were few leaves on the trees, the wood felt dark and confined with the dull winter light.

Standing Stone, Beacon Hill Wood

Old quarrying has left a convoluted surface to the wood - now complicated by drifts of beech leaves marking out false paths between the trees - and the frozen ground often giving way underfoot to a soggy understorey. At the centre of the wood, amongst a gathering of tumuli, we came to a large mound ('the Beacon') surmounted by a substantial Standing Stone of Old Red Sandstone of uncertain age but reckoned to have been 'old' in the 18th century. Along the southern margin, the land fell sharply away and into a misty distance - not even Pennard Hill or Glastonbury Tor could be seen.

[94] *The wood (area 17.28 ha) was bought by the Woodland Trust from the Forestry Commission in 1993; many conifers have been removed and the tree canopy opened. There is a substantial Old Red Sandstone outcrop here (and Silurian volcanics along the ridge) - which explains the quarrying, possibly for hand mills and Roman roadstone. The Roman Fosse Way once passed through the site - long since lost. The tumuli are Bronze Age burial sites. The Beacon Hill Society helps maintain the wood.*

A while later, we took the westward direction at the Beacon Hill junction and after a few miles the road dipped below the ridge where the hill-fort Maesbury Castle (it never was a castle!) stands.[95] It meant taking the steep footpath up to the hill-fort where we arrived at a defensive ditch below a 12ft (3.6m) high grass bank - the churned up mud of the track was frozen solid. A bit of clambering got us to the top of the rampart with the oval of the seven acre fort below us - now an enclosed area of pasture. We walked around the fortification embankment to where some big trees were growing out of the north bank. Here, the wall rose some 20ft (6m) above a ditch glassed over with sheet ice. On this cold December morning, the mist still cloaked Glastonbury and the Polden Hills, but for a few minutes, the cloud-cover eased and to the north-west sunlight illuminated the billowy ground below Priddy and the high transmitting station mast on Pen Hill. To the north, the tree-bordered pastureland of the Mendip Plateau fell gently away towards Emborough and Chewton Mendip.

View from Maesbury Castle - looking west

[95] *Maesbury Castle is an Iron Age hill-fort (circa 300 BC.) some 950ft (292m) high on the Mendip ridge. Probably not permanently occupied; it provided a defensive position to which people and animals could retreat at times of threat.*

Rosie and I have often driven through Oakhill on our way to East Mendip taking the road to Stoke St. Michael and Leigh upon Mendip. The main body of Oakhill village lies on the west side of the A367 from Shepton Mallet and the reason is pretty clear: from the mid-1700s the Oakhill Brewery, under various owners, dominated the area's economy until it finally closed in 2004.[96] Its handsome stone buildings, with 'Oakhill' still emblazoned across the main gable, remain a dominant presence on the village High Street with the brewery workers' cottages lined up along the road - it still feels like a working community.

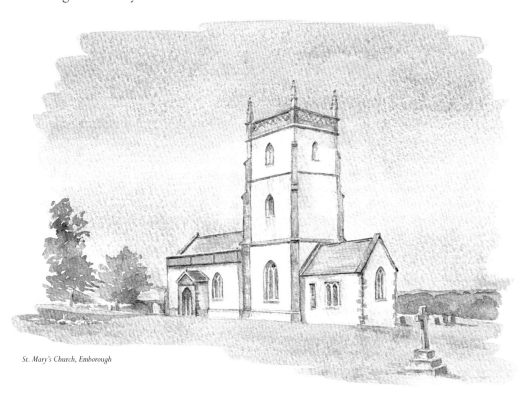

St. Mary's Church, Emborough

[96] *The brewery was founded in 1767 and for a while John Billingsley was a co-owner. Famous for its 'Oakhill Invalid Stout', at its height it was turning out 2,500 barrels a week. In 1904, this necessitated the brewery having its own narrow-gauge railway linking with the main line at Binegar. But after WWI, stout fell out of favour. In 1925, fire severely damaged „the brewery and it was taken over by Courage who continued brewing until 1938. After that it was used as a malting house. Brewing started up again in 1981 as the 'Beacon Brewery' with Fosseway Ales, including 'Fosseway Stout' as a tribute to the original 'Invalid' brew. Owner Gerry Watts died in 1983 and the business was closed until 1984 when Reg Keevil started brewing again - 31 different beers! The brewery finally closed when Reg retired in 2004. (A.W.Coysh & R.Bush).*

From Oakhill, travelling north to the Old Down crossroads, we turned west passing the solemn waters of Emborough Pool. There is little open water on Mendip - the pervious limestone sees to that. The Pool (or Pond) is said to have been a fishpond supplying the monks of Hinton Charterhouse - although it's rather distant for that. (R. Bush).[97] Anglers still come here and there's a legend no-one knows how deep it is… Emborough is a village of dispersed farms. We could see its whitewashed St. Mary's Church standing on raised ground above a right-angled bend, looking out over the wide, flat land of the northern plateau. The tower was picked out in sunlight, creamy white against a dark-cloud sky and inside it was sun-filled and well tended. Gravestones were stacked in line, leaning against the south churchyard wall with the old manor farmhouse next door - a friendly black labrador barked and accompanied us to the south porch.

[97] *Existed as a fishery before 1524 when it was known as Lachmere or Lechmere Pool - and still is on the OS map. Robin Atthill and Graham Chapman both recount the tale of when some lads from Emborough manor house broke open the head to the Pool and let the waters out. So the monks lost their fish supply for a while and applied to 'higher authorities' for the boys to be punished. Nobody seems to know if anything happened - and the actual origins of the pond are unknown.*

CHEWTON MENDIP, LITTON, EAST HARPTREE, WEST HARPTREE

Rather than continue west across the plateau, geography inclined us to the northern slopes of the hills. From Emborough, the road descends through Bathway, down a wood lined combe into Chewton Mendip. Just at the turn-off to Litton, we often stopped off at 'Lynda's Loaf' general stores, to be greeted by a warm aroma of baking and a beguiling array of wonderful bread. We usually left with a sourdough bloomer and a section of irresistible lardy cake! Lording over the village is the magnificent, Perpendicular tower of St. Mary Magdalene's Church. We caught it on a sunny day, entering the wide churchyard through a small Gothic gate, the cream-grey tower (Doulting stone - of course!) shining out between high beeches and yews. Inside the church, Rosie noticed that the north window of the chancel was a curious mixture of old and new glass - and the church guide recounted an extraordinary tale.[98]

From Chewton, the road to Litton follows the curving fall of the valley cut by the tiny River Chew. As we entered the village, we could see evidence of ancient terracing on the hillside - the higher, eastern slopes are rumpled with a sequence of folds and creases.[99]

[98]*Chewton's Rev'd Paul Bush (1931-48) was sold fragments of glass by a pedlar and was told they were found in a ditch near Glastonbury. The vicar had them made into a window for his vicarage summerhouse. When the vicarage was sold in 1956, and the summerhouse long gone, the new owners kept finding pieces of glass in their garden. Washed and cleaned, some of the glass proved to be 13th and 14th century though most was 19th. In the 1960s, Jasper Kettlewell was able to incorporate the pieces in a new design. "The haloed head of the Virgin weeping (known as a Pieta) is of 13th century glass, thought to be from the pedlar's glass."(Helen Curwen)*

[99]*Frances Neale ('Mendip - A New Study') describes these as 'flights of terrace-like lynchets formed between ploughed strips'; the remains of a medieval farming technique at a time when land was scarce.*

We turned into the village, dipping down behind stone cottages and the 15th century King's Arms pub - here the road felt narrow and constricted and probably not much changed for a century or two. We found St Mary's Church standing at the back of the village, a wide churchyard raised a few feet above the road, a retired rectory marking its southern boundary. After the grandeur of Chewton Mendip, Litton's church is a much smaller affair, built of the local White Lias stone with an uncomplicated 15th century tower. But what it does have is that reassuring quietude of an English parish church. And a brilliant guide and history by Christopher Booker (2005), in which he laments the loss of the family-run dairy farms and cider orchards, the village school, shops and post office - but despite all that, he feels Litton has managed to hold on to, and even strengthen, a strong sense of community.[100]

Litton Lower Reservoir

We walked through the churchyard, beneath a spreading purple beech and a walnut tree, to the gate at its west end which opens out onto Back Lane. From there, we turned north to the Litton Reservoirs and to the footpath that skirts their northern margin.

[100]*Christopher Booker tells the story of Jim Young and his wife who, when they came to farm in nearby Greendown in the 1920s, walked two miles across fields to attend their first Sunday service in Litton. When they got there, they discovered they were the only members of the congregation.*

The construction of the reservoirs in the 1850s came as something of a shock to Litton, and involved the damming of the River Chew so its waters could be syphoned off to Bristol.[101] We found the two 'lakes' enclosed by trees; the larger, sixteen acre, 'Upper Reservoir' set above and separated from its eight acre 'Lower' sibling by

a high grass-banked dam. The first acre or so of the lower lake was protected by bird nets, and the occassional bright flick of silver confirmed it was well stocked with fish - it was a breeding station, presumably to stock itself and the bigger lakes to the north at Chew Valley and Blagdon. We stopped at a small wooden fishing lodge (complete with boat) and from its deck watched a lone great crested grebe looking for lunch. Crossing over the lower dam, we headed across the fields to Sherborne and then along tree-bordered Whitehouse Lane to Litton.

Squeeze stile, East Harptree churchyard

From Litton, the B3114 slants north-west, between open fields, following a gentle fall to East Harptree set on a low bluff. The colour of the stone buildings had changed dramatically. Within a few miles, houses and walls had altered from the sober creamy grey of the White Lias to a vivid, rusty red; this was the beautiful Dolomitic Conglomerate stone. (See Special Page on Mendip Geology). East Harptree was familiar territory; our family used to picnic in nearby Harptree Combe.

[101] *The reservoirs were created in the 1850s by 'an army of Irish navvies' to drive watermills at Sherborne and Coley, and thence to supply water to Barrow reservoir, near Bristol, via the 'Line of Works'; a ten mile conduit of tunnels, pipes and aqueducts transporting four million gallons of water a day from the Mendips.*

So we followed our old footpath trail beside the church, through two stone 'squeeze' stiles, then north-west, down across the fields to where a splendid oak tree still resides above a wide grassy bank - our picnic spot. Close by was the combe mouth where a shallow stream, the Molly Brook, ran almost unseen beneath a

foam of willd angelica. Ascending the combe, it wasn't long before we arrived below the impressive intrusion of the Harptree Aqueduct, cutting across the valley on the diagonal, on high stone piers.[102]

A little further and the combe divided; taking the left branch, we came to the remains of one of Mendip's two castles - the other, we had seen standing rather more impressively, at Nunney. What we were looking at here was Richmont Castle, which had clearly once occupied a very defensible position on a high escarpment above the combe.[103] All we could make out now was vague evidence of terracing and broken masonry. Returning to the divide, the right path traced the Molly Brook and the combe deepened and darkened. Water seemed to be spurting out all over the place with small, tumbling cascades, rivulets, stepping-stones and areas of great sog! Fallen trees across our path, hart's tongue ferns and ramsons. The combe eventually opened out below Smitham Hill at Western Lane, and we took the field footpath back to East Harptree.

[102]*Built in 1851 - engineer John Simpson. It continues to function as originally built, supplying Chewton Mendip water to Bristol. It consists of a wide, wrought-iron tube resting on rocker bearings and carried by five limestone piers - the central pier is cruciform. It is listed as Class II by English Heritage. The aqueduct is probably the oldest surviving example of its engineering type.*

[103]*Richmont Castle: a Norman structure held by Sir William de Harptree in 1138. It was considered impregnable until attacked by King Stephen who inveigled the defenders out by trickery. The castle eventually came into the ownership of Sir John Newton who pulled it down for some reason or other!*

East Harptree's St Laurence's Church stands, raised a little, on the western edge of the village with open fields to the west although, sadly, its northern prospect towards Chew Valley Lake has been filled with new buildings. In the church's south porch lies the effigy of Sir John Newton (who levelled Richmont Castle), elevated on his tomb-chest above the figures of his twenty praying children (twelve girls and eight boys). But where's his wife? - who was clearly kept very busy! Presumably, when the tomb was shifted to the porch, she no longer fitted in!

Tilley Manor, West Harptree

Less than two miles to the north-west lies West Harptree; a busy meeting place of five roads which, despite that, retains an amiable sense of space and calm. The intersection is wide and generous with a pub and a general stores, and St Mary's Church surrounded by yew trees.

Approached from the west, the village appears self-contained; its small, copper-steepled church and red stone houses resting in the crook of the hill. On that same west road, facing one another, are two remarkable manor houses: Gournay Court, hidden behind high trees and, on the north side, delightful, rusty-red Tilley Manor House displayed for all to see with wisteria in the spring and a pathway of lavender in high summer.[104]

[104]*Long after the Norman de Gournays had gone, the present, three storey, four-gabled Gournay Court was built by Francis Buckland and his son John in the early 1600s. It is 'typically late Elizabethan with an attic gallery as at Montacute'. (R.D.Reid) Much smaller Tilley Manor House was built around 1659 by Peter Roynon but altered considerably by a succession of Earl family members in the 18th century. Most buildings in West Harptree are constructed from the Dolomitic Conglomerate - even a new terrace of houses on the Bath Road. (West Harptree - History of the Church and Village).*

COMPTON MARTIN, UBLEY, BLAGDON, RICKFORD

The Coombe, Compton Martin

Continuing westwards along the A368, there is a string of villages (Compton Martin, Ubley and Blagdon) occupying the lower Mendip slopes which once looked across wide valleys now filled by the waters of Blagdon and Chew Valley Lakes. Although lamenting the loss of those valleys, it's indisputable that the lakes are eye catchingly beautiful - fitting into the landscape just so. (Special Page: The Mendip Lakes). Most of Compton Martin sits below the side of the hill, with its Church of St. Michael and the old school house looking out from on high, above the main road. After the church, the first thing you notice is the village duck-pond (usually complete with ducks) which receives water from a spring beside the church, and goes on to help fill Blagdon Lake and the River Yeo. Once again the rich, red colours of the Dolomitic Conglomerate predominate here, most of which must have come from the Cliff Quarries up on the hillside, at the top of a lane called The Coombe. The quarry workers' cottages are still there.

St. Michael's is one of only a few Somerset churches to have retained many of its Norman characteristics. It has an uncomplicated, Perpendicular tower, but inside you are back in the 12th century with powerful pillars (one of which lurches disconcertingly)

supporting low arches. All the pillars are plain except for one; which is superbly fashioned in a barley sugar twist.[105]

We came in high summer to Ubley, set down close to Blagdon Lake, built of rubious stone, quiet, warm and contented.[106] The village is blessed by the high road passing it by and, at its centre, the church stands on a grassy plateau above the village cross surrounded by good-looking houses and garden walls capped with 'washed' limestone.[107] St. Bartholomew's Church was steepled and cosy - an atmosphere helped by a friendly, uneven assortment of wooden chairs instead of pews.[108] The back of the church opened out onto a summer meadow - the Glebe Field - where wild flowers and hedgerows are managed and encouraged. The hay, newly mown and sweet smelling, awaited the bailer twine, overlooked by the easy Mendip rise and the trees of Ubley Wood.

We left the village by way of Snatch Lane, taking the footpath across pastureland towards the lake. With the bosomed rise of Breach Hill before us, a tall, redbrick chimney could be seen at the foot of the hill close to the lake. When we got closer, we could see its lower section was built of stone; it looked much like the Smitham Chimney on Smitham Hill above East Harptree.[109] Close by lay Ubley Hatchery, where, refreshed by the River Yeo, Bristol Water raises brown and rainbow trout to stock its reservoir lakes. Sadly, there is no public access onto the shoreline of Blagdon Lake from here - we had to suffer it glittering tantalisingly just beyond the boundary trees and hedges.

[105] The fluted spiral carving is of the highest class by a master mason - although legend describes it as an 'apprentice's column' - where contracts were signed. Another possibility is it's a survivor from an earlier chantry. For years, the carving was plastered over! - and only revealed in 1851. Similar pillar carving is found at Durham Cathedral.

[106] The Bristol Waterworks Company obtained parliamentary approval for the construction of Blagdon Reservoir in 1891, and the construction of a dam across the River Yeo took eight years. The lake took several years to fill its 440 acres. It was first fished in 1902.

[107] 'Washed' limestone is from the sides of caves and tunnels broken into by quarrying. The stone has acquired smooth shaping and hollowing through its solubility and the flow of water. Often used in the Mendip area as decorative capping to garden walls.

[108] Removing the pews and replacing them with chairs was part of a Victorian (1874) restoration - unusual for its time.

[109] The Ubley Chimney clearly predates the lake, even so it seems unlikely it had anything to do with lead smelting - as per the Smitham structure. Apparently there was once a mill here, so it could well have vented a supplementary steam engine.

Cricket at Blagdon

From Ubley, the A368 rises briskly above the lake, fields shelving to its margins below Lag and Holt Farms - now home to the formidably successful Yeo Valley Organic: makers of excellent Somerset yogurt.[110] Further westward, the road reaches Blagdon village, wonderfully placed above its namesake water with its church of St. Andrew positioned on a bluff.[111]

[110]*Roger and Mary Mead bought Holt Farm in 1961 - Roger's family having been farmers since the 15th century.*
They began making yogurt as 'Yeo Valley' in the 1970s moving to purely organic production in 1993.

[111]*St. Andrew's Church, as churches go, is almost brand new. The medieval church was demolished*
and rebuilt in the early 19th century - but very badly! So, preserving the 15th century tower,
the tobacco family Wills had the abberation knocked down and re-rebuilt in 1909.

As you pass by, the lofty church tower attracts the eye with its scenic station on the hillside, while in summer it surveys the local cricket ground. Many times, driving by, we have caught glimpses of a game; "And someone running up to bowl…" So in early August, we decided to spend an hour or two watching a match - it happened to be between Blagdon Seconds and the YMCA. Not sure who won and the standard of cricket was a bit wobbly on a slanting pitch. But who cares! - the setting was supreme! Sunlight catching the church tower against a sky of dark clouds and a scatter of contented spectators in deck chairs on the boundary edge, the ball accelerating away down the slope with a fielder in forlorn pursuit. We left the scene of battle and walked down to the church where the bells were in full peal celebrating a wedding.

A few days earlier, Rosie and I had parked our car just below the Blagdon village stores - this is the part of the village known as West End - and walked down to Walnut Tree House where a society actress Colette O'Neil took rooms in the 1920s.[112] Then it was on down to the lake by Dark Lane; an ancient hollow-way which opened out to glorious views across the water to Butcombe. Access to the lake shore requires permission, so we walked westward beside the perimeter wall - a few fishermen were out in their boats making a slow drift across the water. Eventually we reached Bristol Water's magnificent pumping station, sharply defined in glowing red-brick and Bath-stone detailing.

Blagdon's West End is separated from its East End (where St. Andrew's stands) by a lovely open combe reaching down to the lake and crossed by a winding church path tracing the rise and fall of the land. Along the path we passed Tim's Well, still flowing but no longer fit for drinking. The upper section of the combe is now known as Eldred's Orchard - the land was given to the village on the understanding that the corrugated iron shed at the bottom of the field was preserved - it was where the anonymous benefactor had done his courting! It was good to find it still standing, rather rustily, amongst the village bee hives and apple trees.

[112]In 'A History of Blagdon Vol. 4.', Tony Staveacre gives a delicious account of Colette (real name Lady Constance Malleson) arriving in Blagdon in 1925 on the recommendation of her ear, nose and throat surgeon! She was in the midst of a 20 year affair with Bertrand Russell who had seduced her, she claimed, in the first year of her marriage. She took rooms at Walnut Tree Cottage complete with a 'magnificent trench bath'. Until 1936, for a beautiful, aristocratic lady, Blagdon was a refuge from a host of lovers and a chaotic love-life.

West of Blagdon, the main road runs down through an enchanting, serpentine valley called Blagdon Combe. Confined by high trees and slanting sunlight, it opens out at the small village of Rickford and its landscaped mill pond and waterfall.

Painting Blagdon

The pond is fed by a vigorous spring, the Rickford Rising, that breaks from rocks on the road's south side. In early summer, a small island in the pond is incandescent with rhododendron flowers watched over by Rickford Hall, a former chapel built in a surprising, wood-framed, Victorian Arts & Crafts style. This architectural surprise repeats itself in the form of the Gauge House standing close to where the mill stream flows into the village.[113] Between the two wood-framed buildings stands the 17th century, red-stone Mill House fronted by generous lawns. This was where the mill owners once lived; when we passed by it appeared empty and neglected - a few redundant croquet hoops on the lawn. The mills are long gone although the site, close to the Plume of Feathers pub, remains. The stream flows on, along the main street, past the pub, to emerge at the Rickford Ford beside elegant Brook House. The brook disappears beneath a low, twin-arched, stone bridge (which carries the pathway above the ford) to wind on towards the hamlet of Bourne.

[113]*Rickford Hall was built by W.H. Wills in 1888 as a Baptist chapel, ornamenting the mill pond at the same time. In the 1960s it was taken over as a Freemasons Lodge. In 1888, the Bristol Waterworks Company was able to take water from the Rickford spring (the Rickford Rising) to supply Bristol, and their Gauge House was built in 1895 to control the flow of water returned to the Rickford Brook.*

Between the 1600s and 1880, grist (wheat, barley etc.), fulling and tucking (wool), and paper mills all worked at Rickford at various times. Paper was in production up to 1870 when it returned to grist and finally flour milling. By 1884, the flour mill was no longer in production. (Rickford. A History of a North Somerset Village).

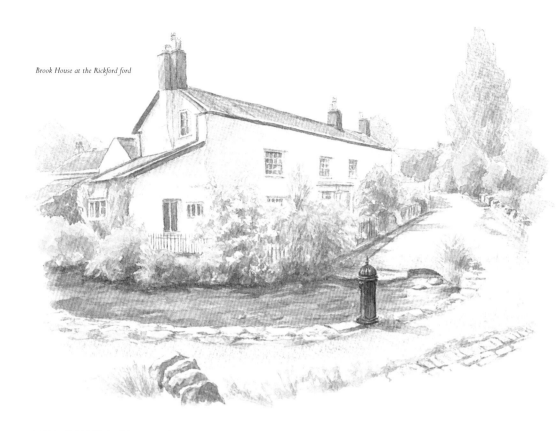

Brook House at the Rickford ford

The Mendip Lakes

Man made they may be, but the Blagdon and Chew Valley Lake/Reservoirs make a huge
contribution to Somerset's northern landscape. Along the hillside between Blagdon and
Bishop Sutton, the reservoirs fit perfectly into the cradle of their surrounding hills adding a
reflective vitality to the scene.

However, an enormous area of the Yeo Valley's quality agricultural land was sacrificed -
along with its farms, small holdings and a lot of heartache. With Chew Valley Lake,
the small village of Moreton disappeared beneath the waters as well as the
remains of a Roman villa. These days, Moreton makes a partial, spectral reappearance
from the waters in times of drought.

The Bristol Waterworks Company obtained parliamentary approval to build a dam across the River
Yeo in 1891. It took eight years for its construction, with the dam extending up to 175ft (53m)
below ground level to reach bed-rock. The splendid red-brick High Victorian pumping station
originally housed three beam engines driving a 20ft (6m) fly-wheel and powered by a combination

of six boilers - coal was brought in on a branch line from Yatton. Overseeing all of this was an imposing, Italianate, chimney tower, 130ft (39m) high - sadly, it lost its colonnaded top in 1956. Electric pumps had taken over in 1949.

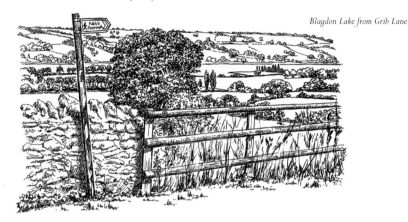

Blagdon Lake from Grib Lane

Parliamentary approval for Chew Valley reservoir was gained in 1939 but work did not begin until 1949. The reservoir was operational in 1956 when it was opened by Queen Elizabeth, but not completely filled until 1958. It covers an area of 1,200 acres. Blagdon Lake has a surface area of 440 acres.

Blagdon Lake was first fished in 1902 when, to everyone's surprise, Brown trout were discovered. And big ones too - up to 4lbs (1.8kg) in weight. In the winter of 1910, an extraordinary, female Brown trout weighed in at 16lbs 4ozs (7.4kg) - she was returned to the lake at Ubley Hatchery, never to be seen again. Rainbow trout were then successfully introduced and it became clear that Blagdon Lake provided an especially supportive environment and it acquired an international reputation. Trout eggs are now exported throughout the world.
The two lakes also support a wide variety (260 species recorded) of birds.

In the 1920s, Dr Howard Alexander Bell, Blagdon and Wrington's GP, developed nymph lures for still-water trout fishing. He did this by carrying out thousands of trout post-mortems and analysing their feeding habits; this enabled him to imitate the insects a trout expected to see and eat. Amongst the lures he invented are: the Amber Nymph, the Grenadier and the Blagdon Buzzer! - all hugely successful and imitated world wide. Dr. Bell enjoyed his own company and that of fellow fishermen. After a short morning surgery, he always had Friday off for fishing at Blagdon - patients knew not to bother him on Fridays! He retired from medicine in 1963 and never embraced his angling celebrity.

Rounding the right-angled bend north-west of Rickford brought us to the mouth of Burrington Combe. The combe has changed quite a bit since I first explored here in the 1950s. At that time, the sides of the ravine were mostly open scree and cliffs with few trees - since then, trees have moved onto much of the lower slopes forming quite dense woodland. The decimation of the rabbit population by myxomatosis was probably the cause - goats have now been introduced to control the scrub. The village from which the combe takes its name sits demurely to the east, and by sidestepping the main road avoids its hurly-burly.[113] At first, the combe rises from north to south before making a right angled turn from west to east - in total, a distance of more than two and a half miles and a rise of 450ft (136m). At the mouth of the combe, on the west side, rises a stack of slanting

Feral Goats,
Burrington Combe

Carboniferous Limestone famously recognised as 'The Rock of Ages' where the Rev. A. Toplady sheltered from the storm and was inspired to write the celebrated hymn. Unfortunately, this may not be quite true. (See Special Page - 'The Rock of Ages Controversy'). A little further up the combe, on the east side, is a wide cave mouth known as Aveline's Hole which appears to be a better candidate for storm protection, but this cave wasn't exposed until some years after Toplady's death.[114]

[113]Burrington - 'the settlement by the burg, the Iron Age camp on high ground above the village'. (Robin Athill) Francis Knight speculates that since the parish was part of Wrington, the name may mean the Castle of Wrington.

[114]Up to its discovery in 1797, Aveline's Hole had probably been closed for 10,000 years. At the initial opening more than 70 skeletons were found and later investigations revealed a further 21. These were people from the Middle Stone Age; a time when sea levels had still not risen to detach Britain from the mainland. Early use may have been by hunters, but Aveline's Hole is now accepted as the earliest dated cemetery in Britain. Also found were: flint tools, deer teeth for necklaces, red ochre and, surprisingly, fossil ammonites! Many of the discoveries were lost during a bombing raid on Bristol in 1941. More recently, a sequence of etched crosses at the back of the cave has been interpreted as Mesolithic cave art. (Chris Stringer, Francis Knight, R.M. Jacobi).

A remaining fragment of Mendip Lodge

In late March, Rosie and I took Link Lane at the western entrance to Burrington Combe. We were hoping to find what remained of Mendip Lodge - a remarkable mansion built in the late 1700s, on the northern escarpment of Black Down, by Dr. Thomas Whalley.[115] The deep lane's hedgebanks were decked in violets and lesser celandine, and a small field set back against woodland was packed with primroses and lilac cuckoo flowers. The footpath turned west into Mendip Lodge Wood following what, in part, must have been one of the driveways of the old house. For a while, there were splendid views across the valley to Wrington, but gradually this was lost as the way became shrouded in dense laurel. When we arrived at the house, there was little left to see; just broken walls, and at the western end of the approach: a single Gothic doorway opening into a small chamber with a solitary arched window. When Sue Gearing passed this way in the late 1990s, the stone walls and window shapes were still to be seen. We learned later that the ruins had been demolished in 2010.

[115]*In the process of building Mendip Lodge, "the loveliest architectural luxury I ever saw", the Rev. Dr Thomas Whalley got through the substantial fortunes of two wives. The house was built in the Italian style with high arched windows and, what John Rutter (1829) described as, "a verandah, 84 feet long, affording, from its elevated situation, a very extensive and varied prospect". In the early part of the 20th century the house still "glimmered ghostly white against the enveloping trees". (V. Waite).*

We now took the track up through the Woodland Trust's Dolebury Warren Wood onto a wide, beautiful path that traced the edge of the north Dolebury escarpment; bordered by birch trees, bright silver-grey in the morning sunshine. Dolebury Warren now opened up as high grassland, and we made an easy ascent along the eastern approach, to the hill-fort that surmounts the headland of the Dolebury ridge.[116] It needed no imagination to understand why this position had been chosen for much of central Somerset lay about us; from the enclosing westward Mendip march of Wavering Down and Crooks Peak to the silvery line of the Severn Sea and the moorlands of the Northmarsh.

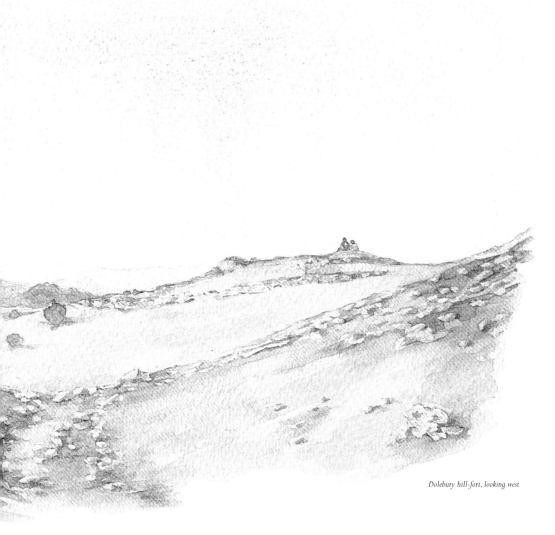

Dolebury hill-fort, looking west

Immediately south, the hillside fell steeply away forming a deep valley-trench that separated the Dolebury headland from the diminutive village of Rowberrow. We could see, perched on the side of the narrow valley, the tower of Rowberrow's small church pressed tight against its manor house.

[116]*Dolebury Hill-fort, like its sister fortifications Maesbury Castle and Worlebury, is an Iron Age structure, probably built over centuries (800-50 BC.) with gradually increasing complexity. To the north, east and west, the defences consisted of a huge stone wall and a deep ditch. To the south, the steep hillside meant that only an earthern rampart was required. The eastern approach was especially vulnerable so had an additional double rampart and defensive trenches. The hill-fort covers some 22 acres.*

We had been there the previous summer and remembered the wonderful, warm stone of the church's walls and the roses over the south porch. On that occasion, we had followed the valley below the church, through where the old mining village had once stood - there were many broken cottage walls.[117] Then, we had picked up the stream at Rowberrow Bottom (where my family often picnicked in the 1950s, and where Dad got his Austin 16 stuck in the stream trying to ford it!) and made the ascent through Forestry Commission conifers to Tyning's Farm on the edge of Black Down. We had then followed the open grassland to Dolebury, faint splashes of lilac-blue harebells along the way and the air sweet-scented by the canary-yellow flowers of lady's bedstraw.

Now, eight months later, it was the beginning of spring after a very cold winter and even the elders were only just starting into leaf. We retraced our summer path to south of the rise of Mendip Lodge Wood; where the fold in the hills has allowed the formation of a chain of swallets and pot-holes: Read's Cavern, Bos Swallet, Rod's Pot.[118] These are circular depressions in the landscape where the limestone has fissured and collapsed. We came on Read's Cavern by following its small stream to where it disappeared into a low cliff face. Continuing around the base of the hill, there were other depressions on either side of the path to Burrington Combe. We then found the small combe formed by the West Twin Brook with the entrance to Goatchurch Cavern and, not far below it, Sidcot Swallet. These were places I had explored long ago.[119]

[117]*According to Francis Knight, the last miner left Rowberrow in 1853 after some hundreds of years of lead and calamine mining. In the 1700s, the fumes from the extraction furnaces had killed most of the trees in the area!*

[118]*Mendip caving terms have entered the lexicon. For example: Swallet: a compression of swallow-hole; where a stream, present or absent, has created a passage in the limestone. Slocker: a water active swallet. Creeps: very narrow cave passages. Pot-hole: now a general term for underground caving (or holes in the road!) but originally used to describe limestone passages formed by stone and water erosion. (H.E.Balch)*

[119]*Goatchurch and Sidcot caves are both reckoned to be 'suitable for newcomers'. I explored them when I was 16, unsuitably attired - although I did borrow a carbide acetylene lamp. I had tried to make a papier-mache helmet but it went mouldy. I shall never forget wriggling down Goatchurch's 'Bloody Tight' and the release of entering the deep, dark Boulder Chamber - actually, everything was deep and dark. I remember the unnerving sound of flowing water (the stream) although I never descended that far. We once got utterly lost - I haven't forgotten that either.*

The 'Rock of Ages' Controversy

'Rock of Ages', Burrington Combe

The Reverend Augustus Toplady (1740 - 78) was curate at Blagdon's St. Andrew's Church between 1762 and 1764. The first complete version of his famous hymn, 'Rock of Ages', appeared in the Gospel Magazine in March 1776 - some 12 years after his curacy in Blagdon. Always in poor health - due to tuberculosis, Toplady died in London in August 1778. The hymn took its time to capture the public imagination but by the mid-1800s it was turning up in nearly every hymn book. By 1900, it was all over the place (particularly America) in postcards, tracts and prints.

The conviction that the song referred to the rocks in Burrington Combe appears to have emerged from local legend around 1850, when Blagdon's vicar Rev. John Swete described the link during a sermon. He, it seems, had been told the story by a number of his old parishioners. Nearly another fifty years was to go by before the tale appeared in print, when in 1898, Lord Winterstoke of Blagdon (W.H. Wills) wrote to The Times stating, quite categorically, that:

"Toplady was one day overtaken by a heavy thunderstorm in Burrington Combe on the edge of my property, a rocky glen running up into the heart of the Mendip range and there, taking shelter between two massive piers of our native limestone rock, he penned the hymn, Rock of Ages".

Continued over.

Continued from over.

This was soon dismissed with the observation that during the hundred years since Toplady's death no-one had pointed any of this out before! Despite that, the conviction took hold and guide books began quoting 'the fact' and it became 'almost heresy' to disagree. The legend then expanded with the introduction of a story that the first draft of the hymn was 'scribbled' on a six of diamonds playing card which had disappeared to America with the family!

In 1911, Toplady's biographer Thomas Wright made a number of observations: 1. Lines from earlier Toplady poems presaged those in 'Rock of Ages': 2. The phrase 'Rock of Ages' first occurs in a sermon preached in Blagdon on Easter Sunday, April 22nd 1764: 3. The sermon was unpublished and therefore unavailable to local people passing on the tradition. In 1938, the Rev. H. J. Wilkins poured some cold water by pointing out that, during a storm, it would have been impossible to write anything in the Burrington cleft! And he had proved this on two occasions while staying nearby in his caravan! Others have claimed that the cleft becomes a waterfall in bad weather. The problem is that in none of his writings does Toplady provide a stated link between his hymn and Burrington Combe. It comes down to what people want to believe.

And believe they did! In the 1920s and 30s, the Burrington Combe Service became very popular. The first, in 1921, attracted 10,000 worshippers and by 1931, the number had risen to 30,000 with the hymn being sung twice over! Services have continued intermittently to the present day. In 1951, Mr. Leaver of Weston-super-Mare arranged for the installation of a metal plaque on the Rock. It reads:

ROCK OF AGES
This rock derives its name
from the well known hymn written about 1762
by Rev. A. M. Toplady
Who was inspired whilst sheltering in this cleft during a storm

Well maybe!

(This summary is indebted to Martin and Renee Bolton's lucid article in
'A History of Blagdon. Volume 4').

CHARTERHOUSE, PRIDDY

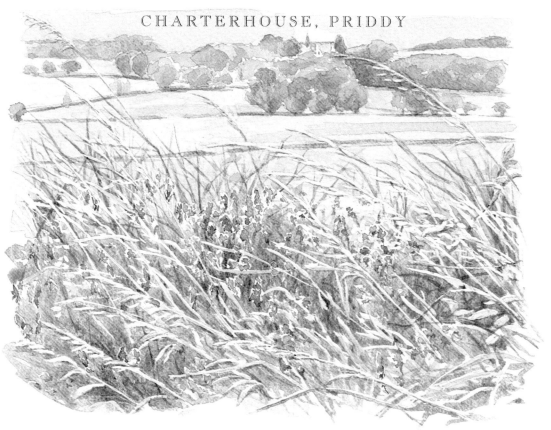

St. Hugh's Church from Rains Batch, Charterhouse

The B3134 winds its way up Burrington Combe and settles down to an almost dead straight, undulating, south-east course across the wide Mendip plateau. Within a few miles of the top of the combe, a road turns south-west, following a gentle fall in the land between dry stone walls, open fields and the occasional cottage or farm, to the scattered community of Charterhouse. Difficult now to imagine the importance this isolated place once held, for within a few years of their invasion in 43 AD, the Romans were here mining for lead and silver - and bringing their roads with them.[120]

[120]*Inscribed ingots of Roman Mendip lead (called 'pigs') have been found as far south as Southampton and on the Continent. Some stamped with the emperor's name have been dated at 49AD. It's possible Uphill near Weston-super-Mare acted as a port. Apparently Mendip lead got as far as Pompeii! Mining reached its peak during the 17th and 18th centuries (Charterhouse and Priddy areas) and by the end of that time the ore was running out. Mid-19th century deep mining was unsuccessful and that led to the resmelting of the lead-rich, medieval waste at both Charterhouse and Priddy.*

This area is known as Blackmoor Valley and there's evidence of mining activity all around: the uneven landscape known as 'gruffy ground', slag heaps of glassy, green-black detritus (19th century resmeltings), dams and washing pits. The lead-poisoned land has engendered a particular wildlife. For example: the nodding sea campion thrives here - many miles from the coast, and adders live happily in nearby Ubley Warren.

On a warm July day, we parked our Fiat Multipla near the Charterhouse Centre. Opposite, the small homely Church of St. Hugh stands close to the road with only its cross, a stone shed and a tree for company. Sadly the church was locked, but peeking in through the windows we could see it resembled a village hall (complete with fireplace) - which indeed it once was. The church is a remote marker on the rolling plateau and we wondered about a congregation.[121] A short distance north, we entered the Blackmoor Reserve with its grass softened remains of an industrial landscape, horizontal distillation flues (to extract the last iota of lead) and washing pits. But long before these scars were made, the Romans were here. Air photography has revealed streets, houses and alley-ways in an area still called Town Field. All of this was pretty much invisible to us, but a short distance up a trackway called Rains Batch we could see, quite clearly, the oval shape of a probable amphitheatre on what was once the outskirts of a small town.[122]

[121]*St. Hugh's Church is a 1909 rebuild of the former miners'*
welfare hall by the architect W.D.Caroe, and the inspiration of Blagdon's
vicar Rev. G.M.Lambrick. Pevsner describes it as "Very pretty in its lonely
position on the top of the Mendips - reassuring in its domestic interior."
St.Hugh was Prior of Witham Friary (near Frome),
a Carthusian order from Chartreuse - in the 13th century Charterhouse
was one of their estates; hence the derivation of the name.
By the time the church was built,
the miners were long gone.

[122]*Francis Knight describes a host of artefacts found in the Town Field area:*
Samian ware fragments, bronze brooches, bells, tweezers and hairpins -
all consisteant with Roman settlement.

Small Copper butterflies on bramble, Rains Batch

On both sides of the Rains Batch track, the bramble was in flower forming a sheltered tunnel with spikes of creeping campanula decorating the high grass. As we walked, we were accompanied by a host of butterflies: Meadow Browns, Ringlets and a myriad of jewel-like Small Coppers - often two or three clustered about a single flower-head. Passing the radio mast, we followed on down the old drove with Bridgwater Bay coming into view.[123] Stopping for a coffee on the raised path-side, we fell into conversation with a Dutch family who had walked up from Cheddar. They seemed surprised to meet us;

"It is like we are in one of your BBC programmes!" they remarked, looking about for a cameraman. And now they're in a book! Reaching the trig. point on Black Down's Beacon Batch (Mendip's highest point: 1068ft/325m) we could see clearly to Weston Bay and Worlebury Hill, and the Holm islands haunting the Channel.

[123]*Shipham miners once travelled this way to and from Charterhouse - so it earned the name: 'The Slaggers' Path'.*

We then cut south, across a sea of flowering heather to reach Charterhouse Farm - passing a collection of evocatively ruined barns along the way.[124] (We were to pass them again, some months later, on the West Mendip Way - looking even more evocatively ruined in misty rain). Across sheep-filled fields and down a drove through the ancient woodland of Long Wood into paradisal Velvet Bottom - a seductively sheltered and warm combe of close-cropped grass, well fitted to its name! The valley opened out into a series grassy terraces set up in the 19th century as settlement pools - an attempt to free industrial waste water of lead and, judging from the glassy slag pathways, probably not successful. Still, the rabbit cropped grass, the terracing and the raised paths made for a comfortable climb back to St Hugh's Church and our car.

Looking to the Bristol Channel, Beacon Batch

[124]*We had crossed 'The Lots' nature reserve, 146 acres bought by the Grassland Trust in 2003 and managed by the Somerset Wildlife Trust - a mixture of acid bog, acid grassland and neutral hay meadows. Black Down is formed of sandstone (emerging from the eroded Carboniferous Limestone) giving rise to acidic soils.*

The post-industrial landscape repeats itself a few miles to the south-west, near Priddy. This was another important mining area although, like Charterhouse, much of what can be seen now are the remains of Victorian resmelting. Most of the mining proper took place in the area now occupied by the Stockhill conifer plantation, close to the various defunct lead works (St. Cuthbert's, Chewton, Waldegrave) - these days separated from them by the B3134. This is an intriguing, atmospheric landscape to wander around but difficult to make sense of: a mishmash of dams, flues and washing ponds - and piles upon piles of glassy slag. Apparently it is classified as 'valley mire' (rare on Mendip) supporting a healthy newt population, along with adders and common lizards, toads, frogs and dragonflies. As at Charterhouse, we found sea campion growing on the warm slag.

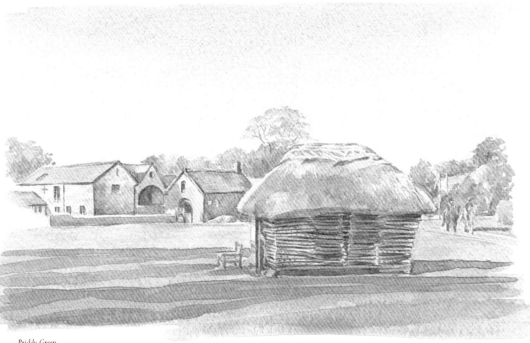

Priddy Green

Priddy is the only true village of the Mendip plateau and in winter it can seem a bleak, inhospitable place - which probably explains why it is so well served by so many excellent pubs with open fires! The village sits in a shallow vale with its central, open green surrounded by high trees, light-grey limestone houses, Manor Farm, barns and hostelries. Its church of St. Lawrence and the school stand on a north-east knoll overlooking the village.

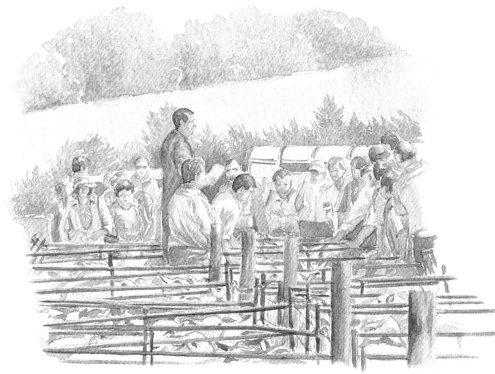

Sheep auction, Priddy Fair

To the south, a ribbon of 20th century houses extends along either side of a road called the Pelting Drove. Priddy is famous for its annual sheep fair and a thatched stack of sheep hurdles always inhabits the centre of the wide, triangular green. Once a year, for a single day, the village explodes into activity and the entire green and adjacent fields are filled with sheep, horses and ponies, stalls and the jingle-jangle of fairground rides.[125]

Priddy is for many the centre of Mendip caving with its pubs (The Hunters' Lodge, The Queen Victoria and The New Inn) especially welcoming to speleologists from all over. The village happily acknowledges this status with a stainless steel information board, at the northerly corner of the green, showing the extraordinary extent to which underground passages and chambers inhabit the limestone deep below the village.

[125]*Legend has it, the fair came to Priddy from Wells in the 14th century to avoid the plague. It's more likely the move was prompted by the city's high taxes! (R.Bush) The stack of sheep hurdles is maintained by a tradition that should they go, so will the fair. The event, held on the nearest Wednesday to August 21st, continues to be hugely popular although the sheep auction side has shrunk in recent years with a corresponding expansion of the fun-fair. Also, the gipsies and horse traders are less exotically dressed than of old - but the sheep auction and the display of horses and dealing remains vigorous and exciting.*

In the immediate area of Priddy, there are upwards of ten accessible caves and swallets, three of particular renown: Swildon's Hole, Eastwater Cavern and St. Cuthbert's Swallet.[126] Swildon's and Eastwater were opened by teams led by Herbert Ernest Balch from Wells in 1903/04 and later wonderfully photographed by Harry Savory on his half-plate camera.

On a bright September day, Rosie and I walked up to St. Lawrence's Church, then taking the southerly footpath down across the fields to the swallet of Swildon's Hole. We crossed several stone stiles on our way - those magnificent Mendip institutions, often constructed with a single enormous slab of Dolomitic Conglomerate. With one we climbed over, the grab-stone had become smooth; polished by the hands of passing cavers. The swallet lay in a wooded depression (a stream-sink), its entrance guarded by a stone blockhouse. The iron entry grill was thrown open… Swildon's 20ft (6m) Pitch and Double Pots awaited us… so we headed back to the church and along Nine Barrows Lane! This was more like it: a beautiful, deep lane lined with ash and old sycamores, past Priddy Pool to East Water Drove and up over North Hill. The wide, open rise of North Hill was distinguished by clusters of Bronze Age burial mounds - particularly the Priddy Nine Barrows which sat conspicuously on the hill-line.[127] We rested for a while amongst a group of ancient beeches and then headed for the disturbed ground (the 'valley mire') of the Priddy Mineries and Waldegrave Pool. Then the footpath south across the fields, following the line of the dry stone wall to tree-canopied Dursdon Drove, so joining the West Mendip Way back to Priddy.

[126]*After Lamb Lair or Leer Cavern (five miles north-east of Priddy and explored since the 17th century), Swildon's Hole and Eastwater Cavern were amongst the earliest caves to be seriously investigated and charted. In the early 1900s, H.E.Balch, along with Harry Willcox and others, opened up the choked entrances and plunged into the unknown. A few years before, Balch had escaped 'near certain death' in Lamb Lair's Great Chamber, crashing 65ft (20m) into unconciousness when his rope parted. To the outsider, there is an obsessive madness to deep cave exploration which these early cavers had in abundance. Balch was of the opinion that candles were the 'most dependable illuminant, as they cast no treacherous shadows'. He considered electric torches to be a good standby! Mind you, that was over a century ago!*

[127]*There are several clusters of Bronze Age funeral barrows on North Hill. The Priddy Nine Barrows figure as a group of seven with two a small distance away. There is another run of eight barrows a little further to the north and, across the B3135, lie the four mysterious Priddy Circles (best seen on Google Earth). About 210yds (190m) diameter, the Circles, unique in Britain for having external ditches, are probably the remains of henge monuments and date from the Neolithic; the same as Stonehenge.*

WELLS, DINDER, CROSCOMBE

On a summer's evening, Rosie and I have often taken the Burrington road from Weston following the direction of the old Roman way across the Mendip plateau, past the Castle of Comfort and Hunters' Lodge Inns, down into timeless Wells. Surrounded by its hills, the small city sits in its own southern vale generously endowed with light and water. On such a summer's evening, a gentle dawdle through the streets will usually end at the Cathedral Green. There, we can stretch out on the grass or find a seat on one of the benches along the warm walls of the close's north side as a lowering sun refreshes the glories of the cathedral's West Front. From there, it's a short walk to the extraordinary, tight symmetry of the Vicars' Close, or the open meadows of The Park, south of the Bishop's Palace. And we often close the evening with half a pint of beer in the White Hart's small garden on Saddler Street looking out over the Cathedral close.

One August day found us south-east of Wells in the beautiful village of Dinder. Such a neat place! - with a leat stream (the diverted River Sheppey) faced by a run of buff and red stone cottages: one still carrying an inn sign 'The Dragon and Wheel'.[128] The small church of St. Michael sits in a wide and generous yard with a lychgate and a sweep of roses to the north door - and Mrs. Chambers playing the organ while we were there.

Below Knowle Hill, Croscombe

[128]Derived from the crest of the Somerville family, although Robin Bush says the dragon should be a wyvern! The Somervilles built the fine Georgian mansion 'Dinder House' beside the church.

We decided to try and take a look at this southerly section of the Mendips from the slopes of a couple of its outliers: Church Hill and Worminster Sleight.[129] We took the footpath near Dinder up into Cliff Wood on Church Hill. Reaching an open field, we looked back to see Wells Cathedral picked out in the morning sunlight against a backdrop of the southern Mendip slopes. Woods and pasture along the line of hills, all the way west to Wavering Down and Crooks Peak. We could even make out the humped ridge of Brean Down, but the sea was tucked out of sight. On the south side of Church Hill, the path led us across a grassy, abandoned railway track onto the incline of Worminster Sleight - where Glastonbury Tor popped into view like an unexpected guest!

Above Croscombe - from Duncart Lane

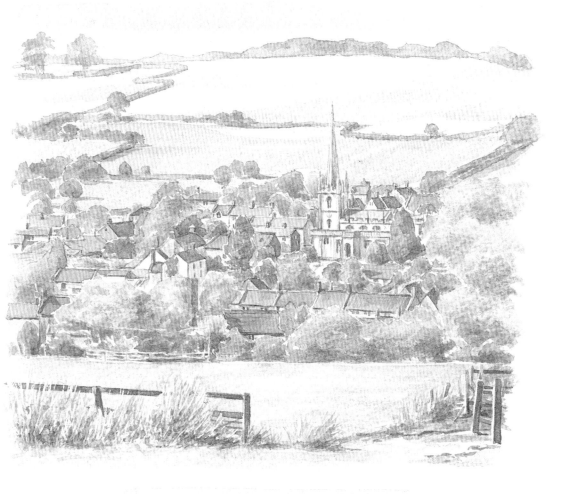

[129]*Sleight is an old word for hill pasture, particularly for sheep.*

From there, we followed the footpath east, to the open grassland of Knowle Hill and its picturesque limestone outcrop - inexplicably known as the Friar's Oven. Below us stretched a field of golden, heavy-headed wheat which we traversed with measured care to arrive, eventually, above Croscombe on Duncart Lane; the white stone church and red-roofed village filling the valley below us.

Despite being bisected by the A371, Croscombe has managed to retain many of its older cottages and stone houses. Meanwhile, the River Sheppey (alias the Doulting Water) slips through almost unseen.[130] Much of the village climbs the lower Mendip slopes, with the pale spire of St. Mary's Church breaking the skyline. We caught the afternoon sunshine on a bench by the church's south porch, overlooking the village. Inside St. Mary's, we were captured by the extraordinary, medieval atmosphere of its dark, Jacobean furniture - which might have been oppressive but for the clear glass windows sprinkling it with daylight.

[130]*Both Croscombe and Dinder, once wealthy agricultural communities, made their money from wool and leather - the River Sheppey providing the power that drove the mills. In Croscombe, many of the mill buildings and their leats remain along the main road. In Dinder, the diverted Sheppey, as well as powering the mills, was employed to entertain the waterfalls and pleasure grounds of Dinder House.*

WOOKEY HOLE, WESTBURY-SUB-MENDIP, RODNEY STOKE, DRAYCOTT

Moving west out of Wells, following the early part of the West Mendip Way which took us to the rim of Underwood Quarry (largely unseen), past the lime kilns in Lime Kiln Lane and up through woodland to the small summit of Arthur's Point. From here, we looked down on the farm buildings of Lower Milton and across to the wide backdrop of the southern Mendip escarpment. The footpath then led us down into the village of Wookey Hole - famed for its cavern and its paper mill. Thankfully, despite being a tourist Mecca, Wookey Hole remains an attractive village; the majority of its buildings are built from red conglomerate with the River Axe winding its amiable way through the streets.[131]

The Axe has powered paper mills at Wookey Hole since 1610. Local St. Cuthbert's Mill continues to produce art paper of the finest quality - for which Rosie is truly thankful.

Just north of Wookey Hole, we picked up the West Mendip Way again to reach the foot of Ebbor Gorge; a deep fissure in Mendip's side incised by summer meltwater torrents during the Ice Ages. (As with Cheddar Gorge, see: 'Geology of the Mendips' Special Page). A steep stairway path climbs the tight contours through coppiced woodland. In April, wood anemones and primroses were in flower, ivy and dog's mercury cloaking the sides of the track. Even with the light tree canopy, the Gorge was shrouded from view until, near the top, a short deviation from the main path led to a wide, open cliff-top where the trees fell away into the spectacular cleft of the ravine. One summer, while Rosie and I were sitting peaceably here; coming from nowhere, a thundering jet fighter, flying implausibly low, 'rent the welkin' and set the whole area, including us, a-jitter. This April, it remained quiet and we had an undisturbed view over the levels and once again, as ever, Glastonbury Tor.

[131] *The River Axe issues from the mouth of Wookey Hole - a cave of some renown; regularly visited since the Middle Ages and suffering human occupation since prehistory. At the time of counting, the Hole has 25 underground chambers extending into the hillside - no. 25 is known as the Chamber of Gloom. Up until 1975, only Chambers 1-3 were open to the public and then a tunnel was driven giving catwalk access to Chambers 7-9. Chamber 9 is especially impressive - over 100ft (30m) long and 100ft high. Entering the other chambers requires sophisticated diving equipment, skill and considerable courage - lives have been lost. In 2005, the River Axe sump at Chamber 25 was explored to a depth of 295ft (90m)!! - an overall journey of 4,000ft/1,213m from Wookey Chamber 9. (Irwin & Knibbs).*

Ebbor Gorge eventually opens out onto the Mendip plateau at Higher Pitts Farm from where the Dursdon and the Pelting Droves (ancient sheep-walks) lead northwards into Priddy village.[132] Pelting Drove links Priddy with the village of Westbury-sub-Mendip by a path cutting across the steep escarpment to join Westbury's Lynchcombe Lane. Westbury rests in a wide combe-hollow on Mendip's southern edge, 150ft (50m) or so above the plain. Many of the houses and walls are built of the Dolomitic Conglomerate - here paler, not so deeply coloured with red iron. In an area known as Old Ditch, where Drappel Lane curves across the lap of the combe, we walked between the stone barns and buildings of Stream Farm, a sow sleeping contentedly at the entrance to her sty.[133]

[132] *Higher Pitts Farm was once the locale of the 'Somersetshire Managanese and Iron Ore Company' which, unsuccessfully, worked the veins of the Dolomitic Conglomerate for minerals. Interestingly, they also unearthed very rare minerals such as Mendipite (an oxide of lead with chlorine) - virtually unknown outside Mendip and precious to collectors. Mendipite still turns up in manganese-rich nodules in Merehead Quarry, East Mendip. (Malcolm Southwood).*

[133] *Drappel is derived from Drop Well, a small spring supplying water to a dipping well set into the wall opposite Stream Farm. (Westbury Village Trail).*

Nearby, great chunks of conglomerate were exposed along the side of the road. In this warm, sheltered place it was easy to understand why glow-worms prospercd in its crevices and walls.[134]

Earlier in Drappel Lane, I had met Mike Brown, mason and dry stone waller, finishing off some beautiful work in an old orchard. Although he now lived in Priddy, it turned out that Mike and I grew up on the same Somerset hill: Worlebury in Weston-super-Mare. He confirmed the Westbury stone was mostly greyish but in Draycott, a village a little further west, the rock returned to rust red. Dry stone masons are running into difficult times - grants are drying up and much wall-work is being carried out by recruited volunteers. Admittedly, if the volunteers weren't available much wall repair would never get done - but it's so important that a balance is struck with the professional craftsmen.

On the West Mendip Way - west of Priddy

[134]*Peter Bright has run an ongoing Villagers' Survey of Westbury glow-worms (Lampyris noctiluca) for some years. They are in desperate decline. Only the relatively immobile female worms glow (larvae glow to a much lesser degree - 'a moving glow') to attract the flying male. Glow-worms prey on slugs and snails. Surveys in 2006 and 2007 yielded similar numbers: 106 & 108. I've only ever seen a glow-worm once in England: all by herself on a dry stone wall on Worlebury Hill, Weston-super-Mare.*

The A371, Wells to Cheddar road, courses the southern Mendip edge passing through and dividing the villages Westbury-sub-Mendip, Rodney Stoke and Draycott. Unlike Westbury, where the main village resides on the hillside above the road, Rodney Stoke, a smaller community, lies on the edge of the plain with its church looking out over open fields.[135] On the hill slopes above the village stand Stoke Woods (Big Stoke and Little Stoke), an 86 acre nature reserve of coppiced, ancient woodland, much of it small-leaved lime. A footpath runs up through the trees to join the West Mendip Way above Draycott, and it's just east of here that the Mendip Gliding Club has its airfield - with a bright orange wind-sock and a mobile, double-decker bus conning-tower. One April lunchtime, walking the Way, Rosie and I parked ourselves against a dry stone wall and watched the gliders being winched and towed into the sky.[136]

[135]St. Leonard's Church has a small but rather extraordinary chapel chockfull of statues and memorials dedicated to the Rodney family. One, rather spookily, has George Rodney (died 1651 aged 21) rising from a coffin draped in his funeral shrouds - there's still a hint of yellow colouring to his long hair.

[136]A few years ago, my old friend Dr Robin Joy, once a member of the gliding club, arranged for Rosie and I to take a flight. It was an amazing experience to be bounced across the grassy airfield and launched into silence out over the Mendip edge - high above the Levels and Nyland Hill, looking to the borders of the Severn Sea.

From the Gliding Club, the West Mendip Way enters an area known as the Draycott Housegrounds, a part of the Draycott Sleights Nature Reserve that occupies a substantial area of steep hillside above Draycott village. You can take a more obliging footpath that cuts across the hillside escarpment towards Cheddar from here, but the West Mendip Way, bless its heart, insists on making the descent all the way down into Draycott. The village straddles the busy A371 (the Wells/Cheddar road) and most of older Draycott resides on the hill immediately above the main road - new housing occupies the slopes just above the moor. Draycott is locally renowned for its strawberries and indeed runs a wonderful annual Strawberry Fair each June in the fields below the village. Fine Cheddar Cheese is made here too - at the Past Times Dairy in Westfield Lane.[137] Draycott was also once highly regarded for its quarried stone which decorates a great many Somerset buildings.[138]

Stawberries from Draycott

After diving down into Draycott, the trail climbs the steep slopes of Batcombe Hollow - awash with violets on a particular April day - to descend again, down the stony hollow-way of the Middle Down Drove, through the outlier hamlet of Bradley Cross, into Cheddar.

[137] *Stephen and Janice Webber have been making traditional, rinded Cheddar Cheese from unpasteurised milk at their 'Past Times Dairy' for many years. Their dairy also produces a particular favourite of ours: 'Draycott Blue', a delicious, soft and creamy, blue cheese.*

[138] *An especially fine form of the Dolomitic Conglomerate was quarried in Draycott. More correctly called a 'breccia' because the embedded stony fragments are angular rather than pebbles. The stone is predominantly a soft pink colour and can be polished - when it's called (incorrectly, because it's not metamorphic!) 'Draycott Marble'. You can see the stone in Draycott's small church of St. Peter with its 'marble' steps. There are also four Draycott pillars in Wells Cathedral.*

Cheddar's Cheese

A truckle of Cheddar

Cheese has been made in Somerset, particularly in the area around Cheddar, since the 12th century and probably much earlier. Henry II rated it so highly that in 1170 he bought forty 'weighs' (a weigh = 224lbs/102kg)) of the cheese for a farthing a pound. In 1586, William Camden in his book 'Britannia' described: "West of Wells, just under Mendippe-hills, lies Cheddar, famous for the excellent and prodigious great Cheeses made there, some of which require more than a man's strength to set them on the table, and are of a delicate taste; equalling, if not exceeding that of the Parmesan." Fifty years later, Cheddar Cheese had become so highly regarded that a Lord Poulett wrote: "these cheeses, once wont to be common had grown to be in such esteem at the Court that they were bespoken before they were made." (F. Knight).

During the mid-19th century, John Harding perfected the 'cheddaring' process where once the curds have been produced by culture, rennet and cooking, they are allowed to set, then cut into loaves which are stacked and turned. The loaves are then chopped up or milled with salt being added to halt the level of acidity. All this reduces the moisture content of the curds which are then placed in moulds and pressed for several days. The cheeses are then wrapped in larded muslin and carefully stored for varying periods of time; deeper and richer flavours developing with maturity. It's no surprise that the perfect storage environment was (and still is) the cool damp of the Cheddar caves.

There was a time when true Cheddar Cheese had to be made within thirty miles of the city of Wells. John Harding actively promoted his cheese-making process and Cheddar-type cheese spread around the globe - to the extent that it isn't possible these days for Somerset's Cheddar Cheese to have particular protection. However, 'West Country Farmhouse Cheddar' only made in Somerset, Dorset, Devon, and Cornwall, does have what's called: Protected Designation of Origin. Which is something I suppose.

The flavour of Cheddar Cheese varies hugely: from the mild soapy examples of mass production to the nutty toothsomeness of an extra-mature farmhouse truckle. My dad liked a Cheddar that "made you break out in a bit of a sweat" or "took off the top of your head"! I haven't tasted one of those for years.

CHEDDAR, TYNING'S FARM, SHIPHAM, WINTERHEAD

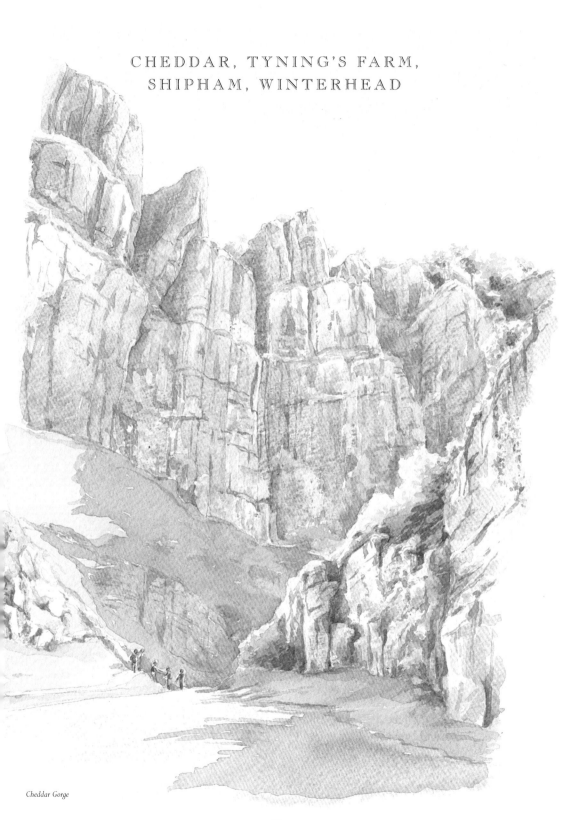

Cheddar Gorge

Cheddar is really more a town than a village these days. It's renowned for its Strawberries, its Caves, its Gorge and of course its Cheese, but what strikes visitors first is the accumulation of touristic paraphernalia around the lower end of the Gorge - and people have grumbled about it for ever! Accepting that, Cheddar offers a lot; Gough and Cox's caves are well worth visiting (Special Page: 'The Caves and the Cheddar Man'); fine, unpasteurised Cheddar Cheese is still made locally (Special Page:'Cheddar's Cheese') and the Gorge, especially whean descending from the top or viewed from its ramparts, is spectacular.

The River Yeo rises at the foot of the Gorge, below Gough's Cave, and immediately has a substantial flow - the Cheddar Risings are the largest resurgence on Mendip, once powering many mills. It's likely the Romans navigated the river to nearby Hythe where a quay survived until 1802 (F. Knight). Excavations in the grounds of Cheddar's Kings of Wessex School have revealed halls belonging to a palace of the West Saxon Kings dating from the time of Alfred the Great (he ruled from 871-899) - and Cheddar remained a royal manor until King John gave it to Archdeacon Hugh of Wells in 1204. (Robin Bush).

Despite the pressures of tourism, Cheddar remains an attractive place of cottages, older houses and a fine market-cross overlooked by the tall tower of St. Andrew's Church. The elegant 'Strawberry Line' railway station, which started off the Victorian tourist explosion, is now occupied by Wells Cathedral Stonemasons, a firm that began life by restoring the cathedral's West Front.[139]

[139] *The railway line from Yatton to Cheddar was opened in 1869, extending to Wells in 1870. The beautiful stations (built of local Dolomitic Conglomerate in the Bristol and Exeter Railway style of high gables and decorative barge boards) were located at Congresbury, Sandford, Winscombe, Axbridge, Cheddar, Draycott, Westbury and Wookey. Although most of the freight was stone and milk, it was the strawberries that captured the public imagination - hence the 'Strawberry Line'. Grown on the loam-rich, southern Mendip slopes between Westbury and Axbridge, the summer months were frantic getting the glorious 'Royal Sovereign' and 'Cambridge' strawberries into the cities - and Wimbledon. Most of the line was closed in 1964 with the Cheddar-Wells section following in 1969. (Colin G. Maggs). Today, only a few strawberry market-gardens still operate.*

The Caves and the Cheddar Man

In 1837, George Cox opened up his cave in the Cheddar Gorge for Victorian visitors. It was immediately popular and successful. More digging and excavation revealed further chambers containing beautiful stalactites and stalagmites, ponds, limpid pools and glorious tapestries of stone. Forty years later, working in a roadside

Richard Gough and his Cave

chamber where carts had once been kept, Richard Gough, Cox's nephew, broke into a new and much more extensive cave sequence. To do so, Gough had had to remove more than 1,000 tons of sediment. The sediment contained a large quantity of animal bones and teeth - a number of which were from extinct animals. Inevitably, the crude excavation of the time meant that archaeological information was lost that could never be recovered.

Gough's Cave went on to be another touristic success - compounded in 1902 when the skeleton of a young adult male was uncovered in an area of the cave now called Skeleton Rift. He became known as 'Cheddar Man'. Subsequent research by the 'Ancient Human Occupation of Britain Project' (AHOBP 2001-10) has shown that he lived some 10,000 years ago and was a rare example of a Mesolithic burial.

He is described as a young man in his 20s when he died. He had a bony depression in his right forehead, possibly from a lethal frontal sinus infection. But he wasn't the first to inhabit Gough's Cave.

Fortunately, Richard Gough hadn't removed everything. Since 1986, excavations near the cave entrance have revealed human remains that had lain undisturbed for 14,000 years. These were hunter-gatherers whose main prey was the horses that grazed the grassy Mendip lowlands of that time - and indeed most of the animal bones uncovered are horse. However, what is a little disturbing is that amongst the human remains lay a skull cap with cut marks consistent with defleshing and possible cannibalism.

13,000 years ago global temperatures dipped again for 1,000 years and the hunter-gatherers disappeared from an Arctic Britain. Which is when Cheddar Man and the Middle Stone Age (the Mesolithic) arrives with warmer weather, a few thousand years later. Mitochondrial DNA studies appeared to link Cheddar Man with some people still living in Cheddar - particularly a local schoolteacher. This evidence is now considered uncertain but the young man who was buried at the entrance to Gough's Cave remains a critical link with our Stone Age past.

(For a full account read Chris Stringer's 'Homo Britannicus').

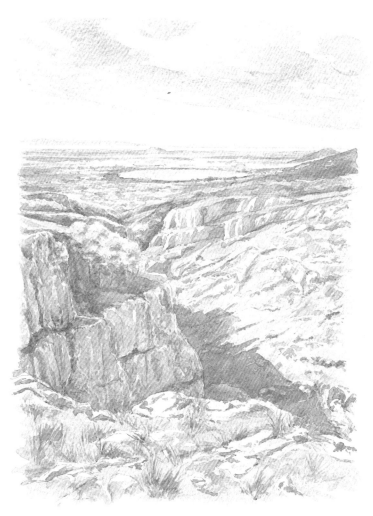

Cheddar Gorge -
south ramparts
looking west

The best way of experiencing Cheddar Gorge is descending on foot, or on a bike, or in an open-topped car. You really do need to have your neck properly cricked to appreciate it! In terms of the Grand Canyon, I suppose the Gorge's 450ft (137m) cliffs are small beer, but it never fails to impress me. And anyway, I've never seen the Grand Canyon.[140] The two sides of the Gorge are in separate ownership; the north side belongs to the National Trust (aquired between 1910 and 1998), while the south (along with the caves) has been part of the Longleat estate since the mid-16th century - this explains why the West Mendip Way, rather perversely, has to follow a route some distance from the ravine on the south side.

[140]My Mum insisted Laura Hamson, a close Canadian friend, just simply had to visit Cheddar Gorge "because it is quite spectacular dear!". Rosie and I weren't too sure that Laura was that impressed - she lived close to the Rocky Mountains in Alberta which soar to some 12,000ft (3,650m) and come complete with glaciers, towering peaks and grizzly bears.

Rosie and I have walked the Gorge on several occasions and, for us, the most satisfying route is travelling clockwise above its cliffs. One late October, we started at Clific Lane, opposite the entrance to Gough's Cave, making the short climb to Clific Cottage and entering the surrounding hazel woodland. From the path, there were glimpses across a small vineyard down to the village and the tower of St. Andrew's. A steady ascent then brought us to the heights above Landslip Quarry where the morning sunlight captured a cascade of rock and strata along the north face - while the southern ramparts sulked in melancholic shadow. Looking south-west, the view was huge: out over the vale to the Isle of Wedmore above the plain, the Polden and Blackdown Hills, Cheddar Valley Lake's incongruous disc of water, Brent Knoll on the edge of Bridgwater Bay folding to Hurlstone Point, the Quantocks and Dunkery Tor. From here, the north path dipped and turned close to the cliffs, to end on Piney Sleight above the steep descent to Black Rock, about threequarters of the way up the Gorge. The prospect was open here with overlapping combes marking the eastward trail to Velvet Bottom and Charterhouse. A tall, solitary Golden poplar stood like an illumination amongst the surrounding woods.

At Black Rock Gate, the footpath meets the B3135 which it crosses and immediately makes a steep, rocky and tree-rooted climb through coppiced woodland to the top of the south side of the Gorge. Here, at last, the southern headlands were catching the sun and we could see the Mendip ridge as a line of hills travelling west, culminating at the the inimitable summit of Crooks Peak. We then came to the lofty Pinnacles with their companions Wind Rock and High Rock - great bulwarks of grey limestone with stands of bright, scarlet-berried rowans and whitebeams rooted in their clefts and crannies.[141]

[141] *Cheddar Gorge is particularly rich in unique plant species - the famous Cheddar Pink (Dianthus gratianopolitanus) for instance. That there are a large number of species of the small tree known as the whitebeam has been known for some time, but between 2005-2006 a further three species were discovered by Libby Houston (Cheddar Gorge Sorbus Survey). They are: the Cheddar whitebeam, the Twin Cliffs whitebeam and Gough's Rock whitebeam - all have different leaf forms and a distinct DNA. All are considered 'critically endangered' - unfortunately, goats introduced to control scrub invasion are damaging the trees.*

Those same crannies provided sun-dipped shelter from where we could watch people and cars inching along the Gorge floor, far below. A small distance further on, we climbed the Lookout Tower (built in 1920) giving us another 'advantageous prospect' which included the violent gash of Batts Coombe Quarry to the north-west.[142] From the tower, it was a short descent through woodland back into Cheddar.

The Market Cross and Arundel House, Cheddar

Walking the West Mendip Way with my brother John and his wife Chris in early April, we stopped off in Cheddar overnight. We 'bed and breakfasted' (sumptuously) at Arundel House close to the Market Cross, where Anne Fieldhouse greeted us with a perfect pot of tea and very delicious simnel cake. The next day, we woke up to a misty drizzle - a complete contrast to the balmy warmth of our walk from Wells the day before. With a comforting Arundel House breakfast inside us, we left by Bradley Stoke and a steady climb through Mascall's Wood (Somerset Wildlife Trust) and up the hillside slopes to the top of, but some distance from, the Gorge. Despite the dull, enclosing mist, the sheep-cropped hillside was alight with bright violets, while along the path sides, that same mist had condensed, highlighting the funnel traps of mesh-web spiders. Then it was down through woodland to Black Rock Gate and along the wide, stony track to the combe mouth of Velvet Bottom. Rosie and I had been here the previous July in warm sunshine, now the mist was turning to rain.

[142]*Batts Coombe Quarry - developed in the Burrington Oolite (a very pure form of Carboniferous Limestone) - is one of only five sites producing quicklime for the steel industry in the UK. (Andy Farrant).*

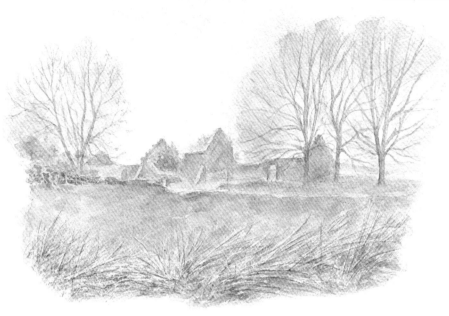

We entered Long Wood, travelling in the opposite direction to before, up its wide drove, to gain the sheep pasture of Charterhouse Farm. John and I rescued a lamb here, trapped between a fence and a stone wall. It was completely unco-operative while being saved and surprisingly strong; we ended up flat on our backs in the wet grass with the lamb flying through the air! Once more, we passed by the Charterhouse Farm barn ruins, this time spectral and half missing in the mist, to reach the tarmacked road to Tyning's Farm. Here at the combe head, we turned down into the shelter of Rowberrow Bottom, sat by the stream awhile, and then up Lippiatt Lane into Shipham - where we found the Miners Arms closed![143] So we had a coffee at the Penscot Inn, close by. Despite some modern building, Shipham, with twisting lanes and terraced cottages slanting on the mid-slopes of Cuck Hill, remains a compact village of great charm. Rosie and I always get slightly lost in Shipham.

[143]*Shipham (and Rowberrow) was a lead and calamine (zinc carbonate) mining area from the late 16th century to around 1870. The calamine went to Bristol where it was combined with copper in the production of brass. The area is surrounded by the scarred landscape left by mining - 'gruffy ground'. Shipham was a notorious rough-house and the local constabulary went in fear of their lives expecting, any moment, to be bonked on the head and cast into an abandoned pit. It didn't stop William Wilberforce's protegees: Hannah More and her sister Martha (who considered Shipham and Rowberrow folk "savage and depraved almost even beyond Cheddar") establishing a day and Sunday school in 1790 - a year after their school in Cheddar.*

Church window, Shipham

When Rosie and I came this way before, we had walked from Winscombe up onto Sandford Hill on the other side of the valley to Shipham. As we had emerged from Sandford Wood onto the south-facing hillside, we were greeted by a scene of an older, rural Somerset: fields, farms and wooded slopes. Urban intrusions were there, but they didn't seem to matter.

The perspective opened out along the Vale of Winscombe into the Lox Yeo Valley below Crooks Peak - a trail of woodsmoke smudging the tree-line and the distance defined by an edge of sea. Just beautiful. And this valley had a legend; I had heard the extraordinary Wimble-stone lived somewhere in the fields immediately below us, but a visit would have to wait for another time.[144] "Oh no! Not another standing stone!!" said Rosie.

Leaving Shipham, we decided to divert slightly from the West Mendip Way by taking the raised footpath just south of the Manor House and the church and tracing a line across the fields to the small hamlet of Winterhead - where an upturned cast-iron bath signed the way. Winterhead occupies a shallow combe with a stream running through, and a gathering of warm stone and white-washed cottages. Above the combe, the path follows a ridge looking out to Sandford Hill before turning south and linking up with the Winscombe Drove - a wonderful, rutted, ancient track that courses the hills for some miles in a gentle, muddy undulation. We were back on the West Mendip Way again.

[144]*The Wimble-stone is a huge, triangular chunk of Dolomitic Conglomerate rock, some 5ft 6in (1.7m) high and 6ft wide at the base, that resides, discreetly, in a field off the Shipham Lane. It is one of Mendip's few standing stones, possibly from the Neolithic period (2000 BC). Francis Knight wondered if it marked a manor boundary or the grave-site of a British chieftain. When I went to visit, it appeared rather forsaken. However, the story goes that by the light of a full moon, on a mid-summer night, the great stone goes dancing the fields and tripping the hedgerows until dawn. 'Wimble' is an old word meaning active or nimble. Apparently, standing stones have a habit of prancing about while no-one's looking.*

WINSCOMBE AND AXBRIDGE

The Winscombe Drove

From Winterhead, the Winscombe Drove ascends and descends to meet the A38 at a stony platform ridge known as Shute Shelve from where the trees of King's Wood rise to fill the eastern slopes of Wavering Down.[145] Due west, a narrow road, Winscombe Hill, winds down to the older part of Winscombe - the village was dragged eastwards towards its hamlet of Woodborough by the arrival of the railway in 1869.[146]

[145]*Known locally as Shute Shelf - 'shute' is an old word for a channel or cutting and 'shelve' is a rocky ledge. It carried the old Bristol to Bridgwater turnpike road. It was also a place of public execution; men were brought here to be hanged following the Battle of Sedgemoor in 1685. In 1609, two men and a woman from Worle were executed and 'hung in irons' for the murder of the woman's husband.*

[146]*On discovering there was another Woodborough in Wiltshire, the railway company decided to change the station's name to Winscombe. Soon after, travellers were surprised to arrive at a station with its sign upside down - it turned out the railway's carpenter, who fixed the signboard, couldn't read.*

The beautiful Church of St. James (the Great!) stands high on a bluff with its great yew tree and Perpendicular tower addressing the village below. The church is famed for its light-capturing medieval and Victorian (Pre-Raphaelite) windows.

Sidcot, which bestrides the A38 on the eastern edge of Winscombe, is well-known for its Quaker School and the Somerset historian Francis Knight who once taught and lived there.[147] Running beneath the road at the Shute Shelve junction is the railway tunnel that once carried the Strawberry Line between Yatton and Wells. Much of the former line has been converted into a cycle-way which, from here, curves round the south side of Callow Hill to the ancient town of Axbridge.

Fred on the Strawberry Line

[147] *The school, "for the education of the children of poor Friends", was founded in 1808, although there had been a smaller Quaker boys' school on the site as far back as 1699. A girls' wing was opened in 1809 and from 1837 the school became co-educational. It continues as a successful, multicultural school with a strong Quaker ethos.*

Although losing its railway in 1964 was sad, for Axbridge it came with the 1967 blessing of the rail-track being replaced with a by-pass road. My generation still recalls the tortuous jams in its narrow streets; ridding the town of traffic returned the community to itself. How Banwell must cast an envious eye! The railway station buildings are still there beside the by-pass and it's now possible to meander (almost) down West Street and the High Street where a feast of old houses and doorways front directly onto the pavement. Many are medieval with 'new' 17th and 18th century frontages. The High Street opens out onto The Square; a splendid, sunny, open space with an intriguing variety of buildings loftily surmounted by the Church of St. John the Baptist lording it from the top of a wide, stone staircase.

The church is a glorious building, light and airy, 15th century Perpendicular, with sun streaming through its clear, glass windows. Looking out from the south porch, the Square below captures a genuine medieval scene highlighted by the dramatic, three-tiered, wood-framed King John's Hunting Lodge.[148] The small town has managed to hold on to its shops and pubs which keeps The Square feeling active and alive. We have friends, Niz and Jenny Hasham, who live in The Old Guild Hall on the north side of The Square with a wonderful, flower filled terraced garden, climbing the hill behind the house. Each level reveals more of the town until from the top, the church, houses and roofs are displayed all about, and beyond the southern edge is Axbridge/Cheddar Reservoir's disc of captured water and there stands, as ever it seems, in the eye's mid-point, Glastonbury Tor.

[148] *Never a hunting lodge and certainly nothing to do with King John!*
Probably built in the late 15th century as a wool merchant's house with
shops on the ground floor, workshops and living space on the 1st,
sleeping and storage on the 2nd. From 1645, it became the King's Head Inn
until the mid-18th century and then a succession of shops.
Saved from collapse by Miss K. Ripley who bought it and donated it to the National Trust.
Fully restored in 1971, it now serves as the town's museum.

Axbridge celebrated the opening of its by-pass with a tableau pageant in The Square. Its great success, involving the participation of hundreds of local people portraying the town's story, led to further pageants, every ten years, between 1970 and 2010.

Axbridge Pageant

We were fortunate to get tickets for one of the 2010 performances and the weather was kind. All 20th and 21st century intrusions were hidden away and The Square covered in sand. Directed by John Bailey, it was a brilliant and moving show, fantastically costumed with intimate dramas being played out alongside the major themes. I especially remember the row of luckless men with nooses about their necks condemned by the Hanging Judge Jeffries, the bull baiting and, more happily, a scene of a Spring Fair and a maypole with children dancing. And then there were the horses - such horses! - and the chugging appearance of a steam traction-engine betokening the arrival of the railway, and the 2nd World War black-market spiv trying to flog dodgy stockings to the audience.

KING'S WOOD, WAVERING DOWN, CROOKS PEAK, COMPTON BISHOP

Back in King's Wood above Winscombe and below Wavering Down on the West Mendip Way. This is ancient woodland with a wide mix of trees - many coppiced or pollarded: oak, ash, small-leaved lime, beech, sycamore, field maple, hazel, yew, sweet chestnut and a few unwanted additions such as Douglas fir and laurel.[149] In springtime, the wood is carpeted in drifts of bluebells, with ramsons (wild garlic) filling the upper slopes - indeed, the spring woodland floor is packed with these two plants which seem to occupy areas to the mutual exclusion of the other. The wood is limited to the north by the high, boundary wall of Winscombe Hall where widely spaced trees of some seniority overlook a bare, stony, tree-rooted track that slowly climbs the hill.[150]

[149]*King's Wood, owned by the National Trust, is a remnant of the medieval Royal Forest of Mendip - land, not necessarily wooded, set aside for the king's hunt. King's Wood has many of the characteristics of ancient woodland (ie. in continuous existence since 1600) with bluebells, ramsons and dog's mercury in the understorey.*

[150]*Built, with later additions, for Rev. John Yatman in 1855 by the architect for Nelson's Column: William Railton. (Derek Moyes).*

Gradually, the trees give way to grassland with the red roofs and barns of Hill Farm marking the point where the track steepens as it approaches the ridge - it seems there may have been a farm nestling here since Saxon times.

When we came this way in April, the mist and fret that had accompanied us along the Winscombe Drove suddenly gave way to bright sunshine slanting through the big trees of King's Wood. We pushed on, up to the open, grassy crest of Wavering Down (696ft/211m) to be greeted by a bustling wind - a wonderful, exhilarating blast. Even more than on Black Down, which is higher, this felt like the very top of Mendip, a sensation emphasised by the way the land and sea spread out below us and the whale-back curve of the high ground to Crooks Peak. A dry-stone wall traced the rise and fall of the Down ahead of us, stretched out beneath a wide cirrus-streaked sky.[151] Just as the grassland dipped before the final rise to Crooks Peak, a rough-hewn bench of Mendip limestone stood with the inscription: "Only a hill but all of life to me" and dedicated to H.B.P. 1937 - 2000.

[151] *A substantial chunk of the southern slopes of Wavering Down; from King's Wood, taking in Barton Hill and Compton Hill, to Crooks Peak, belongs to the National Trust. It is the Trust and its volunteers who are restoring the long dry stone wall that so defines this part of the Mendip hillscape.*

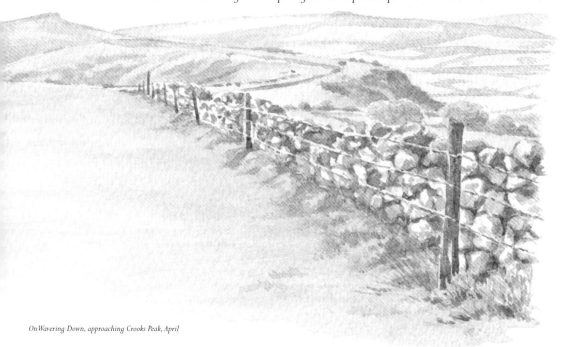

On Wavering Down, approaching Crooks Peak, April

There are other ways of approaching this part of the Mendips; such as taking the lower footpath out of King's Wood which brings you out on to the southern slopes above the discreet village of Compton Bishop, tucked into an encircling arm of the hills; so complete and compact with its church of warm stone and terracotta roofed farms. We came this way with Virginia Flew who wardens this part of Wavering Down looking for sweet violets (Viola odorata). We found violets aplenty glistening on the incline above Compton Bishop but sadly none of them scented - they were all of the species Viola riviniana (the unkindly titled common dog violet).

From the south-west, there's a footpath up onto the spur of hillside that enfolds Compton Bishop. From its low summit, we could see along the south Mendip escarpment to Cross, Axbridge and Cheddar and their shared reservoir, to Wedmore and the Poldens beyond.[152] Flowering gorse and heather and in the short grass, a scatter of bright yellow rock-rose flowers.[153] We then climbed the ridge to the kinked summit of Crooks Peak (627ft/191m) and sat amongst its crags and raged at the motorway roar below.[154] We were looking across the Lox-Yeo Valley, once such a tranquil place, to the rise of Loxton and Bleadon Hills in the west and Banwell Hill to the north - where the motorway dived into a cutting and shamefacedly disappeared.

[152]This is the common rock-rose (Helianthemum chamaecistus) a different species to the white rock-rose (H. appeninum) which, despite being very rare, crowds the southern slopes of Brean Down in June and July.

[153]Cross was once an important turnpike coaching station on the Bristol to Bridgwater road (now the A38) with three inns or 'posting houses': The King's Arms (now Manor Farm), The New Inn and The White Hart - the latter two are still in operation. (Margaret Jordan)

[154]Crooks or Crook Peak? Coming from this part of Somerset, it's always been Crooks for me. The hard 'k' in the middle just sticks in the throat. However, to be fair, the debate has raged for some time! Francis Knight in his two books on Mendip (1902 & 1915) calls the hill Crook's Peak - with the appostrophe! But he quotes the Banwell Churchwardens' Accounts for the maintenance of the hill's beacon-fire in 1580 as recording: "Pd. the firste daye of July for one lood of Wood for the Beaken and for carrynge of the same to Croke peke... 5sh." which supports the spelling without the 's' - except that in 1581 the 's' returns with: "Recd backe of our money for the Beakon at Croks peacke... 2 sh." Knight postulates that Crook's is a corruption of 'Crux' from a crucifix which may have once occupied the hill-top. Others suggest it derives from 'cruc' an old word meaning 'pointed hill'. John Rutter in his Delineations of North Somerset 1829 refers to the hill as Crook Peak as does the Ordnance Survey - but then they weren't local.

In Compton Bishop churchyard

A while later we came off Wavering Down, descending between the high hedgerows of Coombe Lane into Compton Bishop. St. Andrew's Church, standing apart from the village with the hills protectively surrounding it, its fine stone cross, leaning gravestones and grave-chests felt reassuring and complete. Inside, the welcoming atmosphere persisted and a beautifully fashioned, Perpendicular, stone pulpit recalled one in Wick St. Lawrence which Rosie had once painted. We enjoyed this gentle place, sat on Lesley Bubbear's bench with a warm sun lighting the stone cross and south porch, beneath the encircling hills.

LOX YEO VALLEY, LOXTON, CHRISTON

Post box and Howard's bike, Christon

From the crags of Crooks Peak, it's possible to follow Mendip's final push towards the sea. Closer to, along the western rise of the Lox-Yeo Valley and separated by a couple of miles of rolling road, sit the villages of Loxton and Christon - which, despite the continual dirge of the motorway, retain something of the perfect place I so fondly remember. I used to come here with my father, collecting mushrooms in the fields below Christon - close to where the great oaks still stand on the Christon Road. We had family living close-by who provided the local knowledge![155]

[155]*My cousin Malcolm's grandparents, John and Aida Southwood, lived in a cottage
called 'The Beeches' in a dip just north of Christon's church - John was a farm worker.
Malcolm recalls the tiny cottage's huge, living-room fireplace with a chimney open to the sky -
and his grandfather always sitting in the corner with his feet up on the table!
After John died in 1963, Aida had to leave and the cottage became ruinous - it has since been rescued and enlarged.*

Before the motorway came, this was such a beautiful place of quiet fields, streams and high trees stretched out between the wide shoulders of Wavering Down and Loxton Hill - its recollection leaves me with an unrelieved sense of loss.[156]

Both Christon and Loxton occupy choice positions on a sheltered hillside looking to the south-east and capturing much of the day's sunshine. Old barns and stables have been converted into houses and, built with local ruddy conglomerate stone, retain much of their original charm. There are handsome retired rectories, farmhouses and grand houses - and two small churches to complete the pastoral scene. In an effort to soften the motorway din, a good many intervening fields have been planted with trees and orchards. Loxton's Church of St. Andrew stands hidden, well below the village and just above the valley floor. Crooks Peak towers above it - seemingly just over the churchyard wall. But Christon's St. Mary's Church has it rather better; placed comfortably above the road, its splendid Norman doorway looks the mountain straight in the eye.

[156]*Other things were lost - in 1970, motorway construction uncovered an Iron Age farmstead and burial site in the valley below Christon. If it hadn't been for the vigilance of Betty Tabrett and her binoculars, the remains might have gone unrecorded. There were 65 storage pits: some containing the skeletons of around 13 individuals, including several dogs sharing a pit with human remains. Grinding stones and loom weights were also discovered. After a hurried excavation, the site was obliterated. (Chris Richards).*

SANDFORD, BANWELL, WHITLEY HEAD, BLEADON HILL, SHIPLAIT SLAIT

Sandford Station

Winscombe Vale and the Lox Yeo Valley amount to an excavation of the Mendips' western escarpments such that the separated ridges of Carboniferous Limestone are shaped like the pincers of a lobster's open claw. The northern limb is formed by the Sandford and Banwell Hills, the southern by Wavering Down and Crooks Peak - with the claw reaching out to nip Bleadon Hill! Sandford village is quartered by two main highways: the A368 and the Winscombe road; as a result, the village has developed piecemeal along these highways and lacks a defined centre. Amazingly, its old Great Western railway station, on the western outskirts of the village, has survived and been brilliantly restored.[157] Close by and also successfully surviving is Thatcher's Cider at Myrtle Farm on the Banwell road. Drop into their Cider Shop and have a taste of their 'Katy' single variety brew - really good![158]

[157]*Following the Strawberry Line's closure in 1969, Sandford station became a workshop and retail area for stone and paving supplies - at the same time the station building and train sheds were largely unmolested. The business eventually closed and, during the early 2000s, the land developed as a 'retirement village'. The station buildings have been refurbished to a very high standard and are now used as a heritage centre. They include a Station Master's office and there are carriages lined up alongside the platform. It's a pity they can't go anywhere.*

[158]*Thatchers have been making cider in Sandford for over 100 years. Back in the 1960s when it was a touch rougher, I remember calling in with a jug to be filled with their draught cider - and you still can. Thatchers now have 380 acres of apple orchards and they're still planting.*

Despite being within an Area of Outstanding Natural Beauty, poor old Sandford Hill has taken quite a battering. Sandford Quarry, at the western end of the hill has removed an enormous section of hillside - it has been likened to a hollowed-out tooth. Fortunately, the quarry is no longer worked and its gigantic terraces are slowly being colonised by trees and plants. It's easing back into the landscape, but it can never disappear.[159] But the injury doesn't stop there; for some inexplicable reason, a section of the northern slopes of Sandford Hill was allowed to be grotesquely plasticised into a ski slope; virtually rendering its AONB status meaningless.

To the south, Sandford merges into Winscombe and to the west, its boundary is limited by the former Strawberry Line - now a walking and cycle path with several entrances along the Winscombe road. A footpath by the village cemetery took us across the old railway line to the fields between Sandford and Banwell. We could just make out the grey tower of Banwell Castle tucked amongst trees about a mile to the west.[160] In front of us rose the low wooded hill known, rather curiously, as Banwell Plain - presumably alluding to the clear central area of the hilltop occupied by a hill-fort. Lower areas of the hill were splashed with flowering thyme and ladies bedstraw, purple field thistles and blue scabious - but there was no permitted path through the trees to the fort; so we had to leave it be.

Filling a steep cleft between two hills, Banwell is the predominant village of the northern escarpment with a 101ft (30.6m) Perpendicular church tower, an abbey and a history going back to before Domesday. It also has, sadly, a very busy major road (A371) running through its heart; wrecking local businesses and any aspirations to a quiet country life. The road has to negotiate a right-angled chicane where traffic alternately moves one way or the other.

[159]Sandford Quarry began life in the mid-19th century. The quarry expanded with the arrival of the mainline railway at Yatton. Further expansion occurred during and after the 2nd World War exploiting the valuable Burrington Oolite. It was included in the AONB in 1972 and the quarry ceased working in the mid-1990s - a deal that allowed Whatley Quarry in East Mendip to enlarge. (British Geological Survey).

[160]Built around 1845 by London solicitor John Sympson in the Gothic Revival style, putatively to a design by Augustus Pugin. It took over the site of an old farmhouse and was constructed of stone quarried from the spot. Francis Knight described it as 'altogether modern'. In order to forestall intrusion, a notice on its wall once stated: "Built in the 19th century and has no historic or other interest." Making it very interesting indeed! It is now listed Grade II.

The Bowling Green, Banwell

Why it's been denied a bypass is hard to fathom, although nowadays that would simply increase traffic through villages further along the A371. But Banwell does suffer terribly. From off this main road (West Street), Church Street runs down to St. Andrew's Church, set back from a thoroughfare lined with an engaging mix of cottages, houses and a Gothic chapel. The street then opens out to reveal the village's hidden secret: a wide, elevated, emerald-green bowling lawn with St. Andrew's tower rising imperiously over all. It's a captivating scene. This space was once filled by Banwell's Village Pond and as well as the houses, the church looked over a brewery with a tall red-brick chimney and a corn mill.[161] Today, further down Church Street, the Banwell River emerges from its source below the green, flowing on past the Brewery Arms, and across the Northmarsh to meet the Severn Sea at St. Thomas's Head, north of Weston-super-Mare.

[161] *The spring water that still issues here, and which gave Banwell its name (Bana's Well), was purloined in 1914, through Act of Parliament, by a burgeoning Weston-super-Mare. Initially, it was hoped the pond could be restored but Weston wasn't prepared to spend the money on sealing the pond floor. In the end, the village reluctantly agreed to an ornamental garden. It was converted to a bowling green in 1934. (Roy Rice). A local tradition says that once the pond was lost, the church bells never sounded so sweet.*

On the corner of East Street (the Sandford road) stands The Bell; a pub of fond memory for Rosie and me. For many years, from the 1960s to the 80s, it supported a hugely popular folk club attracting some of the outstanding musicians and singers of the day.[162] A little further along East Street, behind high stone walls, lies The Abbey.[163] Rising abruptly from the main road, opposite East Street, is High Street with houses pressed tight against the road - one particularly constricted section is called 'The Narrows'. The road then runs westwards along the mid-heights of Banwell Hill to Well Lane and the small amorphous hamlet of Knightcott.

Taking the steep hill-road up the western end of Banwell Hill brought us to 'The Caves', a private residence, where the remarkable Banwell Stalactite and Bone Caves are found; the latter is open to the general public two or three times a year. It's a strange experience entering the dark, damp grotto; walls stacked with regimented bones like a charnel-house.[164] Outside, the rusticated stone walls and arches add to the curious mood of the place. During the mid-1800s, this was the summer residence of George Law, Bishop of Bath and Wells and old prints show the hill crest virtually clear of trees, with a Bone House (the Osteoicon!) and various follies decorating the slopes. In 1840, the bishop also built a high viewing tower crowning the hill - unfortunately tall trees now largely obscure a landmark that was once visible for miles around.[165]

[162] Particularly, we remember seeing Richard Thompson sing his dark songs with matchless guitar. And brothers Bev and Richard Dewar - who were pretty good too!

[163] The Abbey, also known as Banwell Court, was one of the palaces of the Bishops of Bath and Wells from the 13th to the 18th centuries - by which time it was 'ruinated'. In the 1870s, it was rebuilt as an embattled, Gothic manor house, although the old chapel was retained and still being used for baptisms in 1913. Since then, the house has been subdivided. (F. Knight and R. Rice).

[164] The Stalactite Cave was discovered by miners (looking for lead and ochre) in 1757 and reopened in 1824 by William Beard who subsequently located the Bone Cave. The latter was filled with sediment and the bones of reindeer, bison, bear and wolf. The animals had probably died in sub-Arctic conditions by falling into deep, snow-filled ravines; their remains being washed into the cave by spring melt waters some 80,000 years ago. (Chris Stringer)

[165] The Banwell Heritage Group and the current owner have been hugely active in the restoration of these idiosyncratic buildings as well as the caves.

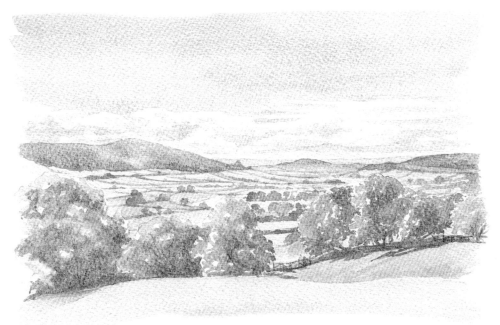

Rounding the west end of Banwell Hill leads to an area known as Whitley Head, and a farm-track bridge over the M5 motorway to Bridewell Lane and Christon Hill. Before heading that way, we took the footpath up through Whitley Head Farm following the middle contours eastward, back towards Banwell. Ignoring the roar of motorway traffic, it's a wonderful open way with an extraordinary prospect down the Lox Yeo Valley to Crooks Peak and Brent Knoll with the blue Quantock Hills inhabiting the far distance. In the corner of a field, not far from where the footpath dips down towards Banwell Castle, we came on a great lozenge of rough limestone that turned out to be the gravestone of an unknown man.[166]

Early July and back at Whitley Head, we crossed the motorway and made the gentle ascent of Bridewell Lane, a well-worn bridleway banked with bracken, cow parsley and rosebay willow-herb.[167]

[166] *The skeleton was uncovered in 1842, near Bishop Law's cottage and a small dagger "with gold-inlaying still bright on its blade" found in a dry stone wall close by. William Beard reburied the bones and marked the position with the stone and some doggerel verse: "Beard with his kindness brought me to this spot, / As one unknown and long forgot..." etc! (F. Knight).*

[167] *Bridewell (or Bridwell) Lane is an ancient, possibly Roman, Mendip drove of some importance, clearly marked and titled on the early Ordnance Survey maps.*

The lane leads to the Christon Plantation at the top of Christon Hill. Just before that, we detoured south across the fields, following the footpath towards Christon's Manor Farm. And there it was once again! - the glorious panorama of western Mendip stretching from Crooks Peak to Black Down. In a field patched with wild thyme, great chunks of Dolomitic conglomerate rock were assembled in a line along the contour of the hill. They appeared to mark an abandoned driveway to the rear gateway of Barleycombe Lodge - just visible amongst the trees.[168]

Bridewell Lane curves round the dense tree-planting of the Christon Plantation to meet Weston Lane, coming up from Christon, at Keeper's Cottage - yellow summer jasmine and bright blue campanula tumbling over the limestone wall on that July morning. This is a meeting of the ways, for the West Mendip Way also arrives here having made the long climb from Loxton village up Loxton Hill. There's a bridleway that tracks south-west from here which led us onto a domed, open field above hillside known as Shiplate Slait.[169] This was beginning to feel like a coda to West Mendip, for we stood with the Bristol Channel stretched out before us in a breathtaking silver arc from Worlebury Hill to Bridgwater Bay, the hump of Brean Down dipping to the sea and the conclusory chunk of Mendip limestone, Steep Holm island, standing off mid-Channel. Moving south from here, with a view filled by Brent Knoll rising from the coastal plain, the bridleway continues steeply down Shiplate Slait to the farming hamlet of Shiplate on the Loxton/Bleadon Road. Further west, that road climbs the hillside through the small, intriguingly named hamlet of Wonderstone before arriving at Bleadon.[170]

[168] Barleycombe was built as a shooting lodge for a Mr. Charles Wainwright. During road construction to the lodge, evidence of lost cottages (crockery, knives and forks) was found on the high ground above Christon village. Lead and calamine were worked locally, so it's possible these were miners' homesteads. (F. Knight).

[169] As with the 'sleights' above Wells; 'slight', 'slait' and 'slate' are alternative spellings of a word for pasture - usually for sheep and often on hill slopes. The farm names: Shiplate, Shiplate Manor, Shiplett House and Shiplett Court along the south Mendip rim between Loxton and Bleadon, are probably all forms of the term 'Shiplade or Shiplake' - words for 'sheep-fold' and 'sheep-path'. (F. Knight)

[170] In 1877, L. & M. Jackson speculated that the name 'Wonderstone' was "probably from the beautiful Breccia" found locally. The stone consisted of "yellow translucent crystals of carbonate of lime, disseminated through a dark red earthy dolomite".

Back at the West Mendip Way junction on Christon Hill, the Way continues westward along the Bleadon Hill ridge. This straight, tarmac highway is called Roman Road and proceeds directly towards Uphill; the small harbour at the mouth of the River Axe below Brean Down.[171] We elected to carry on over the rise and down into Hutton village which lies below the wooded escarpment of Hutton Hill. Unlike the south side of Bleadon Hill which is mainly given over to pasture, the steep northern slopes are almost entirely woodland. The road from Christon Hill snakes down tree-dark Canada Coombe through the small hamlets of Upper and Lower Canada.[172] Miriam Wood, who has lived in Walnut Cottage, Upper Canada since she was a child, says the combe has always been wooded but rather more so since larches were planted in the 1950s. Towards the mouth of the combe, the trees give way to open fields and a footpath led us across the lower slopes to Church Lane in Hutton.

[171]*It was once thought that this was indeed a Roman road which carried lead from Charterhouse on the Mendip plateau to boats at Uphill. Unfortunately there is no hard evidence of this, although Knight insists the cart-track that existed in his time was superimposed on a Roman route. Others claim it is a manifestation of enclosure in the late 18th century. At present, it appears more likely the lead travelled across Salisbury Plain to Winchester and the English Channel at Southampton - where lead ingots from Mendip have been found.*

[172]*Curious name for a Somerset combe. In North America, 'canada' is derived from an Iroquois word for 'village or settlement'. In Spanish and entymologically different, it refers to a narrow valley or glen. (OED and Wikipedia). It may have been inspired by the unification of Canada in 1867. In 1902, Knight refers only to Hutton Coombe but goes on to mention Upper Canada Farm.*

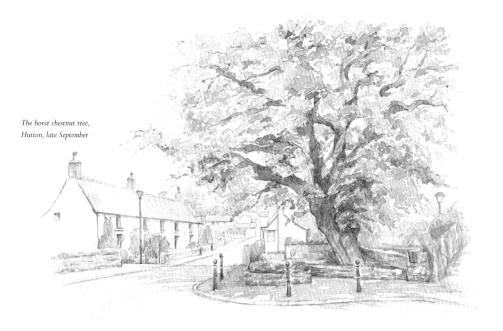

*The horse chestnut tree,
Hutton, late September*

Old Hutton, despite all the housing that has gone up since the war, still holds true to Francis Knight's description of a "quiet coloured West Country rural landscape". Traditional Somerset farmhouses line the busy main road ('The Street' to locals) with the lane up to the church marked by a splendid horse chestnut tree - now under threat from the fungal disease 'black canker'. At the top of Church Lane, next to the church, stands Hutton Court, a towered manor house from the 15th century, although parts of the building may go back to the 13th. It has an impressive medieval hall. A small doorway leads through the Court's boundary wall into St. Mary's churchyard, emerging below ground level. St. Mary's has a fine 15th century tower in the Somerset Perpendicular style, but the church itself was enlarged and refashioned in 1849. For all that, it's a lovely building in a peaceful setting.

Opposite the old village pound in Church Lane, a path took us across hay meadows to the steep, wooded slopes on Hutton Hill. After a short climb, breaks in the trees allowed us to look westwards over Oldmixon and the southern limits of Weston-super-Mare to Brean Down and Steep Holm. With binoculars, we could make out the Old Church of St. Nicholas atop its fastness on Uphill's seaward rise.

Our path climbed steeply through ash woodland furnished with dog's mercury and dashes of hart's tongue fern. Close to the top, at the edge of the wood, the soft, red earth was burrowed with badger setts and, almost immediately, we stepped out of the shadow into bright, open pasture. Moving south and crossing Roman Road, we rejoined the West Mendip Way down into Bleadon village beneath Hellenge Hill.

Bleadon fills a sunny hollow on the south side of the western Mendip escarpment, with the village cocooned from the moors by the upward turn of its diminuitive but quarried South Hill. In 1969, the village was able to save its hill from further destruction, which meant Rosie and I could enjoy a hillside walk behind the church onto the south facing wild flower meadows overlooking the River Axe.[173] As with Hutton, new houses have arrived around Bleadon's original settlement but the essence of the village has remained intact. The tower of St. Peter & St. Paul's Church rises from a crook in the hill with its companions, the village cross and old village post office just about 'postcard perfect'.[174] Coronation Road curves past the church and then divides to become the Shiplate Road travelling east and Celtic Way, climbing the face of Hellenge Hill to join Roman Road. At the bottom of Celtic Way stands 'The Queen's Arms'; for as long as I can remember a hostelry with a great pint of ale.

The Queens Arms, Bleadon

[173]*In 1969, assertive community action halted extension of the quarry which already had 1957 planning consent. The public inquiry was persuaded by the village that the destruction of South Hill and its footpaths would be a serious loss of local amenity.*

[174]*For many years the shaft of the church cross went missing until, in 1929, a new vicar arrived and 'discovered' it supporting a hen house roost - for a while it had been employed as a horse hitching post, complete with iron ring, at a nearby cottage.*

Indeed, Bleadon must have always been a hospitable place, because in 1997 a housing development, in the heart of the village, revealed evidence of an Iron Age farming community and 'Bleadon Man'.[175]

The closing undulation of Bleadon Hill merges with the Uphill coastal rise - a lift sufficient, at one time, to isolate village Weston-super-Mare from the southern moors. Nowadays, much of the western extremity of the hill has been purloined by the suburbs of Weston, and railway and road have cut through the land bridge - each with its own impressive cutting.[176] This means there is no uninterrupted green track from Bleadon to Uphill Hill - where Mendip meets the sea. The West Mendip Way does its best by crossing Purn Hill and the A370 west of Bleadon, and then skirting the dykes to the mouth of the River Axe below Uphill's Old St. Nicholas Church - to end (or begin) just beyond the boatyard entrance. We went that way, but instead of continuing to the river mouth took the more satisfying footpath up over the grassy slopes of Walborough Hill (the south side of Uphill Hill) with the old windmill watchtower in our sights. From here, you can see how perilously poised the roofless old church is - on a quarry edge with a cliff face of Carboniferous Limestone: a sheer drop of 115ft (35m)! The quarrying was halted a fraction from the churchyard wall![177]

[175] The excavation at Whitegate Farm, Rector's Way yielded the graves of a man and woman, carbon dated to 100 BC. Mitochondrial DNA showed that the 50 year old man (who suffered with arthritis) was related to four local people - one of whom strongly resembled the facial reconstruction of the Iron Age 'Bleadon Man'. The findings are on display at the Wellcome Wing of the Science Museum in London and the reconstructed head can be seen in Bleadon village hall.

[176] In 1835, the Bristol/Weston railway line necessitated a cutting 69ft (21m) deep through the Bleadon/Uphill rise, with a 110ft (33.4m) single-span, brick arch bridge (then the highest in the country) to reconnect the Weston/Bleadon road along the ridge. Owner of the land and Lord of the Manor, Charles Henry Payne required I.K.Brunel to build a station on the Weston side close to the bridge - which was done. On the line's opening day, Charles Henry Payne and his wife, in formal attire, waited at their station for the train. It came, gave a toot, and passed straight by. Brunel had built Payne's station but there had been no agreement for trains to stop! For him, they never did. Payne, known as 'Devil Payne' because of his temper, was apoplectic - sued Bristol & Exeter Railway Co., lost, and two years later was bankrupt. The bridge is still called Devil's Bridge. (Donald Brown).

[177] By 1840, Uphill had outgrown its old church up on the hill and a new St. Nicholas was built on flat land at the eastern edge of the village. The old, Norman St. Nicholas, with its small tower, went into steady decline and by 1860 was short of a roof. In 1864, Thomas Knyfton funded its partial restoration: roofing the chancel and fixing the tower and belfry. The nave was left open to the sky. The church is now in the safe hands of the Church Restoration Trust.

Old St. Nicholas Church, precariously stranded on its limestone bluff, marks the endpoint of the southward sweep of Weston Bay. At one time, the church would have been whitewashed as a landmark for those at sea in the channel. Whether Uphill served as a Roman port remains the subject of much debate, although it's difficult to resist the logic of Mendip lead making the hill journey from Charterhouse down to the Severn Sea.[178] Up to the early 1800s, the river was navigable as far inland as Rackley below Crooks Peak carrying barges loaded with coal, potatoes, sand and other heavy goods. The port also allowed the export of limestone, lime, bricks and tiles. With the railway, fish caught in the bay were transported as far as London, with sprats and shrimps being served up as local delicacies. These days, the mouth of the River Axe is a busy harbour for pleasure craft with a small marina and a busy boatyard.

August. We approach the crest of Uphill Hill over limestone grassland dotted with yarrow, thyme, and clear blue scabious while a wide, chromium-bright Bristol Channel swings into view before us. From this perspective the old church seems safe within its churchyard walls. Weston's wooded Worlebury Hill appears to the north and below us lies the boatyard marina with the promontory of Brean Down, foreshortened and hiding Steep Holm. Black Rock stands sentry at the mouth of the Axe and the coastline curves south in an arc of yellow sand.[179] Climbing the windmill tower, the panorama expands to the Welsh hills across the estuary and to our backs, Glastonbury, across the levels - indistinct in the hazy south-east, but quite definitely there! In the early evening, the windmill platform is filled with excited French students. It's impossible to make out what they're saying but then, out of the boisterous banter, comes the surprised exclamation of "Oui, c'est Glastonbury!"

[178] There are ancient trackways (eg. Bridewell Lane on Bleadon Hill) that can be traced from Shipham and Charterhouse to Uphill - indicated by the positioning of Roman villas along the route. There is evidence of a small Roman temple on Brean Down and a Roman signal station on Steep Holm.

[179] Black Rock was the western limit of the Forest of Mendip under the Saxon and Norman Kings. Francis Knight quotes from a 1413 document preserved in the Axbridge archives: thirty two of the town's burgesses held "the right of hunting and fishing in all places, except preserves, from the place called Kotelliasch (now Cottle's Oak near Frome) to the rock which is called 'le Blacston' in the western sea."

The Axe, very effectively, separates the Brean Down peninsula from Uphill and Weston-super-Mare with a substantial width of water when the tide is in - and a deep, impassable ravine in the estuary mud when the tide is out. There was a time when wooden causeways traversed the muddy banks on either side of the river mouth with a short ferry crossing in between. Sad to say this no longer functions; so from Weston it's a surprising, higgledy-piggledy, nine mile road journey across the Bleadon Levels to get to the Down.

Brean Down, with its satellite Steep Holm island, really is the closing chapter of the Mendip Hills. Now in the care of the National Trust, the Down extends about one and a half miles into the Bristol Channel and rises to about 320 ft (97 m) at its highest point. It has been described as having the profile of a beached whale. Steep Holm is over four miles out at sea from the promontory's tip.[180] Promontory and island are, almost entirely, made up from the Carboniferous Limestone - the stone that generates the characteristic high grassland of Mendip. Along the north side of the Down lies a beach platform formed when sea levels were considerably higher than now. No longer strictly limestone country, this area is characterised by the rich growth of bracken along the upper northern slopes. Here, the north cliffs slant easily to the sea and much of the corrugated shoreline is accessible. The south cliffs are different; precipitous and dangerous, they are best left to the feral goats the National Trust has released to control the spread of scrub. Cattle, sheep and rabbits help keep the grass well trimmed. In June and July the southern slopes will be covered with the beautiful flowers of the rare White Rock Rose.

[180] *Owned by the Kenneth Allsop Memorial Trust as a nature reserve since 1976, to perpetuate the memory of an outstanding, campaigning, environmental journalist. Like Brean Down, it has remarkable Victorian fortifications but also the remains of a medieval priory. Home to the rare wild peony, thousands of gulls and a colony of cormorants, it remains a wild place and difficult to get to - although there are regular trips, weather willing, from Weston between May and October.*

From the crest of Uphill Hill looking to the Severn Sea, late summer

Marbled White butterflies

There are two approaches onto Brean Down: a fearsomely, steep stairway straight up the south side or the old military road which makes a gentler ascent eastwards to the crest and then moves west above the north cliffs. We take the military road in mid-July.[181] A bright, sunny morning with the barest wind and Weston Bay, flat-ironed with the tide out, shining and sparkling in the morning sunlight. The occasional early blackberry asks to be picked and swallows plane and skim around us along the road. The detritus of war is inescapable; whether it's Second World War machine gun positions, Iron Age fortifications or where the road is leading us: the elaborate Victorian fort at the end of the promontory. Out in the channel, Steep Holm eases into view as we walk above small pebbled bays and inlets revealed by the low tide.

The fort, which straddles the nib of the peninsula, is fashioned from beautifully crafted, grey Mendip limestone with quoins, windows and doorways edged in Bath stone - the very best in Victorian masonry. So clean and etched it could have been built yesterday - the corrosive wind-blast from the Channel appears to have had little effect. Brilliantly over-engineered, it could last a thousand years. In contrast, most of the World War II structures have either been removed, blown up, or are falling to bits; a different time with different priorities.[182]

Centaury

[181] The road, built in response to fears of French invasion during the 1860s was constructed to service the fort at the western end of the promontory. The fort, with similar batteries on Steep Holm, Flat Holm and at Lavernock Point on the Welsh coast, formed a heavily gunned, defensive chain across the Bristol Channel. The positions were rearmed with searchlights, guns and rocket launchers during WWII.

[182] The Victorians didn't get it all right. In 1900, Gunner William Haines, judged temporarily insane, discharged his carbine into an ammunition magazine and blew himself up - along with a fair bit of the fort. Some years later, a horrified picnicking party came across a skull where Gunner Haines's head might have arrived.

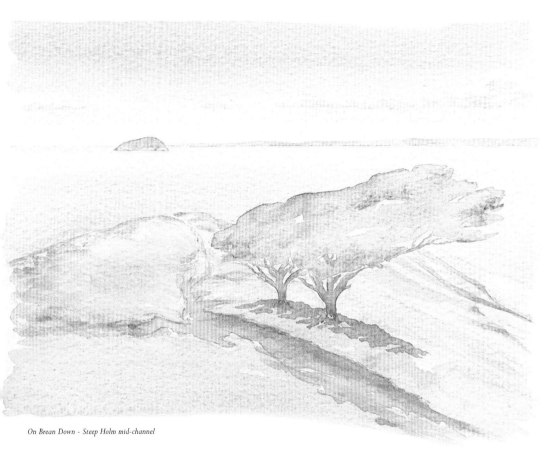

On Brean Down - Steep Holm mid-channel

Beyond the fort, the tide is turning; splintering and churning in the race across the rocky point. In clear sunlight, Steep Holm appears within an arm's reach - it's easy to make out its pebble beach, the woodland and the Victorian barracks above the island's southern cliffs.

We turn and head back, this time up onto the crest of the promontory and along the wide, grassy corridor above the south cliffs. Scattered with clusters of wind-blown hawthorn, the close-cropped downland rises and falls before us in a series of arching swoops. Here and there, the limestone breaks through the turf forming sheltered pockets where wild thyme and centaury flower. Marbled White butterflies, in their black and white livery, patrol the longer grass. Looking east, we can make out Old St. Nicholas Church defying its high cliff-edge, Bleadon and Hutton Hill rising behind. And there, in the seemingly distant south-east, reassuringly, the distinctive top of good old Crooks Peak.

EPILOGUE

Most times it will be there,
The memorial bench, placed just so
Against a sunny wall.

We'll set our rucksacks down
To sit and contemplate
The droves and hollow-ways
Along which we've come.

And as we sit,
(Steam rising from our coffee cups),
We'll repeat the name
This resting place so gently celebrates,
Placed just so, with love and care
And which we now share.

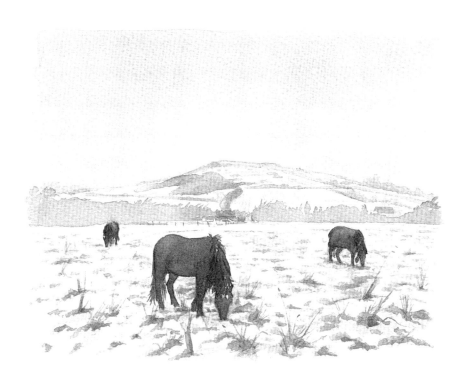

BIBLIOGRAPHY

Allen, Noel & Giddens, Caroline, 1994, Exploring the Quantock Hills with Chris Chapman.
Atthill, Robin, 1971, Old Mendip.
Atthill, Robin, 1976, Mendip. A New Study.
Balch, H.E. 1937, Mendip, Its Swallet Caves and Rock Shelters.
Barrett, J.H. 1993, A History of Maritime Forts in the Bristol Channel 1866-1900.
Bird, Sheila, 1986, The Book of Somerset Villages.
Brown, Donald, 2006, Victoria's Uphill.
Bush, Robin, 1994, Somerset.
Chapman, Chris,1998, Secrets of the Mendip Hills. HTV Ltd Video.
Cleverdon, F.W. 1974, A History of Mells.
Copas, Liz, 2001, A Somerset Pomona.
Crowcombe Parish Council, 1999, A Short History of Crowcombe.
Dobson, D.P. 1931, The Archaeology of Somerset.
Dunning, Robert (editor) 2004, Victoria County History. Vol.8. A History of the County of Somerset.
Eddy, Andy, 1998, "The West Mendip Way.
Farr, Grahame, 1954, Somerset Harbours.
Farrant, Andy, British Geological Survey, 2008, Eastern Mendip.
Farrant, Andy, British Geological Survey, 2008, Western Mendip.
Farrant, Andy, 1999, Walks Around the Caves and Karst of the Mendip Hills.
Gearing, Sue, 1999, Walking on the Mendip Hills.
Gould, Shane,1999, The Somerset Coalfield.
Griffiths, Ken & Gallop, Roy, 2000, Fussells Ironworks Mells.
Hall, W.G. (editor) 1971, Man and the Mendips.
Hardy, Peter, 1999, The Geology of Somerset.
Harte, J.M. The Holy Wells of Somerset.
Irwin, D.J. & Knibbs, A.J. 1977, Mendip Underground.
Jackson, L. & W. 1877, Visitors' Handbook to Weston-super-Mare.
Jordan, Margaret, 1994, The Story of Compton Bishop and Cross.
Knight, Francis A. 1902, The Seaboard of Mendip.
Knight, Francis A. 1915, The Heart of Mendip.
Lawrence, Berta,1951, A Somerset Journal.
Lawrence, Berta, 1952, Quantock Country.
Lawrence, Berta, 1973, Somerset Legends.
Mead, Audrey & Trolley, Annie, 2008, Old Broomfield.
Mee, Arthur, 1951, The King's England - Somerset.
Mooney, Bel, 1989, Bel Mooney's Somerset.
Moss, Rev. Arthur, 1985, Aisholt and its Church.
Nichols, William L. 1891, The Quantocks and Their Associations.
Pevsner, Nikolaus, 1958, South and West Somerset.
Porter, John, 2006, Crosse Connections.
Rice, Roy, 2007, Banwell, Somerset.
Rickford History Group, 2000, Rickford. A History of a North Somerset Village.
Riley, Hazel, 2006, The Historic Landscape of the Quantock Hills.
Riley, Hazel & Wilson-North, Robert, 2001, The Field Archaeology of Exmoor.
Savory, John, 1989, A Man Deep in Mendip. The Caving Diaries of Harry Savory.
Sellick, R.J. 1981, The Old Mineral Line.
Smith, Edward H.1. 1944, Quantock Life and Rambles.
Somerset Wildlife Trust, Andrew Crosse, Scientific Squire of Broomfield.
Somerset Wildlife Trust, 2004, The Story of Fyne Court & Broomfield.
Stringer, Chris, 2006, Homo Britannicus.
Rowe, J., Davis, P. & Cooper, B. 1992, St. Peter's Church, Catcott. History & Guide.
Van der Bijl, Nicholas, 2000, Brean Down Fort.
Waite, Vincent, 1964, Portrait of The Quantocks.
Webb, Jeanne, 2003, Old Cleeve Parish Walks.
Wolseley, Pat & Neal, Ernest, 1980, Quantock Wildlife.
Wright, David, 2000, A Guide to the Mendip Way.

NOTES

NOTES

The missing footnote! (see Page 48).
Will's Neck - nothing to do with Will or his neck. Probably derived from 'nek' meaning a ridge and 'Wealas':
the name given to the Celtic tribes by the invading Saxons around 680 AD.

Flat Holm

Sand Point

NORTHMARSH

Steep Holm

Worlebury

Weston-super-Mare

Sandford

Rich

Hutton

Banwell

Winscombe

Bu
Rowberro

BRISTOL CHANNEL

Brean Down

Uphill

Bleadon

Christon

Shipham

Brean

Loxton

Compton
Bishop

Axbridge
Reservoir

Che

M5

Brent Knoll

Ro
St

Burnham-on-sea

Wedmore

Steart

THE LEVELS

Westhay

Woolavington

Nether Stowey

Cossington

Edington

Chilton
Polden

Catcott

Shapwick

Bawdrip

Ashcott

St
Walton

Chedzoy

Moorlinch

Aisholt

Enmore

Bridgwater

Sutton
Mallet

POLDEN HILLS

Goathurst

QUANTOCK HILLS

North Petherton

Compton

Othery

Dun

Cothelstone

Broomfield

High Ham

Kingston
St Mary

Som

THE LEVELS

Langport

Taunton

Muchelney